Contemporary Painters

Danijela Kracun & Charles McFadden

Schiffer Publishing Ltd

4880 Lower Valley Road Atglen, Pennsylvania 19310
Printed in China

Library of Congress Control Number: 2011945826

Cover and book designed by: Bruce Waters
Type set in DeVinne heading font/Zurich text font

ISBN: 978-0-7643-4108-3
Printed in Hong kong

Schiffer Books are available at special discounts for bulk purchases for sales promotions or premiums. Special editions, including personalized covers, corporate imprints, and excerpts can be created in large quantities for special needs. For more information contact the publisher:

Published by Schiffer Publishing Ltd.
4880 Lower Valley Road
Atglen, PA 19310
Phone: (610) 593-1777; Fax: (610) 593-2002
E-mail: Info@schifferbooks.com

For the largest selection of fine reference books on this and related subjects, please visit our website at **www. schifferbooks.com**
We are always looking for people to write books on new and related subjects. If you have an idea for a book, please contact us at
proposals@schifferbooks.com

This book may be purchased from the publisher.
Include $5.00 for shipping.
Please try your bookstore first.
You may write for a free catalog.

In Europe, Schiffer books are distributed by
Bushwood Books
6 Marksbury Ave.
Kew Gardens
Surrey TW9 4JF England
Phone: 44 (0) 20 8392 8585; Fax: 44 (0) 20 8392 9876
E-mail: info@bushwoodbooks.co.uk
Website: www.bushwoodbooks.co.uk

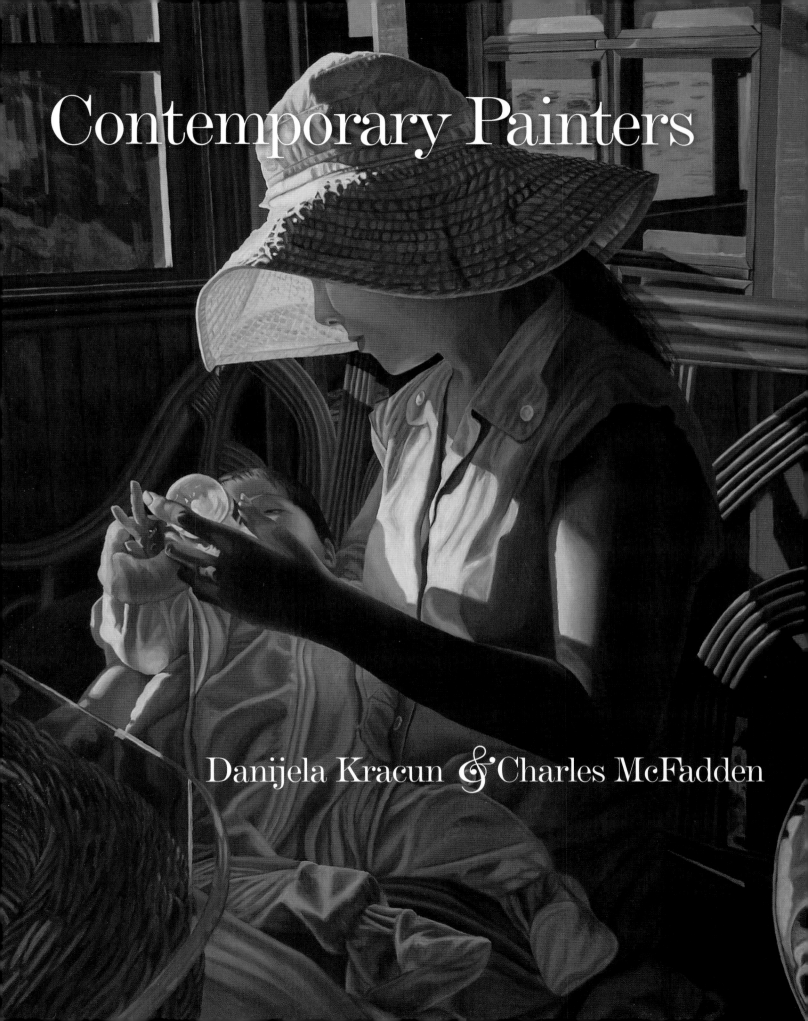

Contemporary Painters

Danijela Kracun & Charles McFadden

Acknowledgments

Thanks to our editor, Douglas Congdon-Martin, and the entire Schiffer Team. Thanks to all of the artists for providing us with pictures, artists statements and biographies. Peace and love to our family and our children, Paisley, Sam, Tim, Kordy, Cameron, Lucia and Tristan.

Contents

Introduction

In this book you will find an eclectic group of modern painters. The participants were selected from submissions received from around the world. Each of them is unique in style, background, and education level. The criteria for being chosen was simple, be different and catch the eye of the beholder. Now this is where things may got tricky. My eye may be drawn to a piece that you may not like. That is okay. Everyone has their own opinion regarding art and that is why there are so many works of art to choose from.

As you go through this book, you will see many historical influences shining through and many new styles emerging. There is a beautiful visual variety as the pages are turned and each artist is revealed. Some painters were very traditional in representing their mother country and some ventured in their own direction. The Naïve painters seem to have undergone a resurgence with a new spark, while other painters moved into a more futuristic direction, mixing styles and creating a completely unique and innovative canvases. No matter which direction the artists took, their work is truly exceptional.

Art is an personal process. It comes from inside the artist's heart, soul or psyche, and is a transformational process from the individual to the canvas. A piece of the artist can always be found in a work of art. The artists paint with strong feeling and emotion, with an extreme amount of hard work. Often the times when the artist is going through a painful personal experience or through a period of questioning the most imaginative and striking pieces of art are created. Each piece of art is like a child; it is hard to part with and always invokes a memory of how it was created.

An artist's work seems never to be done. A piece of work can be on an easel for months before it is "completed," and, even so, years later an artist can find ways to improve upon their creation. That as three years old to the elder years, the body can be a creative vessel through which art just comes pouring forth.

The creation of this book allowed us to travel the world in search of contemporary artists and their creations. So many fantastic works were brought to our attention. The enormous creativity of the individuals chosen really shows how beautifully the world is seen through the artist's eyes.

There were many more artists that deserve recognition, however, we had to narrow down the list. Like beauty, art is in the eye of the beholder. What one finds beautiful someone else may not. Art is such an individual passion.

The artists chosen have a strong sense of individuality and enormous creativity. We hope the reader will find an artist that speaks to them and that they will check them out further. The range of talent showcased in these pages may spark an interest in visiting more galleries and supporting the much needed art programs in your local schools and communities.

Jeffrey Abt

Huntington Woods, Michigan, USA
www.jeffreyabt.net

Jeffrey Abt is an Associate Professor in the James Pearson Duffy Department of Art and Art History at Wayne State University. After studying painting in graduate school he went into curatorial and exhibitions work, first at the Wichita Art Museum, then in the Special Collections Research Center of the University of Chicago, and finally at the University of Chicago's Smart Museum of Art, before coming to Wayne State. His paintings and drawings are in the permanent collections of several museums including the Des Moines Art Center, the Minnesota Museum of American Art, and the Nelson-Atkins Museum of Fine Arts, as well as several corporate collections including Dow Automotive, Polk Technologies, and the Federal Reserve Bank of Chicago (Detroit branch). Abt is also a writer and he has published two exhibition catalogs and nearly two dozen articles, most recently focusing on museum history. His book, *A Museum on the Verge: A Socioeconomic History of the Detroit Institute of Arts, 1882-2000*, published by Wayne State University Press, received the 2002 Award of Merit from the Historical Society of Michigan. His next book, *American Egyptologist: The Life of James Henry Breasted and Creation of His Oriental Institute* will be issued by the University of Chicago Press in fall 2011.

There are three lines of concern weaving through my work. One is the poetics of close observation and rendering. Another is migration, transience, and the tangibility of absence. The other is the nature of display spaces and their parallels with religious sanctuaries. An important aspect of my work is the level of craftsmanship I invest in each piece. I try to reward my viewers with experiences that become richer the more time they spend with and closely examine my work. I don't believe in technique for its own sake, but I feel its intelligent use invites and compensates a viewer's attention.

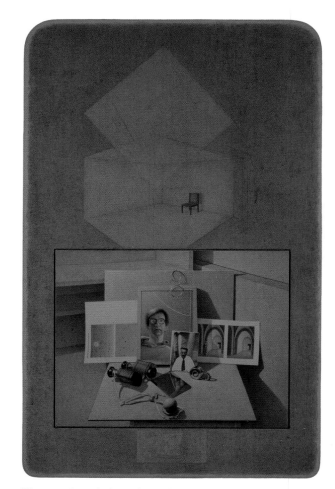

The poetics of cleansing, 1998, acrylic on panel, 27 x 17 in. Photography by Jeffrey Abt

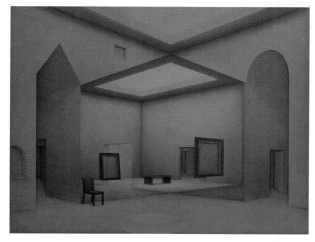

Museum (visitor), 2003, acrylic on panel, 30 x 38 in. Photography by Jeffrey Abt

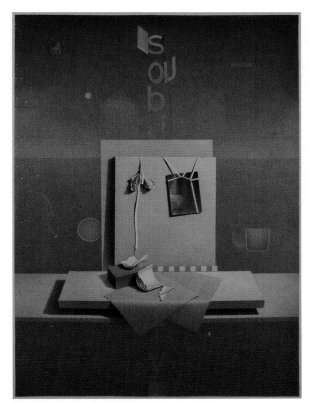

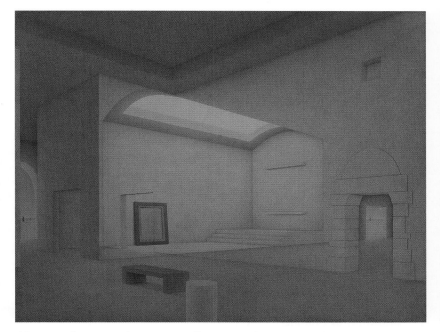

Museum (sanctuary), 2003, acrylic on panel, 30.75 x 39 in.
Photography by Jeffrey Abt

Questions of evidence, 2000, acrylic on vellum,
33.25 x 26 in. Photography by Jeffrey Abt

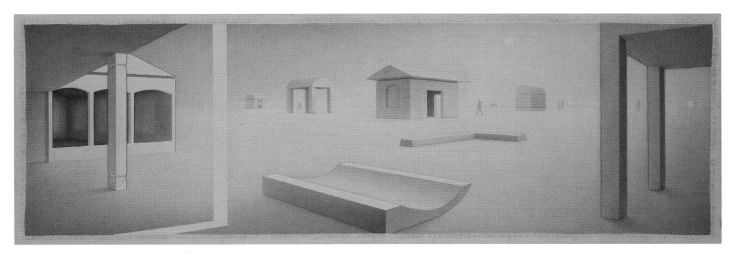

Khamseen, 2010, oil on linen over panel, 16 x 48 in. Photography by Jeffrey Abt

Jose Acosta

Poughkeepsie, New York, USA
www.artid.com/jose

Born in San Jose, Cuba, in 1966, Jose Acosta immigrated with his family to the United States a few years later. He enjoyed painting from an early age and, in fact, has been creating art as long as he can remember. In 2003, he enrolled in the Art Students League of New York to further his art education. While there, he studied with John Hultberg, an abstract expressionist and surrealist, who greatly influenced him and encouraged him to pursue his artistic vision.

I create paintings characterized by their bright colors, swirling figures, and vibrant energy. I think my background and conditioning are the ingredients. I am a Cuban-American and very proud of my Cuban heritage as well as my American citizenship. Generally, my paintings depict and reflect on my history as well as my surroundings and experiences, while expressing passion from the heart, the mainspring of life.

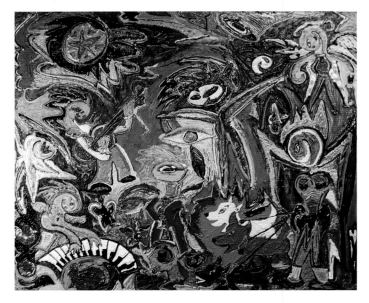

3 Dogs, 2010, acrylic, 36 x 42 in. Photography by Jose Acosta

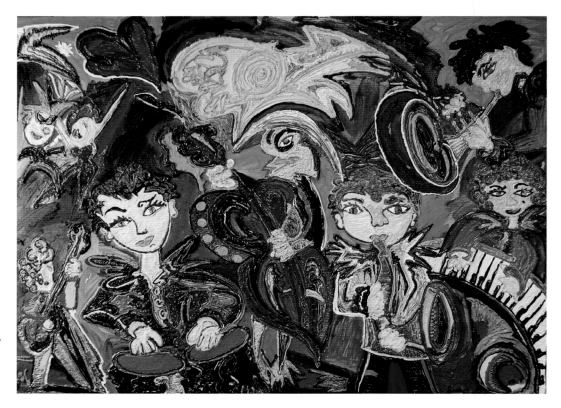

Music & Dance, 2010, acrylic, 36 x 42 in. Photography by Jose Acosta

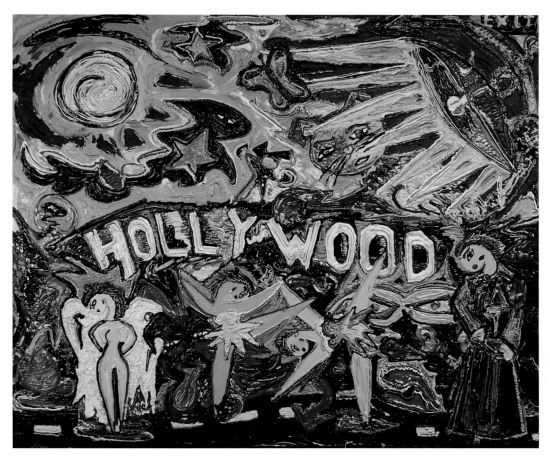

Hollywood, 2009, acrylic, 36 x 42 in. Photography by Jose Acosta

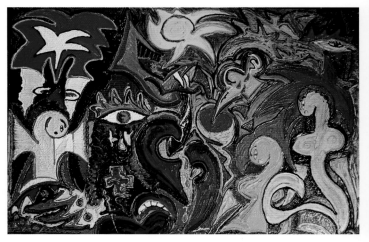

Sirens, 2008, acrylic, 30 x 40 in. Photography by Jose Acosta

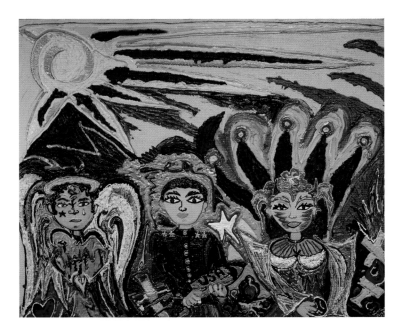

Usual Suspects, 2009, acrylic, 36 x 42 in.
Photography by Jose Acosta

Kareem Ralph Amin

Los Angeles, California, USA
www.kareemralphamin.com

Composition of Figure, 2009, oil on canvas, 48 x 48 in.
Photography by Kent Mercurio

Faces and Figure, 2009, oil and pastel on canvas, 48 x 48 in.
Photography by Kent Mercurio

Kareem Ralph Amin is a self-taught artist born in Guyana in 1976. He studied radio and electronics technology at St. John's College and Guyana Technical Institute. In 1999, he migrated from Antigua to San Diego California, where he lived and develop his professional art career. At present he lives and works in Los Angeles.

As an Abstract painter, I am forced to create images and pattern with selfless authority. These images develop from an imaginary concept that includes figures, movement, and the dancing brush strokes of the composition. The textural pattern is painted to balance the figures, distinctively allowing contrasting color palette to render as Light and Dark. This dichotomy in my work is brought about by disguising the figures so that the viewer is free to interpret their own subject and voice.

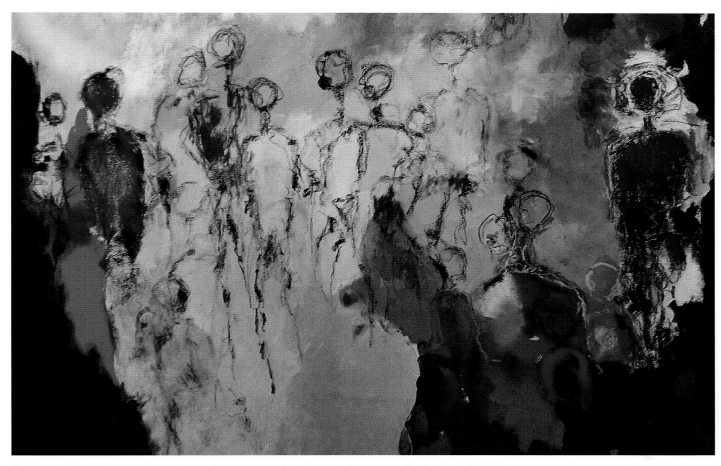

Past and Present, 2010, oil and pastel on canvas, 70 x 120 in. Photography by Kent Mercurio

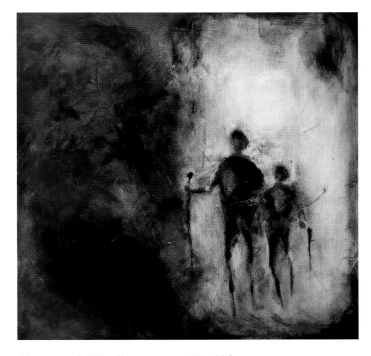

Harmony, 2003, oil on canvas, 48 x48 in.
Photography by Kent Mercurio

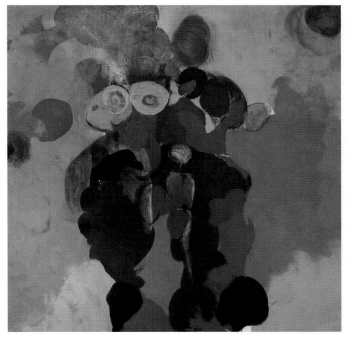

Portrait of Faces, 2009, oil on canvas, 48 x48 in.
Photography by Kent Mercurio

Ray Becoskie

Saint Paul, Minnesota, USA
www.becoskie.com

I started painting in 1986. I've been painting since then. I started showing my work in 2005. I have always thought of painting as a by-product rather than as a product. It was always something that had to be done, then put away. Using it as fuel for the next. Never really intended for show.

That changed somewhat when I sold a painting. After that, *I figured out that if I sold a painting, I could buy more paint and canvas. Then I found myself a little more inclined to share.*

The work is generally constructed from three things. Things I know, things I believe, and things I make up. I get them all together in a room and I do my best to document the conversation that happens.

12 Secretaries, 2010, acrylic, ink, wax, gouache, and graphite on canvas, 51 x 64 in. Photography by Ray Becoskie

What You Need to Be Forgiven, 2009, acrylic, ink, wax, gouache and graphite on canvas, 64 x 51 in. Photograph by Ray Becoskie

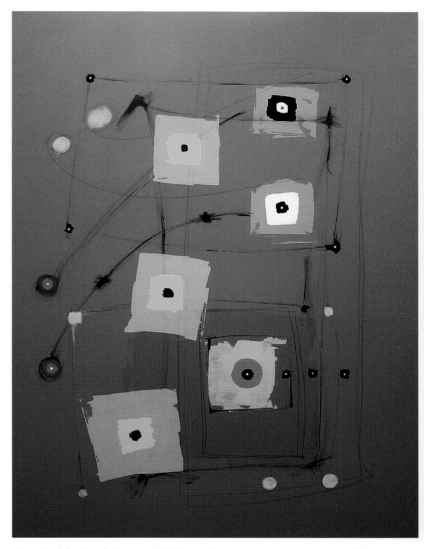

Seven Men Hold My Hand, 2008, acrylic, ink, wax, gouache and graphite on canvas, 36 x 64 in. Photography by Ray Becoskie

I've Had Better Chicken, 2006, acrylic, ink, gouache and graphite on canvas, 64 x 51 in. Photography by Ray Becoskie

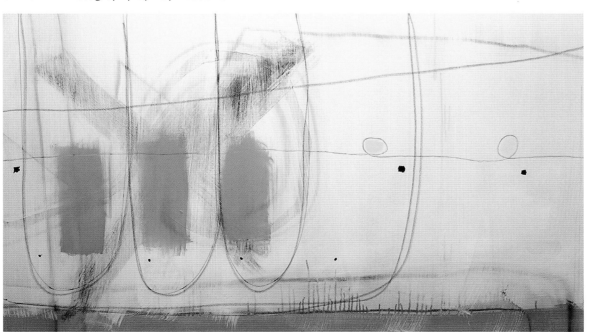

BeelZan

Springfield, New Jersey, USA
www. BeelZan.com

Herzel Yerushalmi was born in Iran. At seven, instructed by his father, a self proclaimed poet, he took his first painting class. Islamic and Persian mysticism continue to intrigue his imagination and influence his imagery. His development as an artist was profoundly transformed when he moved to Israel. Exposed to intense national, cultural, and religious opposing forces, he found that artistic expression couldn't be confined and limited by any rules, influences, contexts, or boundaries. He wanted my art to breath, digest, absorb, and metabolize all. Academia, he felt, would exactly do the unthinkable to his art: confine it and produce something resembling art. Becoming a professional psychologist and learning the revolutionary ideas of Freud, Jung and the Existentialists, he became infatuated with the personal intra-psychic and the symbolic. Everything merged together when he moved to America. A complex integrative narrative began to emerge, intensifying and revolutionizing his artistic approach, expression, and career. In recent years he has worked from a studio located at Springfield, New Jersey.

With a dual existence I strive to attain the freedom of expression I deeply need when looking at the canvas to be worked on. I sign my paintings "BeelZan" which in Farsi means a laborer, a farmer; one who carries a shovel; who digs. The meaning of art for me lies in my belief that the "normal" lives by and through images a fantastic and selfish reality. My imagination leads my technique through a mysterious path. Whatever and however I genuinely paint, is my style. I discover as I proceed. I cherish the tension that conflicts while searching for the to-be-revealed. My artistic creativity rejects machination and mechanistic approaches. My art speaks of the individual and his/her cultural, existential and historic narrative. In doing so, the strokes, the colors, shapes and lines in my paintings follow a very personal narrative struggling to communicate our sufferings, fears and hopes facing unhappiness with the human condition. Transforming fear through art is what I experience while painting as a cosmic experience of internal freedom.

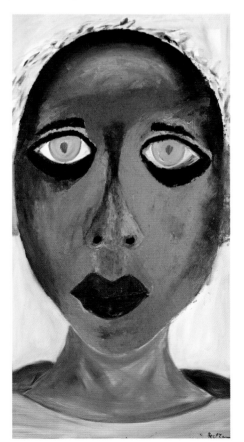

Eve, 2010, oil on linen, 36 x 18 in.
Photography by Colossal Imaging

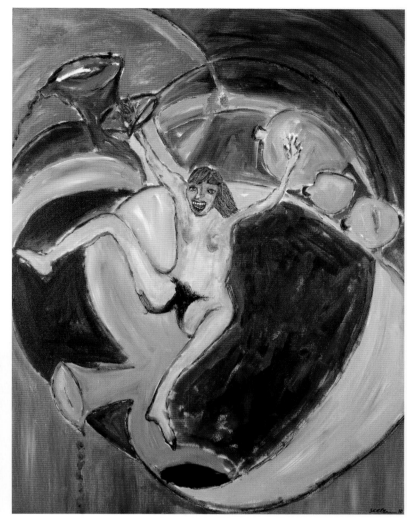

Joy, 2008, acrylic on canvas, 40 x 30 in.
Photography by Colossal Imaging

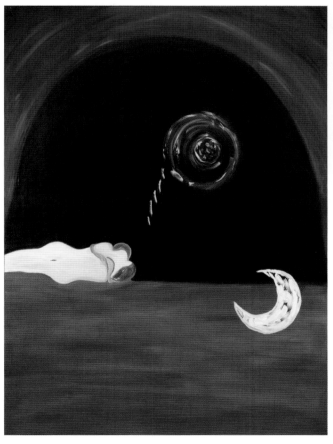

Oneness, 2007, oil on canvas, 48 x 36 in.
Photography by Peter Jacobs

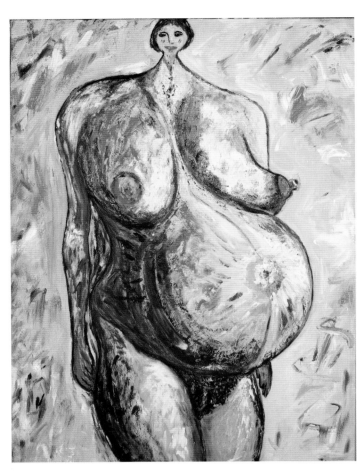

Pregnant Woman, 2010, oil on canvas, 48 x 36 in.
Photography by Colossal Imaging

Pilgrims/Hajj, 2010, oil on linen, 18 x 24 in.
Photography by Colossal Image Printing LLC

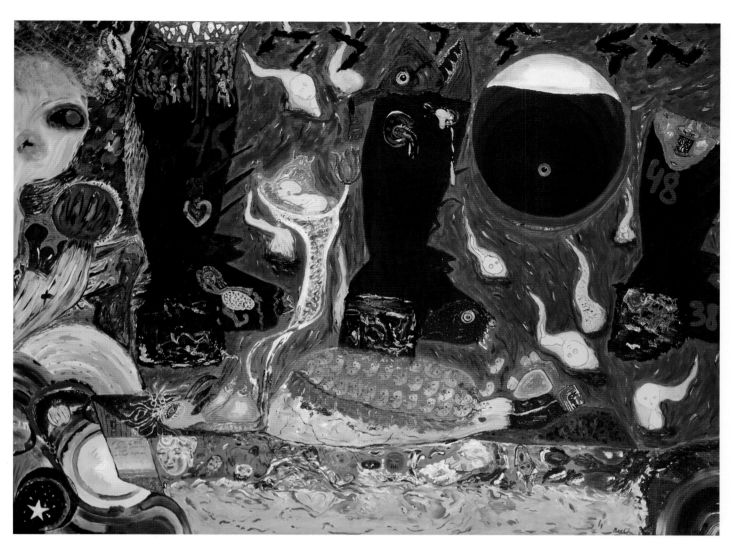

Mother-Machines #2, Al Tirzakn (thou shalt not kill), 2005, acrylic, oil, mixed media on canvas, 36 x 48 in.
Photography by Colossal Imaging

Steven J. Bejma

Roseville, Michigan
www.classichorrors.etsy.com

Steven Bejma is a self-taught artist working as a self-employed graphic artist for the last 20 years. His company is Graphics By Artman. Steven is 50 years old, married with one son, Christopher.

I work as a commercial graphic artist during the day, but my passion has always been oil painting, Classic Horrors is my side project that I do at home to relax. I started with the idea of taking all the old classic horror movie icons and updating them into color paintings as I think they may have been intended.

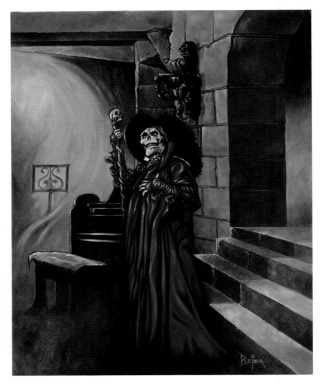

Phantom of the Opera, 2009, oil on canvas, 18 x 24 in.
Photography by Robinson Photography

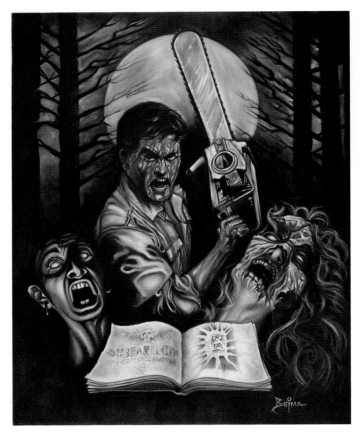

Evil Dead, 2009, oil on canvas, 24 x 30 in.
Photography by Robinson Photography

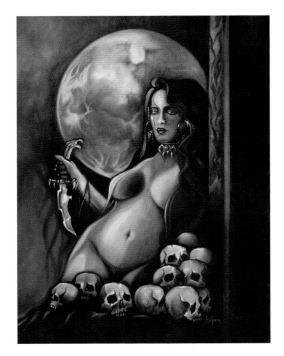

Charlotte, 2009, oil on canvas, 18 x 24 in.
Photography by Robinson Photography

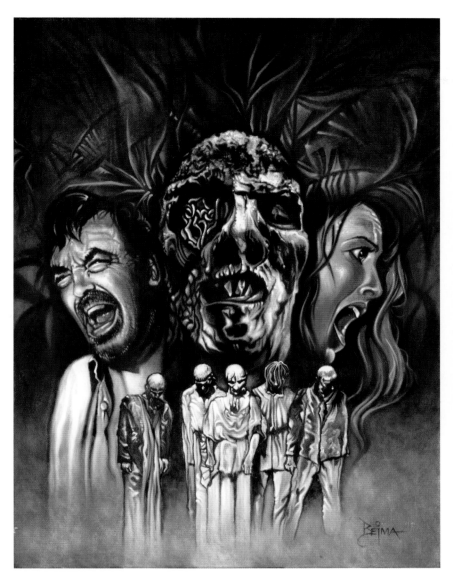

Zombie 2, 2009, oil on canvas, 18 x 24 in.
Photography by Robinson Photography

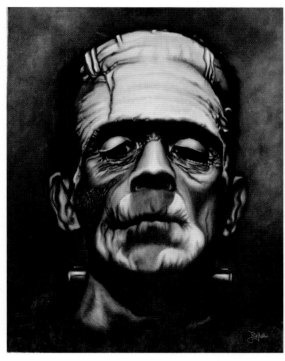

Frankenstein, 2008, oil on canvas, 16 x 20 in.
Photography by Robinson Photography

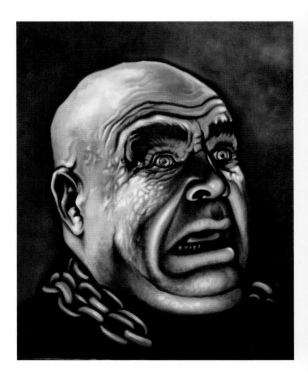

Tor Johnson, 2008, oil on canvas, 16 x 20 in.
Photography by Robinson Photography

Bhat Boy

London, England
www.bhatboy.com

Boy's cityscapes reinvent the urban environment into a medieval context. His paintings are more like how we remember or dream of a place than how they actually are. Nuns and goldfish are all part of the language of Bhat Boy's work. Nuns are a potent and thought provoking symbol that represent the traditions of human society and the powerlessness of the individual human, while Goldfish represent the inexorable forces of nature and our relationship to the natural world. Imagination is the only boundary in the world of Bhat Boy.

He was born in London England, the son of a cleaning lady and a spy. As a child he became a naturalized Canadian and grew up in Canada's national capital, Ottawa. He studied fine arts at the Ontario College of Art and Design in Toronto and in Florence, Italy, where he decided that it was his calling to become a painter. Bhat Boy sells work in Canada, the United States, and Europe. His work can be found on every continent but Antarctica. Most recently his work has become a Ravensburger Puzzle as part of the Canadian Artists Collection. Bhat Boy is an internationally renowned artist and refers to his work as "Envisionism." He is represented at the Gordon Harrison Gallery in Ottawa and currently lives in London England.

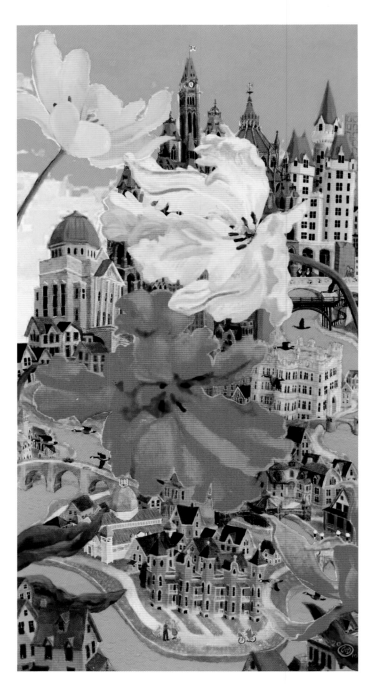

Spring's Revenge, 2010, acrylic on canvas, 25 x 50 in.
Photography by Bhat Boy

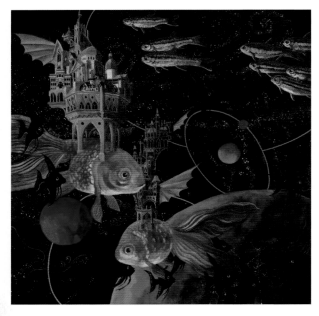

Drifting Off At Night, 2010, acrylic on canvas,
36 x 36 in. Photography by Bhat Boy

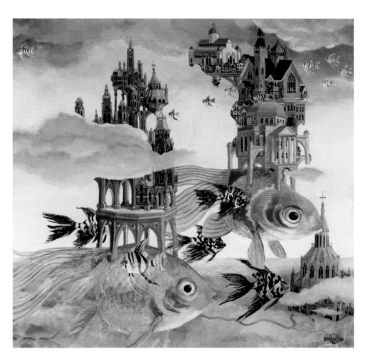

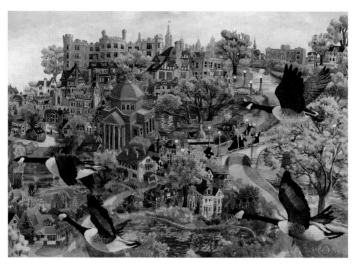

Gooseflight, 2009, acrylic on panel, 48 x 36 in.
Photography by Bhat Boy

Journey to the Library, 2010, acrylic on canvas, 36 x 36 in.
Photography by Bhat Boy

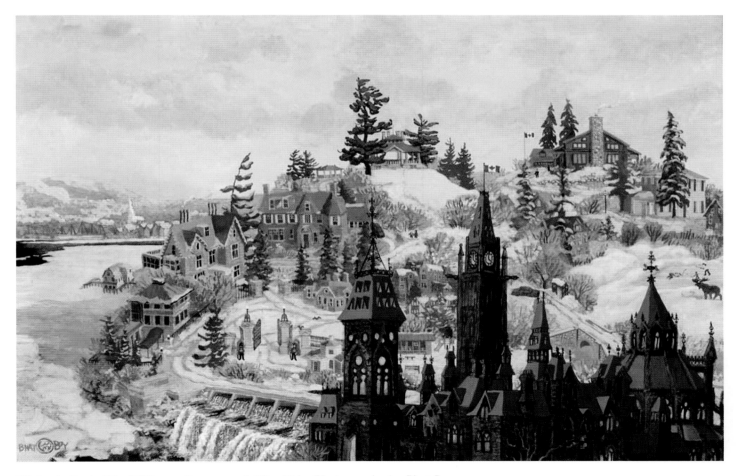

Winter in Rockcliffe, 2009, acrylic on panel, 30 x 40 in. Photography by Bhat Boy

Martin Blender

Southampton, New Jersey, USA
www.martinblender.com

Martin Blender was raised in New York City where he attended the High School of Music and Art, majoring in art. Instead of becoming an artist upon graduation, he attended Washington University in St. Louis and became an architect. His successful professional practice, in which many of his buildings were cited for their excellence of design, continued until his retirement. He moved to Florida and then ended his retirement and became the architect for the University of Miami. It was in that school, with its excellent art department, where he honed his drawing skills and then ventured into lithography and printing. Eventually he evolved into oil painting.

Because of his architectural training most of his work developed a rigid geometry, so to break that mold he devoted himself to the use of the nude human form, painting them in his unique style that gives substance to his work. His representations, although realistic in nature are formed into abstract compositions using line, shape, texture and contrast to create simple beauty. He works with a limited palette to keep his work simple and uncomplicated, to further his commitment to simple beauty.

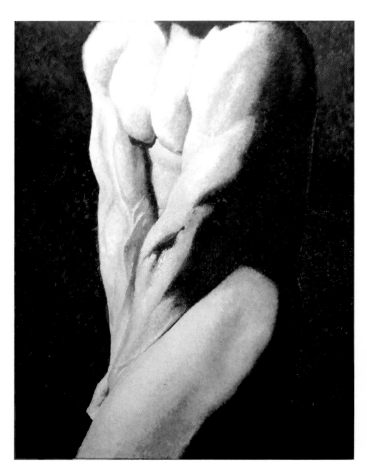

Oil Figure 3, oil on canvas, 30 x 40 in.
Photography by Martin Blender

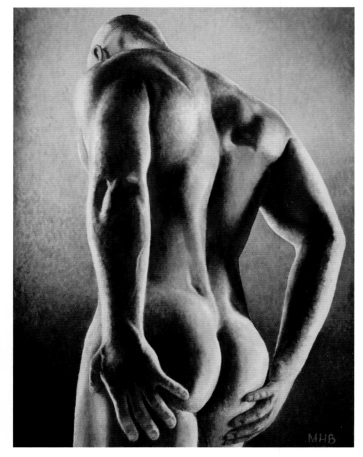

Oil Figure 34, oil on canvas, 36 x 48 in.
Photography by Martin Blender

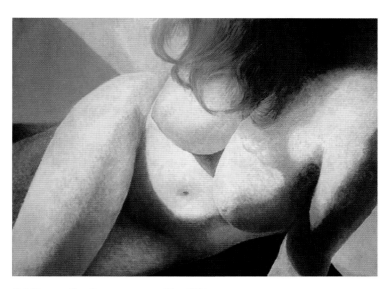

Oil Figure 5, oil on canvas, 48 x 36 in.
Photography by Martin Blender

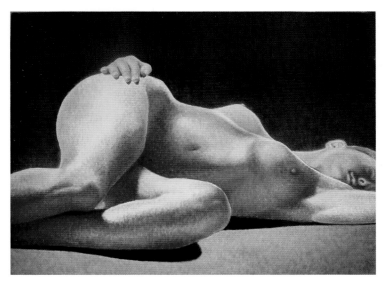

Oil Figure 33, oil on canvas, 48 x 36 in.
Photography by Martin Blender

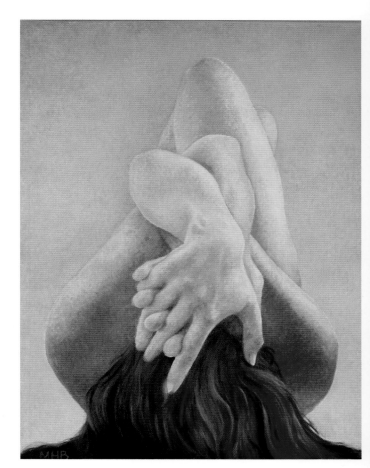

Oil Figure 13, oil on canvas, 36 x 48 in.
Photography by Martin Blender

Paul Bond

San Clemente, California, USA
www.paulbondart.com

Award-winning artist Paul David Bond Pesqueira was born in 1964 in Guadalajara, Mexico, and currently lives and works in Southern California. His deeply symbolic paintings draw from the Latin American genre of Magic Realism, where magical elements are blended with realistic atmospheres to portray a deeper understanding of reality. Bond's art illuminates a dreamlike world where anything and everything is possible. Often he will juxtapose and rearrange common elements to narrate a spiritual or metaphysical ideal. Sometimes they are simply uplifting illusions expressing the whimsical, surreal, and fantastic side of life. Always, they are soothing visual meditations that delight the imagination and stir the soul.

Bond's work has won numerous awards and been featured in solo and group exhibitions in galleries and cultural centers around the country, including the Gateway Museum in Farmington, New Mexico; William DeBilzan Gallery in Santa Fe, New Mexico; Magidson Gallery in Aspen, Colorado; Lu Martin Gallery in Laguna Beach, California; Haro Gallery, Culver City, California; Evocative Arts Gallery in Palm Springs, California; Haro Gallery, Culver City, California; and The San Diego Art Institute. His work is in private and corporate collections, including Hotel Hershey in Hershey, Pennsylvania.

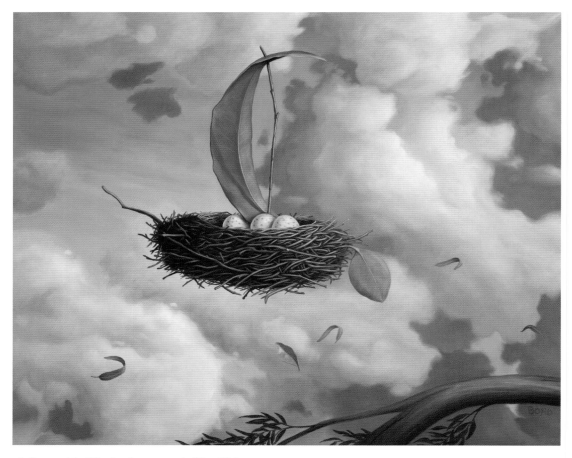

A Favorable Wind, oil on panel, 22 x 27 in.

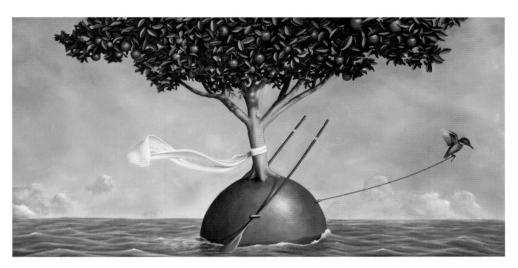

Passage of the Wisdom Keeper, oil on panel, 20 x 40 in.

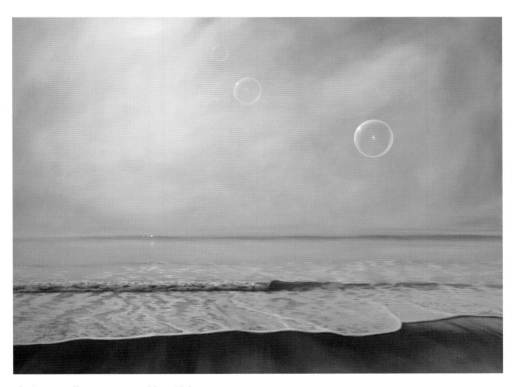

Sojourn, oil on canvas, 30 x 40 in.

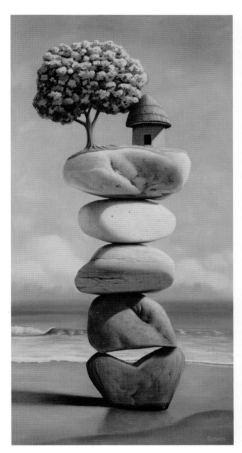

Rooted in the Years of Uncertainty, oil on panel, 36 x 18 in.

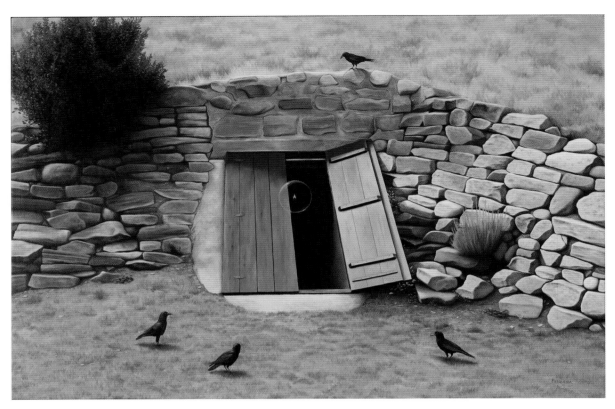

Effects of Departure from Ideal Proportions, oil on panel, 32 x 48 in.

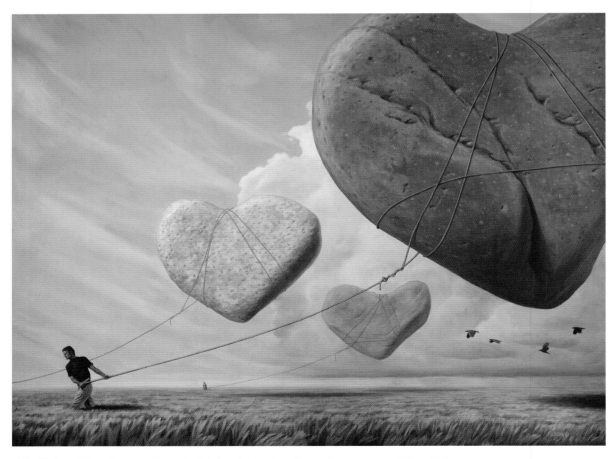

We Hoisted Our Dreams into the Light of Another Sun, oil on canvas, 36 x 48 in.

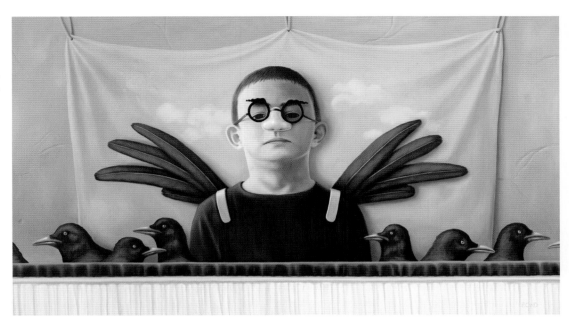

The Reluctant Prophet,
oil on panel, 23 x 41 in.

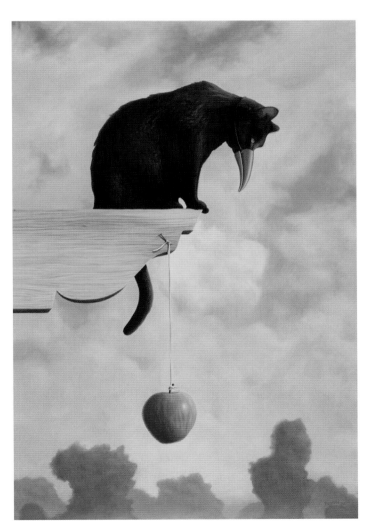

The Kindest Premeditation, oil on panel, 48 x 32 in.

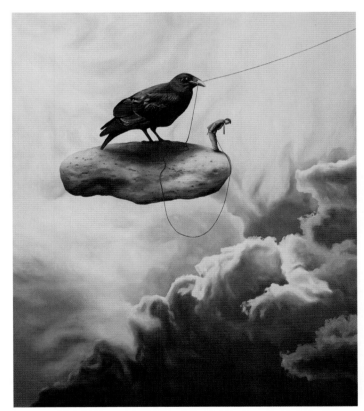

Unexpected Departure, oil on panel, 48 x 40 in.

Todd Bonita

Greenland, New Hampshire, USA
www.toddbonita.com

Todd Bonita grew up in Winthrop, Massachusetts, surrounded by the Atlantic Ocean and Boston Harbor. This historically rich environment, the salty air and the romance of the sea found their place in his creative imagination at a very young age. After earning his BFA from the Art Institute of Boston, he spent 12 years as an illustrator and fell in love with the process of making narrative pictures. This has evolved into creating images with deeper, poetic and sometimes metaphoric imagery. Since 2006, he has primarily focused on expressing this work as a fine art oil painter.

My oil paintings often reflect my affection for the coastal waters of New England, with many of the compositions featuring the men and boats that work those waters. Some of my paintings are inspired by the long history of romantic and symbolic imagery that the seas possess, while others simply represent my love of design and picture making. My art is a combination of personal feelings, the sometimes nostalgic subjects that inspire me and the process through the use of materials and techniques. In the end, my primary goal is a composition that portrays simplicity and a contemplative serenity.

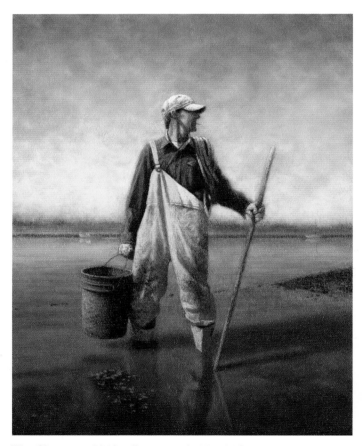

The Clammer, 2010, oil on wood, 14 x 11 in.
Photography by Todd Bonita

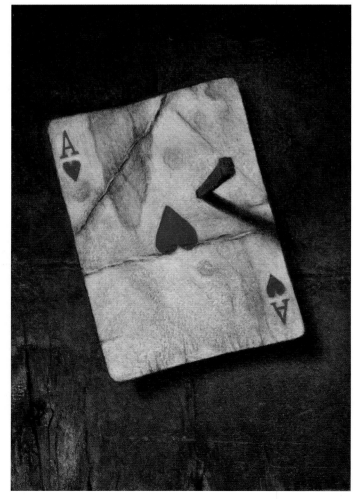

Through the Heart, 2010, oil on wood, 7 x 5 in.
Photography by Todd Bonita

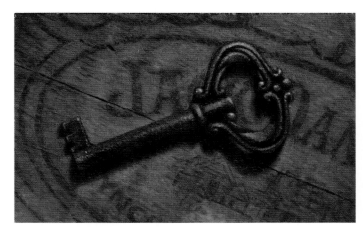

Key, 2009, oil on wood, 4 x 6 in. Photography by Todd Bonita

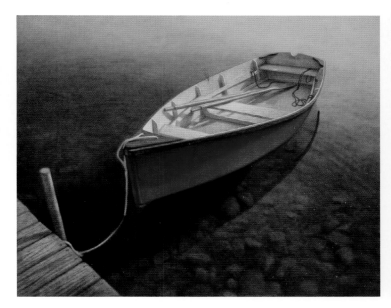

The Lake, 2010, oil on canvas, 48 x 60 in.
Photography by Todd Bonita

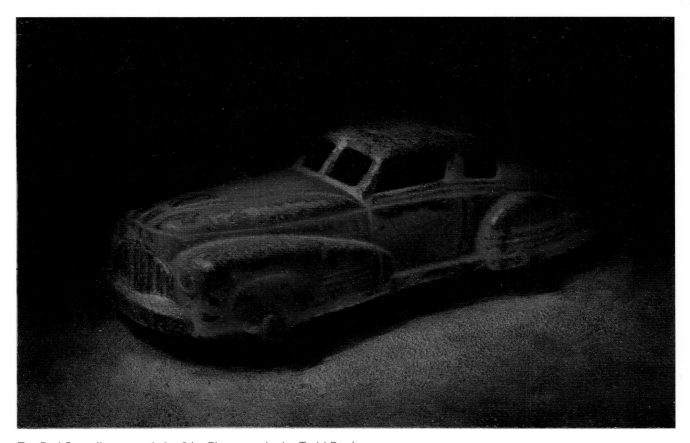

Toy Red Car, oil on wood, 4 x 6 in. Photography by Todd Bonita

Brian Boylan

Manhattan Beach, California, USA
www.celticcolor.com

Brian Boylan was born in Dublin, Ireland, in 1966. He began his artistic career in animation at Sullivan Bluth Studios in Dublin and then decided to travel. After working for studios in England and Australia he settled in the United States. He has worked for all the major studios, Disney, Dreamworks and Warner Bros.

I have always drawn and find it a very peaceful process. In my work I try to convey that peace mainly through color. The Flamingo series is simply fun pieces with no deep meaning, everything else has a story.

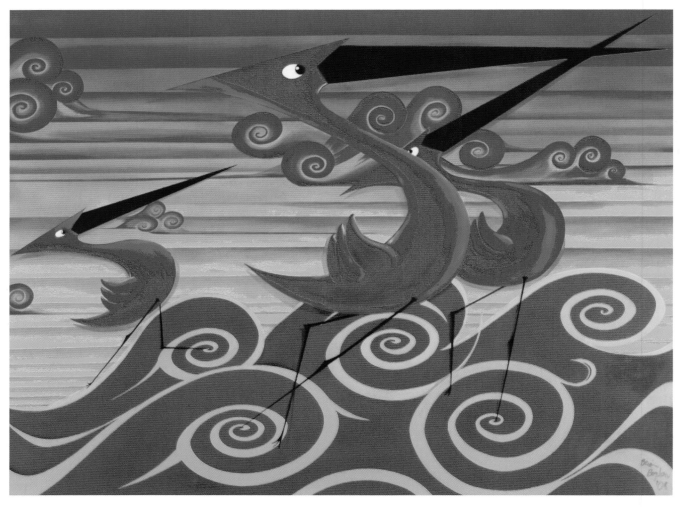

Race to the Finish, 2009, oil on canvas, 28 x 40 in. Photography by Brian Boylan

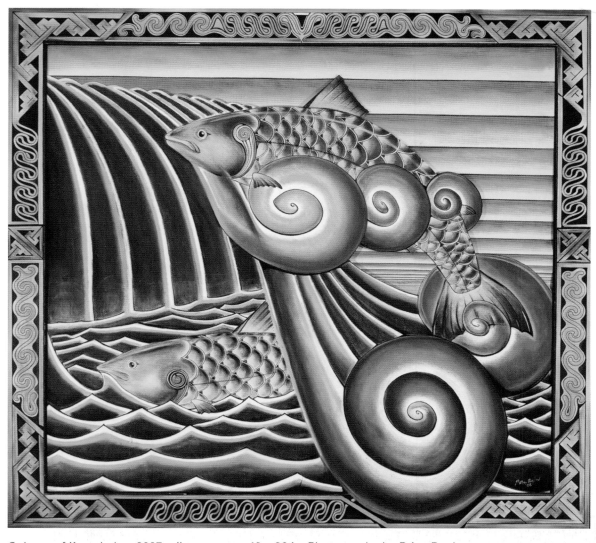

Salmon of Knowledge, 2007, oil on canvas, 40 x 36 in. Photography by Brian Boylan

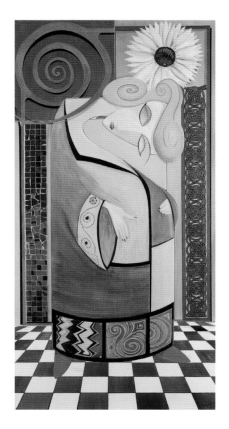

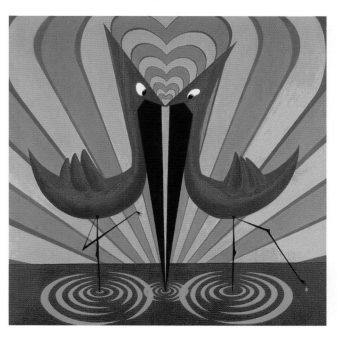

The Kiss, 2007, oil on canvas, 36 x 36 in. Photography by Brian Boylan

Possibility of Joy, 2008, mixed media, oil on canvas, 48 x 24 in. Photography by Brian Boylan

Will Bullas, a.w.s., n.w.s., k.a.

San Francisco, California, USA
www.willbullas.com

Will Bullas was born in Ohio in 1949 and raised in the Southwest. He was attending Arizona State University on a scholarship and majoring in art and drama when he was drafted and served in Vietnam. Will is a signature member of the American Watercolor Society and the National Watercolor Society, and was elected to membership with the Knickerbocker Artists of New York in 1986. He is a past president and continuing member of the Carmel Art Association. Will has exhibited twice with the National Academy of Design in New York. In 2007, he received the Mario Cooper and Dale Meyers Medal from the American Watercolor Society for his contributions to watercolor.

Will Bullas makes fine art fun. This master of one-liners combines award winning artistic skills with a hilarious point of view, creating a refreshing and unexpected new way to enjoy fine art.

The Tall One with Big Melons, 2002, watercolor, 9 x 7 in. Photography by Will Bullas

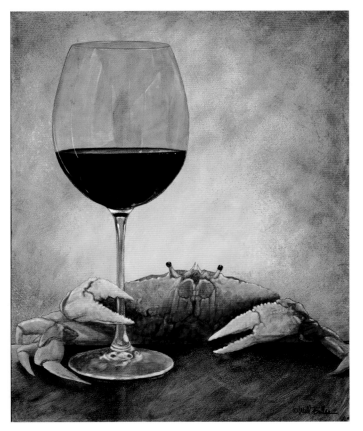

Crabernet, 2006, acrylic, 30 x 24 in. Photography by Will Bullas

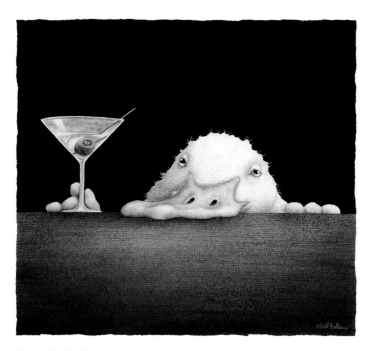

Bar Bill, 2005, watercolor, 14 x 14 in.
Photography by Will Bullas

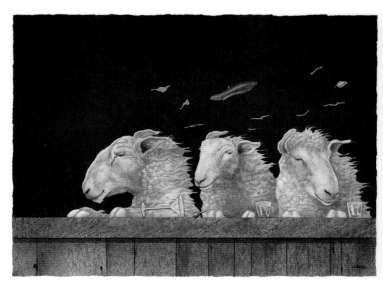

Three Sheeps to the Wind, 2010, watercolor, 14 x 18 in.
Photography by Will Bullas

Court of Appeals, 1993, watercolor,
10 x 24 in. Photography by Will Bullas

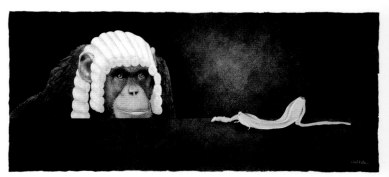

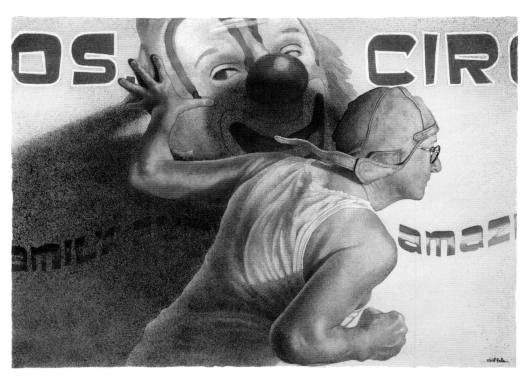

*Running… The Human
Cannonball*, 2009, watercolor, 16 x
22 in. Photography by Will Bullas

P. John Burden

Prince Edward Island, Canada
www.johnburdenart.com

"You have the right to work, but for the work's sake only... Desire for the fruits of work must never be your motive in working. Be even-tempered in success and failure . . ." - Bhagavad-Gita

After long discussions with the dogs and crows, it became apparent that artists possibly paint because they cannot say this thing in words.

Like many artists, I always try to push further into the unknown each time I work. Being a cowardly sort, I eventually run back to safe centre, albeit already relishing the thought of the next sortie.

Hard won technique? I value it. It is a vehicle to further the adventure — like a well-oiled bicycle. However, I know the danger of becoming fully absorbed in the bicycle/technique.

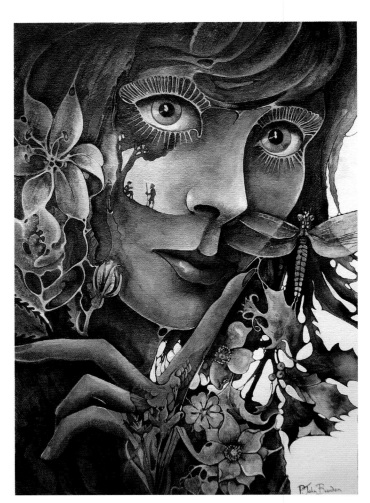

The Story, 2009, watercolor, 20 x 14 in.
Photography by P. John Burden

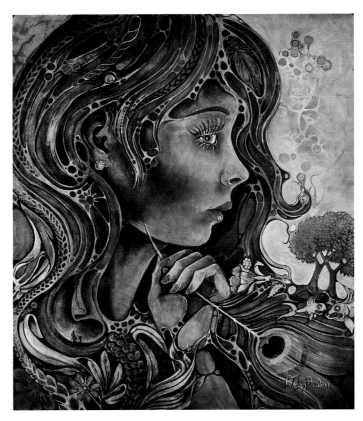

Astrid, 2010, acrylic, 24 x 20 in.
Photography by P. John Burden

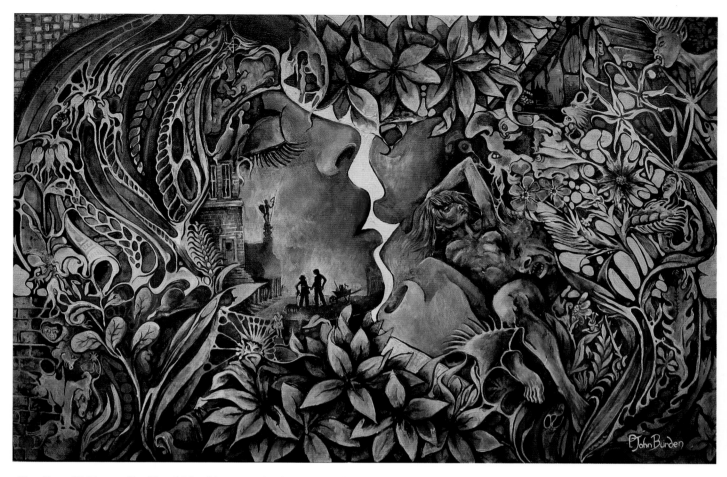

Kiss Two, 2010, acrylic, 20 x 30 in. Photography by P. John Burden

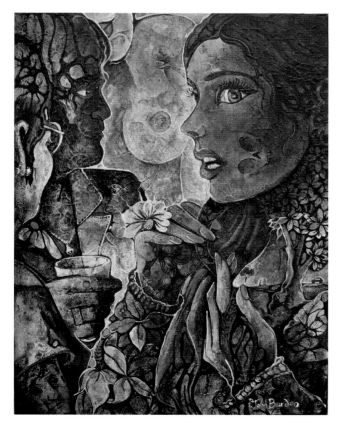

Body Language, 2005, acrylic, 24 x 18 in. Photography
by P. John Burden

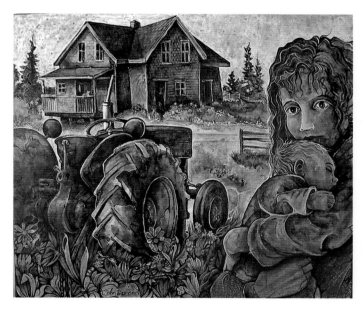

Last Generation, 2003, acrylic, 20 x 24 in.
Photography by P. John Burden

Bryan Bustard

Greenville, South Carolina, USA
www.bryan-bustard.artistwebsites.com

Bryan Bustard studied art at a fundamentalist Protestant school in Pensacola, Florida, before venturing out into the world after graduation. After a few decades of listening to those who said an artist can't make money in the field, doing only the occasional portrait for co-workers and friends, he finally returned to his love of illustration. An interest in movies, fantasy literature, humor, the pin-up styles of Vargas and Elvgren, popular music, and even a relatively new found devotion to the Roman Catholic Church provides him with a great deal of inspiration for a wide variety of artistic inspiration. The pieces here primarily focus on his offbeat sense of humor. He describes them as "a little bit Charles Addams, a little bit Gil Elvgren, a little bit Hildebrandt Brothers, and a little bit Norman Rockwell." His work is primarily done in acrylics and Prismacolor colored pencils. He prefers to do most of his work on illustration board.

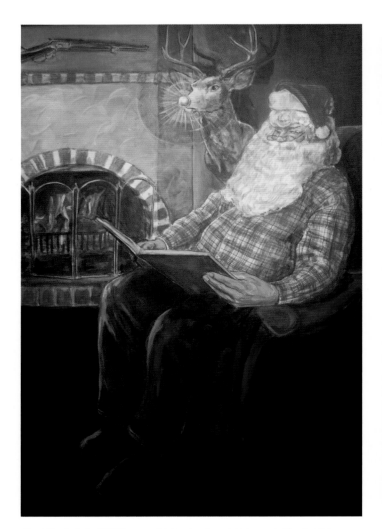

Bad Rudolph, 2009, acrylic and prismacolor on illustration board 20 x 30 in. Photography by Bryan Bustard

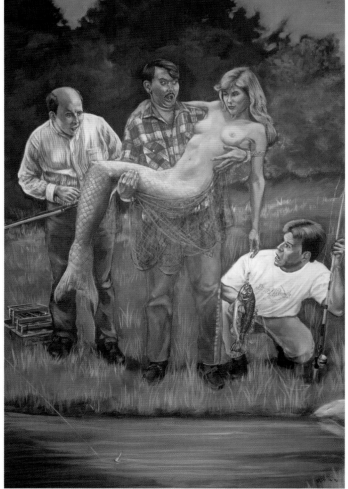

Catch of the Day, 1996, acrylic and prismacolor on illustration board, 20 x 30 in. Photography by Bryan Bustard

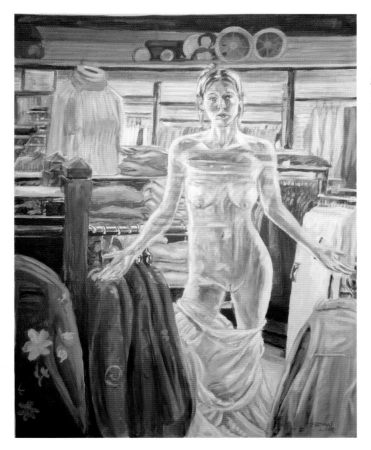

She Goes Through Her Clothes So Quickly, a portrayal of a fashion conscious ghost who can't materialize enough to actually try on clothes anymore, 2008, acrylic and prismacolor on illustration board, 15 x 20 in. Photography by Bryan Bustard

Well Preserved, 2009, acrylic and prismacolor on illustration board, 20 x 30 in. Photography by Bryan Bustard

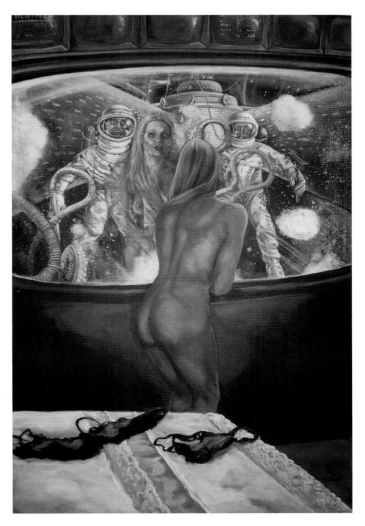

Window Washers On A Space Station, 1997, acrylic and prismacolor on illustration board, 20 x 30 in. Photography by Bryan Bustard

Svetlana Cameron

Isle of Man, UK
www.svetlanacameron.com

Svetlana Cameron (b. 1978) is a classically trained artist specializing in portraits, figures and still life. She was born in Russia and grew up and lived in many places in Eastern and Western Europe. She currently lives in the Isle of Man (UK) and works out of her studio in Braddan. Svetlana trained in the traditional private atelier system. She attended drawing and painting courses at the Jason Lu studio in Malta, the Florence Academy of Art, Italy, and the Prince of Wales Drawing School in London . Although she has interest in many genres, including still life and narrative painting, Svetlana Cameron is predominantly known as a portrait artist. She regularly undertakes commissions and her portrait drawing and paintings can be found in many private collections.

Svetlana works in the style of classical realism using traditional methods practiced by few artists today. She is well known for her portrait drawings executed in the so-called 3-color technique, where the artist uses charcoal and red and white chalk to create very realistic life-like images. Svetlana paints in traditional manner in oil on linen. She develops her paintings in layers, starting with a detailed drawing and a monochrome underpainting, followed by an opaque overpainting and rich colour glazes.

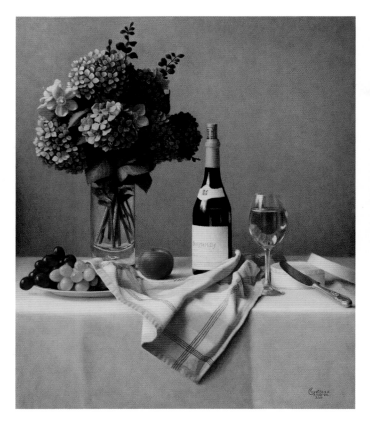

Hydrangeas, 2010, oil on linen, 24 x 20 in.
Photography by Svetlana Cameron

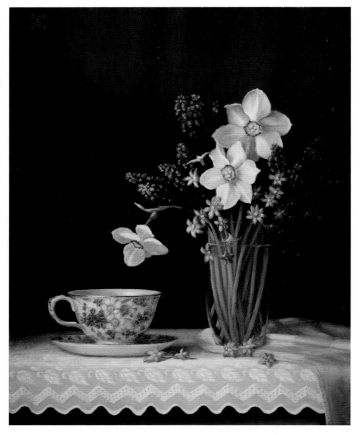

Inspiration, 2009, oil on canvas, 20 x 16 in.
Photography by Svetlana Cameron

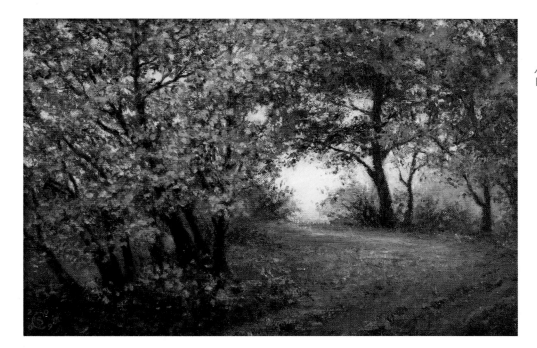

Autumn, 2009, oil on linen, 8 x 12 in.
Photography by Svetlana Cameron

Sisters, 2009, oil on linen, 28 x 40 in.
Photography by Svetlana Cameron

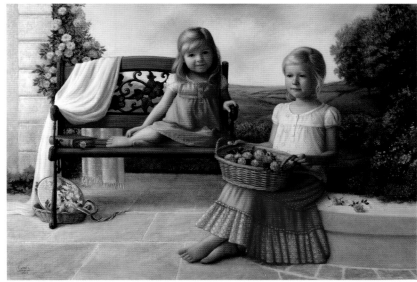

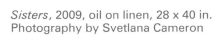

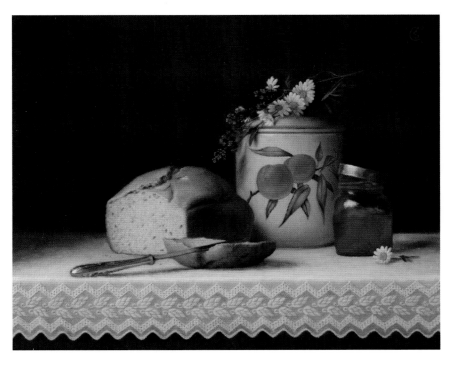

Still Life with Lavender and Bread, 2010, oil on
canvas, 16 x 20 in. Photography by Svetlana
Cameron

41

Ibolya Casoni

Targu-Mures, Romania
www.divat-muveszet.mlap.hu

Ibolya Casoni was born in 1961 in Targu-Mures, Romania. She has been a member of the Association of Visual Arts Artists Mures since 2007. After abandoning work in medical field for health reasons, she accidentally discovered her great talent as a painter and also as a fashion designer.

Winner of national and international competitions and festivals, she graduated as a fashion designer form the School of Visual Arts Mures. Her first works were still lifes, portraits, and landscapes, initially in neo-realist, later in pop-art, impressionist, and super-realist style. In only a few months after she began painting, she developed her unique style, which is a mix between pop art, fauvism, impressionism and super-realism, called by her friends "The IBY Style." Her works are known and appreciated all over the world.

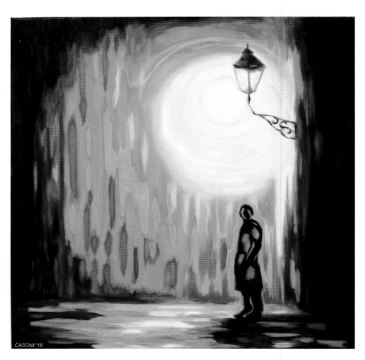

Night Light Street, 2010, oil on canvas, 50 x 50 cm.
Photography by Casoni Ibolya

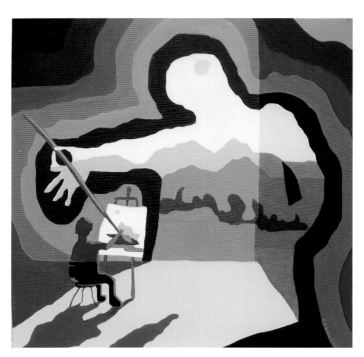

Inspiration, 2010 ,oil on canvas, 50 x 50 cm.
Photography by Casoni Ibolya

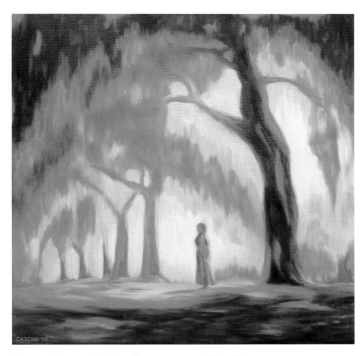

Sunny Forest, 2010, oil on canvas, 50 x 50 cm.
Photography by Casoni Ibolya

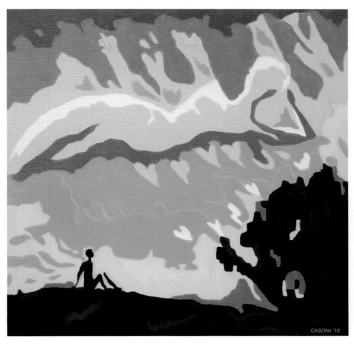

The Dreamer, 2010, oil on canvas, 50 x 50 cm.
Photography by Casoni Ibolya

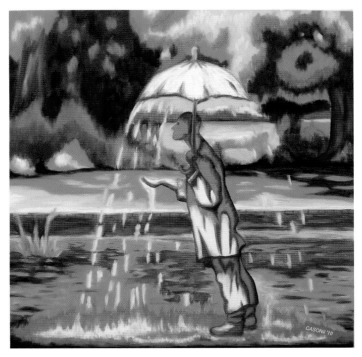

The Man that Brings Rain, 2010, oil on canvas, 50.x.50 cm.
Photography by Casoni Ibolya

Mario Cespedes

La Quinta, California, USA

www.amazonfinearts.net

Born in Bolivia and growing up in Brazil, the Andes and the Amazon River are the themes of my artwork. Actual paintings are about mythology, piranhas and politicians from de Amazon River in Brazil.

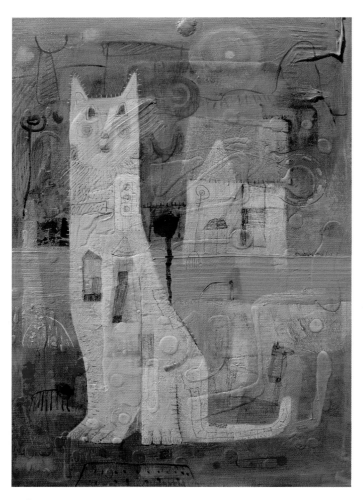

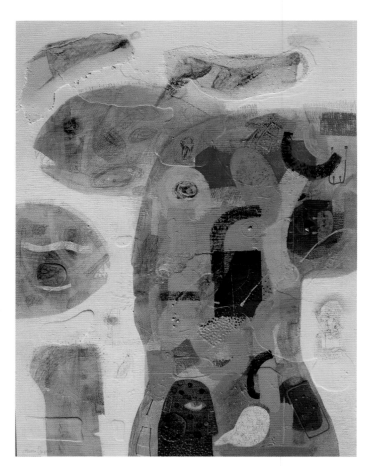

The Piranhas and the Politician, 2010, acrylic on canvas, 30 x 40 in. Photography by Mario Cespedes

A Cat, Who Looks Like a Hollywood Star, 2010, acrylic on paper, 26 x 32 in. Photography by Mario Cespedes

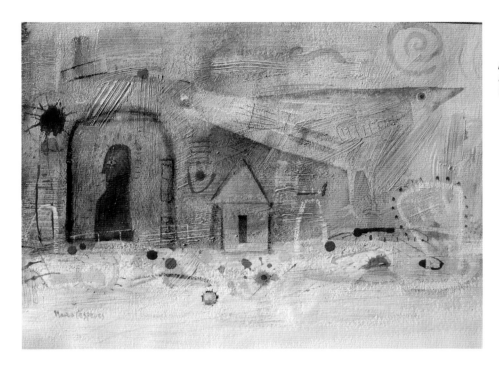

Landscape with a Self Portrait, 2010, acrylic on paper, 26 x 32 in. Photography by Mario Cespedes

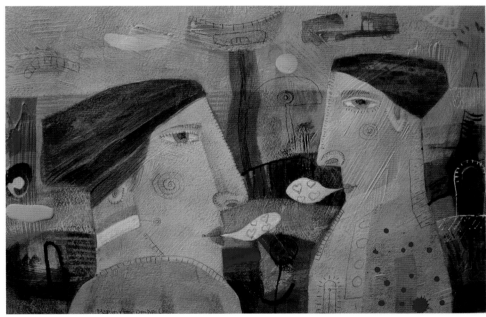

Romance with No Limits, 2010, acrylic on paper, 26 x 32 in. Photography by Mario Cespedes

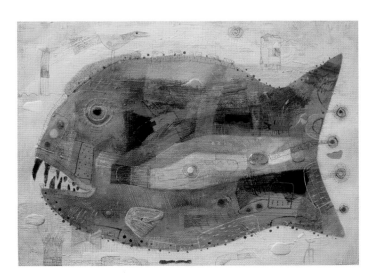

A Sardine Who Wants to be a Piranha, 2010, acrylic on paper, 26 x 32 in. Photography by Mario Cespedes

45

Ione Citrin

Los Angeles, California, USA
www.artbyione.com

Ione is an *avant garde* artist whose artistic expression takes fantastic shape through her diverse oil and watercolor paintings, bronze sculptures, found object collages and mixed media assemblages. Her contemporary paintings and sculptures range from abstract to realistic to impressionistic — all visionary interpretations from her imaginative soul. Ione uses only one name but a variety of styles to soothe her wild imagination. A native of Chicago, she is a former television star and commercial voice-over artist. Now she wins awards and expresses her creativity through her hands instead of through her larynx. Her art is as original as she is — bold, colorful and highly decorative.

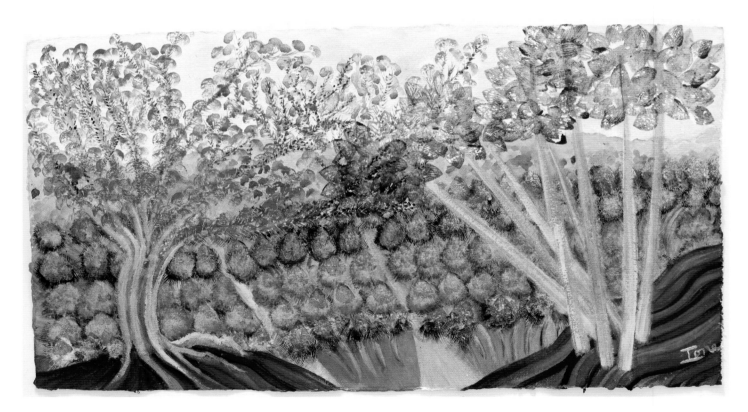

Field of Dreams, 2007, watercolor, 20 x 38 in. Photography by Joshua White

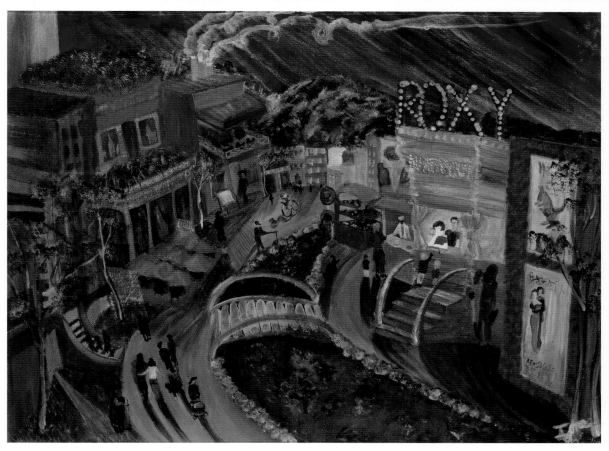

The Promenade, 2007, watercolor, 22.5 x 30 in.
Photography by Joshua White

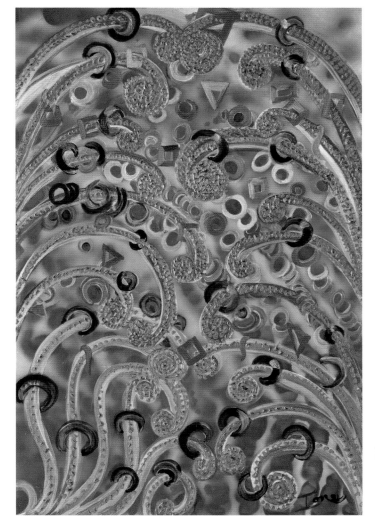

Succulents, 2007, acrylic on canvas, 34 x 24 in.
Photography by Joshua White

Chris Cook

Madison, Georgia, USA
www.chriscookartist.com

Chris was born in Atlanta, Georgia, in April, 1962, the second of four children. Chris now lives in beautiful historic Madison, Georgia, with his wife and children. He exhibited his works in many shows and galleries in the metro Atlanta area in the 1980s, including the Callanwolde Fine Arts Center and, most notably, the juried shows Mardi Gras for the Arts 1987 and the Georgia Artist Show in 1989, where he received a Kilpatrick Cody purchase award for "Deterioration." His work was featured on Georgia Public Broadcasting (GPTV) for an "Interstitial" on the award-winning, one hour TV Show "State of the Arts".

In my quest to constantly improve my craft, vision and interpretation of life as I move through it — I shed my skin and allow myself to wander and wonder. I never rest on my laurels — I explore, turning my back on both successes and failures, to move on, unburdened by, but certainly learning and building on, my past work.

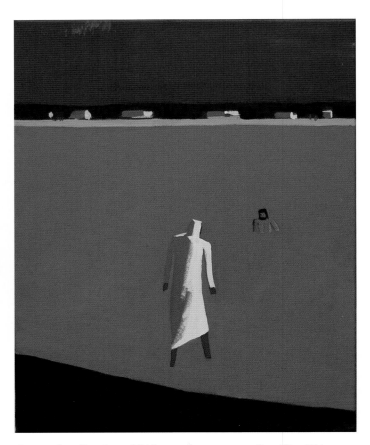

Chicken Farm, North Georgia, 2010, acrylic on masonite, 20 x 16 in. Photography by Chris Cook

Jesus after Baptism, 2010, acrylic on masonite, 16 x 20 in. Photography by Chris Cook

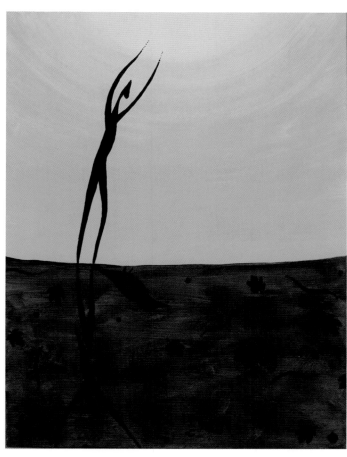

Jesus Desending into Hades, 2010, acrylic on masonite, 16 x 20 in. Photography by Chris Cook

Peach Orchard with Black Birds, 2010, acrylic on masonite, 38 x 25 in. Photography by Chris Cook

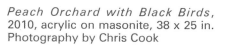

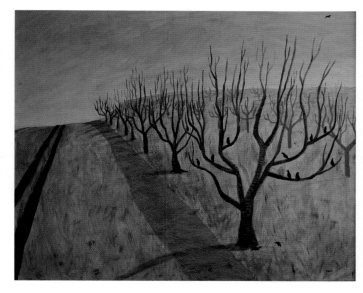

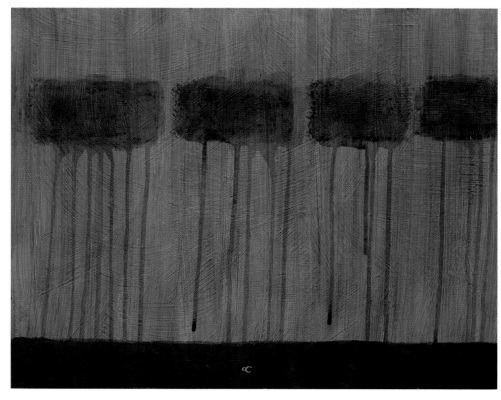

Rain 1, Madison, Georgia, 2010, acrylic on masonite, 20 x 16 in. Photography by Chris Cook

Gregory Copploe

Seattle, Washington, USA
www.gregorycopploe.artspan.com

Gregory Copploe likes to blend old and new styles together to create a portrait for today that includes elements from the past. He began his career in art graduating from UCLA with a BA in Theatre, and began painting in oil in 2001 after the passing of his father who also painted in this medium. As an homage to his father, he began his journey in oils experimenting with sky, water, and the creation of faces in the clouds, creating relationships between the water, sky, and moon surrounding those faces. He had no idea that this homage to his father would soon become a passion of his own, as he branched out into portraits, inspired by Sergey Smirnov and Modigliani. As a world traveler, Paris and Spain would also play an important role in influencing Gregory's style and palette. The long, drawn out features of the face, pouting lips, and thought-provoking eyes would soon tell a story on each canvas that Gregory would so poignantly paint. Through thick, impressionist brush strokes, each character had a story to tell, an emotion to give, and each canvas created a relationship between the art enthusiast and the character depicted in each painting. It was important for the eyes to have a life of their own, and not, in a sense, to be dead in meaning or life, but alive and virulent as our own souls. Gregory Copploe's complete works include oils on canvas as well as busts and sculpture in clay.

Oil is such a sensual medium, and I couldn't imagine mixing it with any other. It gives me everything I require, and fills me with such joy and beauty that I am left completely full.

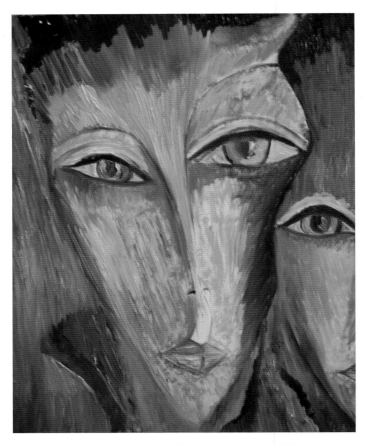

Mother and Daughter, 2010, oil on canvas, 20 x 24 in.
Photography by Gregory Copploe

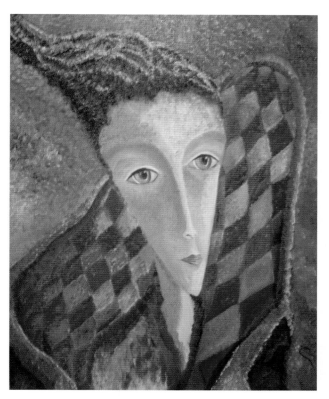

Lady in Waiting, 2010, oil on canvas, 24 x 30 in.
Photography by Jeff Hartsock

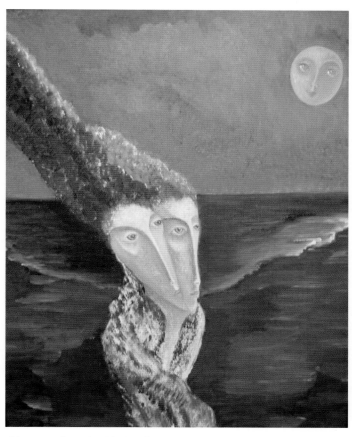

Siamese Couple, 2010, oil on canvas, 24 x 30 in.
Photography by Jeff Hartsock

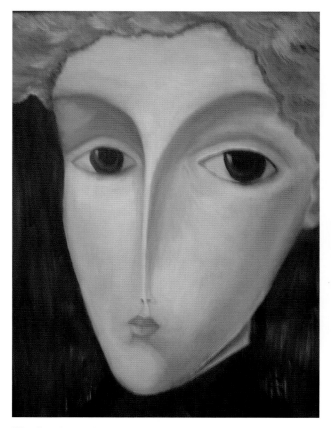

The Duchess, 2007, oil on canvas, 20 x 24 in.
Photography by Jeff Hartsock

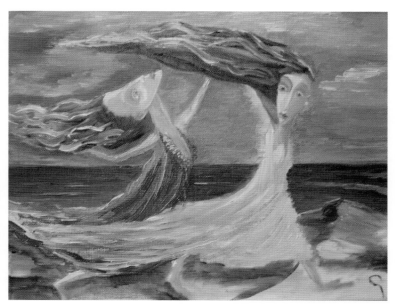

Two Sisters in Ibiza, 2010, oil on canvas, 11 x 14 in.
Photography by Jeff Hartsock

Mihai Dascalu

Oradea, Bihor, Romania
www.mihaidascalu.com

Mihai Dascalu paints in a traditional Romanian style with traditional Romanian folk scenery. His vibrant colors draw you into the multiple happenings in each scene. Mihai's attention to detail will have you finding something new with each glance at his work. He has a completely unique way of seeing trees that brings them out to the foreground with utter vibrancy, particularly seen in "The Painter."

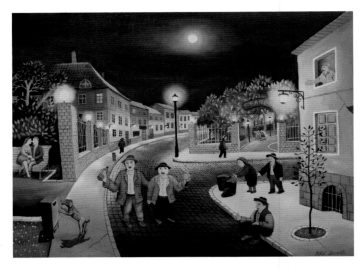

Night in the City, 2009, oil on canvas , 40 x 50 cm. Photography by Mihai Dascalu

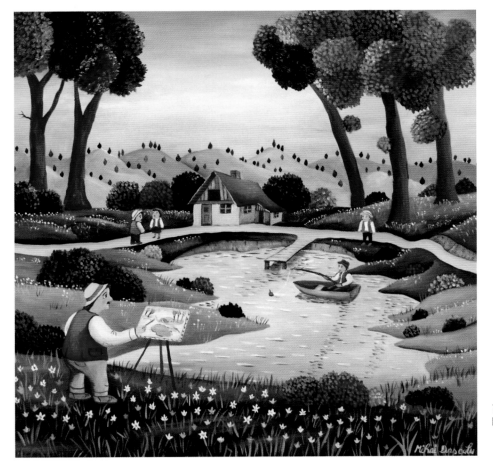

The Painter, 2008, oil on canvas, 50 x 50 cm. Photography by Mihai Dascalu

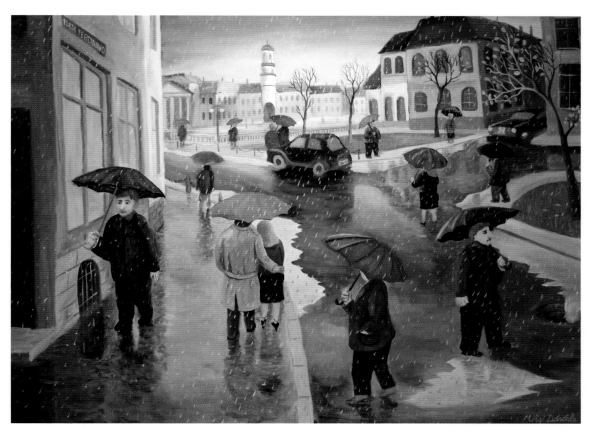

The Red Umbrella, 2010, oil on canvas, 80 x 60 cm. Photography by Mihai Dascalu

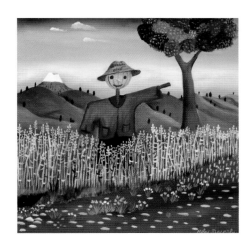

Scare Crow, 2010, oil on canvas, 50 x 50 cm. Photography by Mihai Dascalu

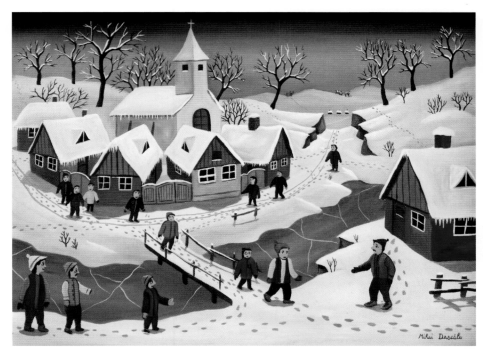

Winter, 2008, oil on canvas, 50 x 40 cm. Photography by Mihai Dascalu

Anneke Dekker-Olthof

La Porte, Indiana, USA
www.artid.com/members/anko

Dutch by origin, African by osmosis and American by assimilation, Anneke Dekker-Olthof, painting under the name of ANKO, draws her artistic passion from her experiences as a Chicago fashion designer and her lifelong interest in travel and photography. Travel all over the world sharpened ANKO's appreciation of color, texture, and pattern, while 13 years of living in Africa brought her an awareness of that diverse landscape and the uniqueness of the people born to the continent which many consider to be the cradle of humankind.

A fascination with something beyond reality, with fantasy and dreams, with nature, fairy tales, spirit world and mystery, with primitive civilizations, Africa, geology, outer space, inner space and texture: my inspiration for painting, collage, pottery, 3D and fabric art. I work mostly non-representational and abstract while enjoying the play with materials, textures, colors and found objects. I love the working process: the surprises and unexpected effects that happen while I'm working.

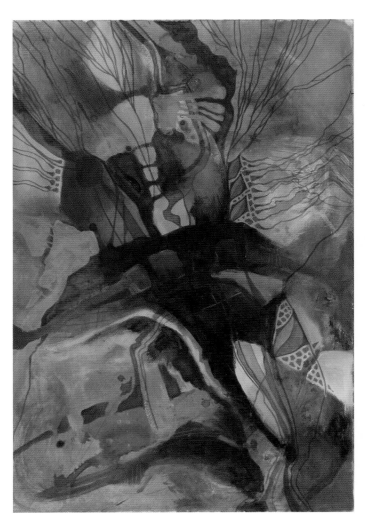

Alien Angel, 2010, acrylic on paper, 15 x 22 in.
Photography by ANKO

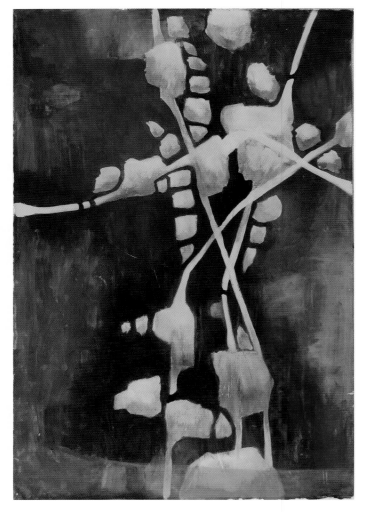

Bones II, 2010, acrylic on paper, 15 x 22 in.
Photography by ANKO

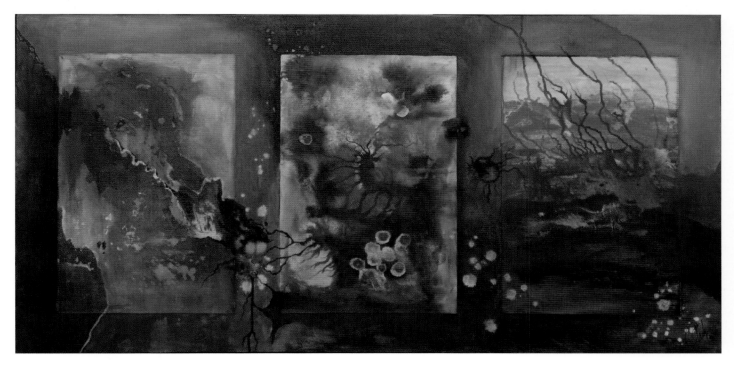

3xDeepDown, 2010, acrylic on paper on canvas, 48 x 24 in. Photography by ANKO

Africa-Londolozi, 2010, acrylic collage on paper, 15 x 22 in. Photography by ANKO

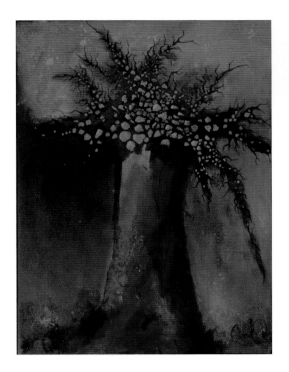

Africa-Boabab, 2009, acrylic on canvas, 18 x 24 in. Photography by ANKO

Brian Despain

Fleming Island, FL
www.despainart.com

Like any child, growing up I entertained ideas of becoming a fireman, an astronaut, or a lion tamer, but when it came time to leave the childhood trappings behind and choose my career I, not surprisingly, gravitated towards that one thing that I'd been doing with some regularity for most of my life, art. Working professionally since eighteen, a myriad of art related jobs, from graphic design to photo-retouching to concept illustration, I've tried it all. However, through the years and the many career paths, I found my greatest art and my deepest satisfaction came from drawing and painting those images that were well and truly my own. In 2005, I reinvented myself as a gallery artist and haven't looked back. At the time of this writing I'm a full time painter, living and working in Florida and showing in galleries across the globe.

If I had to define what I do, I'd say I'm a "Neo-Symbolist." Though my work is often lumped with the popular counter-culture genre "Pop-Surrealism," and though my work is sometimes surreal and definitely rife with pop culture iconography, I think it goes deeper than that. I try to construct images that hint at a complex allegory. I try to assemble visual medleys that tease the viewer with stories that grow and change the longer one looks. I infuse my art with emotional triggers to pluck at the mind and heart and create a complex weave of half revealed ideas to spark in the viewer a deeper sense of connection, until ultimately the art becomes something greater, a melding of two minds, myself and a viewer. It is the use of shared ideas, the exploration of symbols and their associative emotional connotations that makes all this possible. And why the robots? Well, they're just cool.

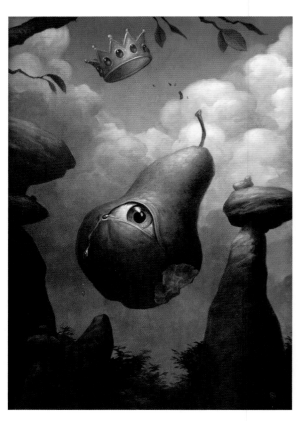

A Vexing Quiet, 2007, oil on board, 16 x 20 in.
Photography by Brian Despain

The Bartlett Regicide, 2007, oil on board, 10 x 14 in.
Photography by Brian Despain

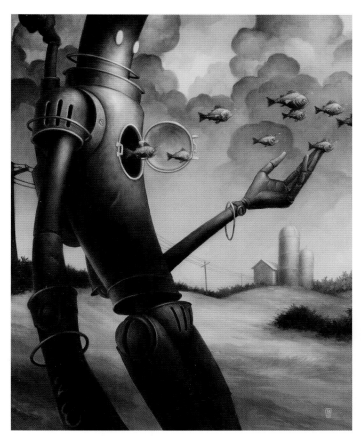

The Escape, 2008, oil on board, 16 x 20 in.
Photography by Brian Despain

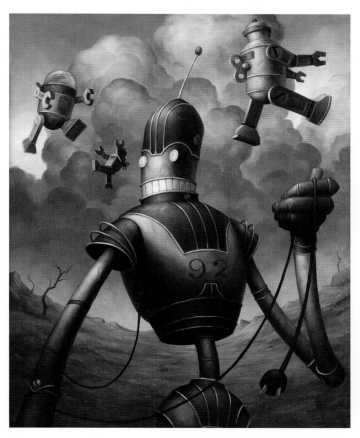

Ghosts, 2008, oil on board, 16 x 20 in.
Photography by Brian Despain

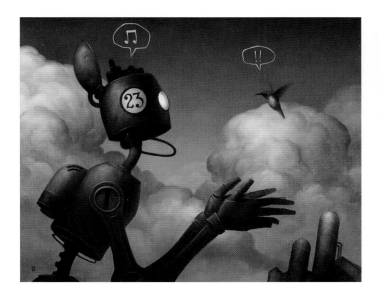

The Exchange, 2007, oil on board, 20 x 16 in.
Photography by Brian Despain

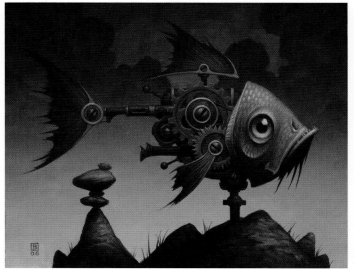

The Second Leviathan, 2006, oil on board, 10 x 8 in.
Photography by Brian Despain

Ray Donley

Austin, Texas, USA
www.raydonley-online.com

Ray Donley was born in Austin, Texas, in 1950. He attended The University of Texas at Austin, graduating *summa cum* laude in 1981. In 1983, he completed his master's degree in art history with particular focus on Dutch and Spanish baroque art. Since 1981 he has exhibited in numerous museums, universities, and galleries throughout the U.S., Europe, Canada, and Mexico. His psychologically charged, baroque-inspired figurative work has, during this time, attracted wide critical attention. He and his wife Sharon currently live in Austin, Texas.

The subjects of my fictional portraits are the solitary itinerants who, together, comprise what I term "los bien perdidos," or "the lost ones." With their suggestions of silence, solitude, reverie – and even madness – these paintings are meant to evoke aspects of our more reflective (and sometimes darker) states. By tapping into these reflective/introspective states, I seek above all to create an art that, while seemingly possessing a Renaissance or Baroque pedigree, is itself rich with its own mythic and symbolic potential.

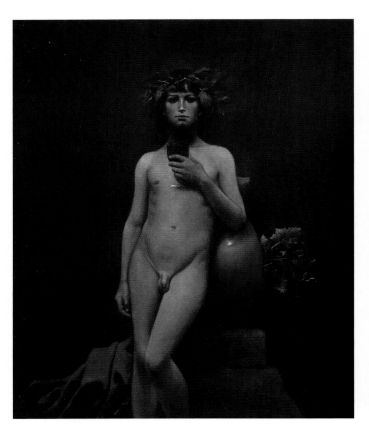

Young Bacchus, 2009, oil on canvas, 48 x 40 in.
Photography by Ray Donley

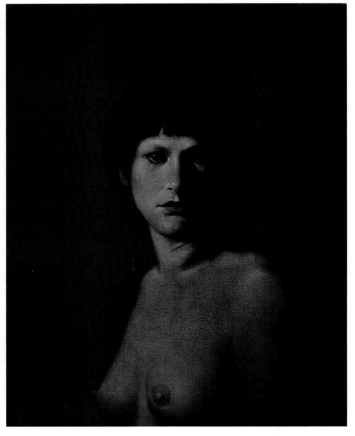

La Perdida (No. 65), 2010, oil on canvas, 20 x 16 in.
Photography by Ray Donley

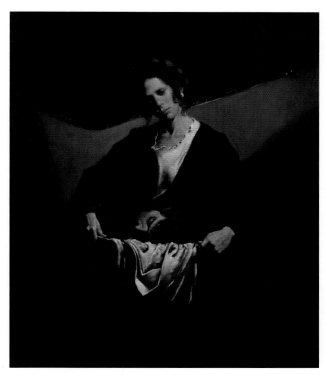

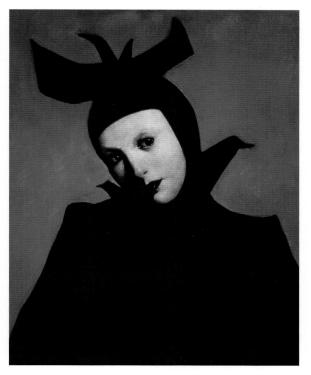

Salome, 2010, oil on canvas, 48 x 40 in.
Photography by Ray Donley

Figure with White Face (No. 2), 2009, oil on panel,
20 x 16 in. Photography by Ray Donley

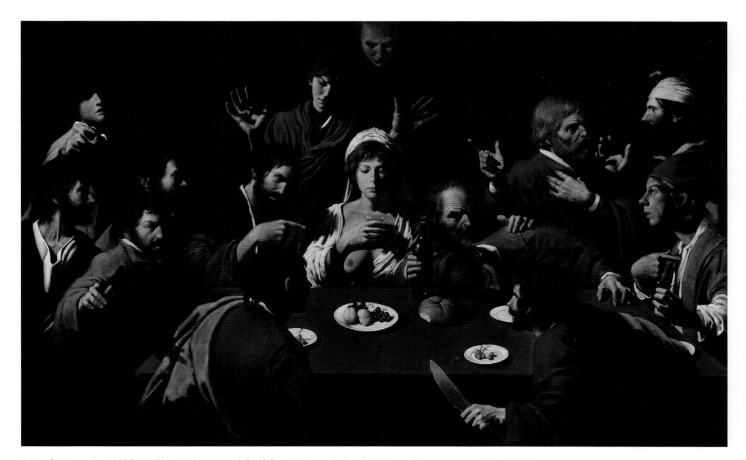

Last Supper (with Mary Magdalene and Self-Portrait as Judas), 2009, oil on canvas, 80 x 50 in.
Photography by Ray Donley

John Dorish

New York, NY
www.johndorish.com

John Dorish was born in Pittsburgh, Pennsylvania in 1947. He received a Bachelor of Arts degree from Clarion University of Pennsylvania in 1970. Mr Dorish has lived in New York City since 1977. He currently maintains a studio on 13th Street in Greenwich Village. Mostly a self-taught painter, Mr Dorish has been a printmaking student at the Art Student's League of New York since 1989. His work is collected by many corporate and private collectors around the world. The etching *Blue Moon* was purchased by the New York Public Library. A watercolor titled *Still Life Migration* won first prize in Aqueous 2000 a national watercolor exhibit in Pittsburgh.

I am constantly inspired by the city around me. New York is a never ending source of subject matter. I spend many nights on my Greenwich Village roof looking out at the city around me. Other times I walk through Central Park, a constant source of material. I love color and depict scenes which are mostly imagined yet based on real experience. The city at night is a constant subject and I like to say I paint the city the way I feel it as well as the way I see it.

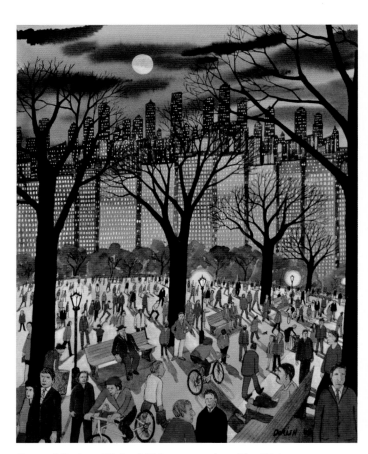

Central Park at Night, 2009, watercolor, 17 x 22 in.
Photography by Ed Lee

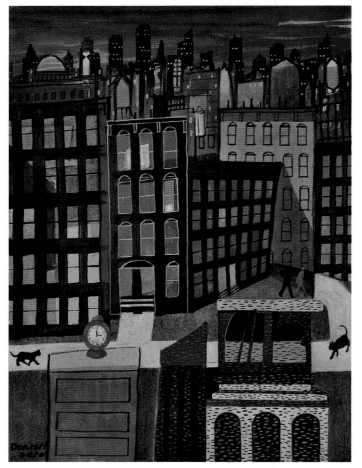

Chance Meeting, 2010, watercolor, 11 x 15 in.
Photography by Ed Lee

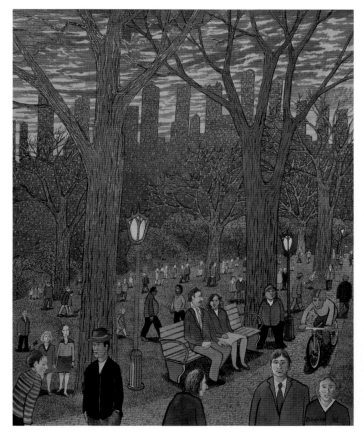

The Pink Road, 2008, watercolor, 17 x 22 in.
Photography by Ed Lee

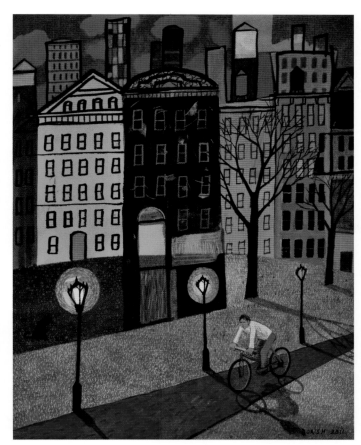

Cat Watching in the Grass, 2011, watercolor, 11 x 14 in.
Photography by Ed Lee

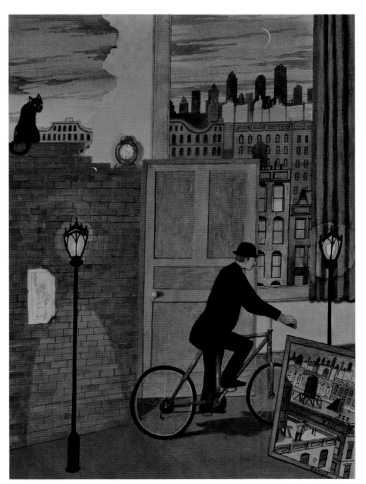

January Dream, 2011, watercolor, 13 x 18 in.
Photography by Ed Lee

Bob Dornberg

New Smyrna Beach, Florida, USA
www.dornberg-impressionism.com

Bob Dornberg was born in California in 1940. He studied painting at the University of California in Los Angeles. He has produced over 1200 oil paintings. His "Slices from Life" series depicts subjects from his lifetime surroundings.

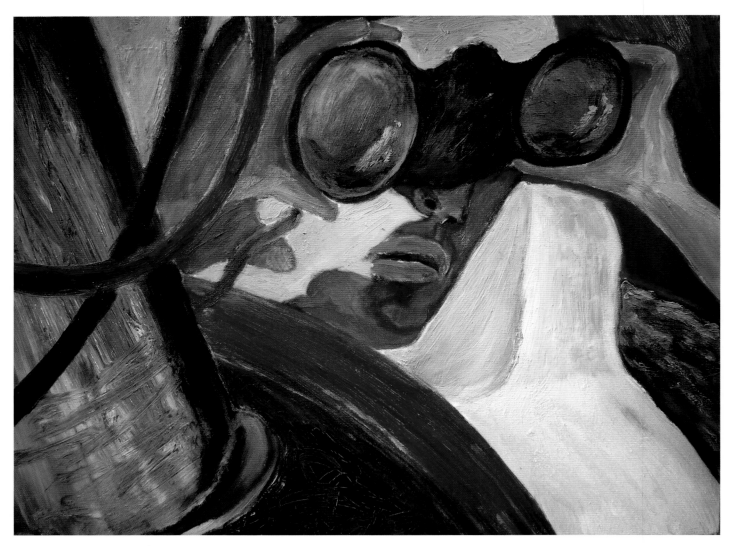

Binoculars, 1996, oil on canvas, 18 x 24 in. Photography by Bob Dornberg

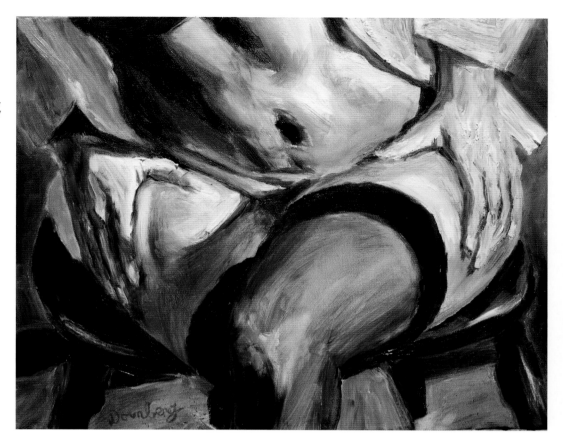

Hands, 2009, oil on canvas, 16 x 20 in. Photography by Bob Dornberg

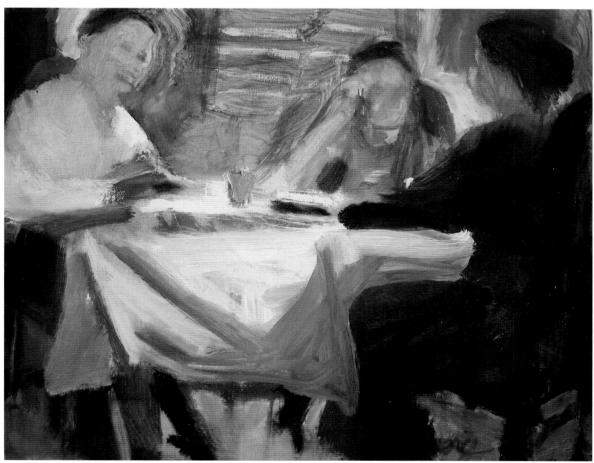

Table Talk, 2002, oil on canvas, 16 x 20 in. Photography by Bob Dornberg

Juliana Duque

Miami, Florida, USA
www.juduq.com

I believe there is an energy within everyone of us, an energy that is powerful enough to create and transform whatever we set our minds on. The motion and natural flow driven by this force, is the heart & soul of my art. Dripping has become not only my technique, but a limitless extension of my feelings in a materialized world.

My work is characterized by the mixture of bright colors, and prominent black lines intended to balance the emotions. Its an open invitation for everyone to enlighten themselves and share a smile.

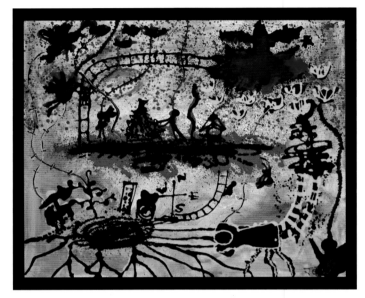

Los Tres Planos, 2010, acrylic on wood, 40 x 40 in.
Photography by JuDuq'

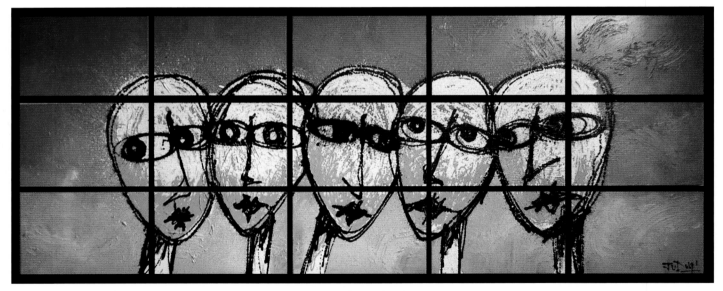

Looking for, 2010, acrylic on wood, 120 x 48 in. Photography by JuDuq'

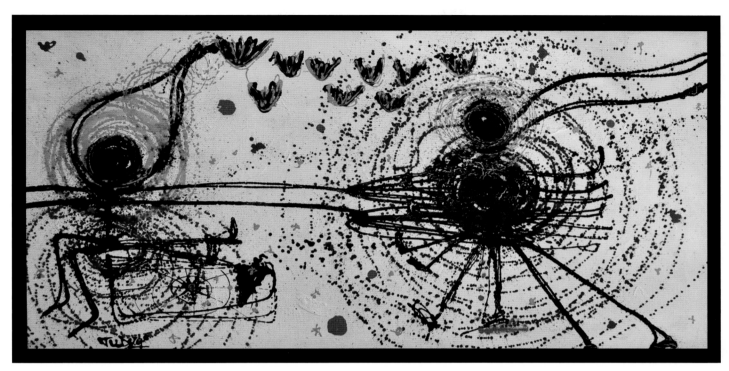

Ejercicio para la creatividad, 2010, acrylic on wood, 108 x 48 in. Photography by JuDuq'

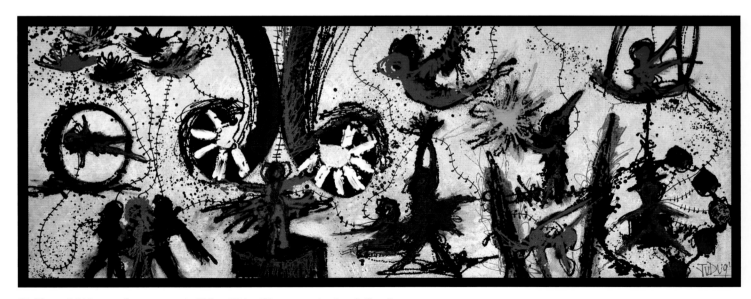

El Circo, 2010, acrylic on wood, 108 x 48 in. Photography by JuDuq'

Brandi Elkin

Punxsutawney, Pennsylvania, USA
www.paintingsilove.com/artist/brandielkin

I was born in Punxsutawney, Pennsylvania, in 1989. I have had a passion for art my whole life. As a child I could always be found drawing. In my teenage years I discovered the world of painting.

I am a self-taught artist. My paintings are raw. I paint my emotions. Each painting is personal, and I approach a painting as I would write a poem. So each painting has a story under its layers of paint, I love the mystery behind it. I am an abstract artist with a twist. I love the freedom of it. I use acrylic paint and watercolor. I love painting larger scale paintings. My work is heavily influenced by my favorite artists Jackson Pollock and Jasper Johns.

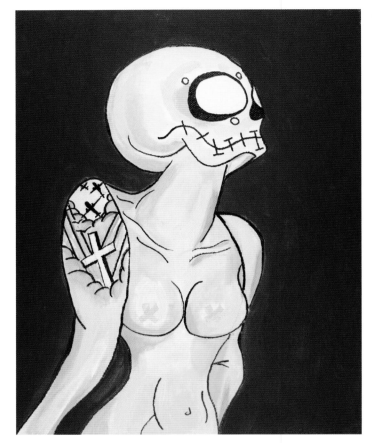

Catch One's Death, 2011, acrylic, 11 x 14 in.
Photography by Delbert P. Highlands

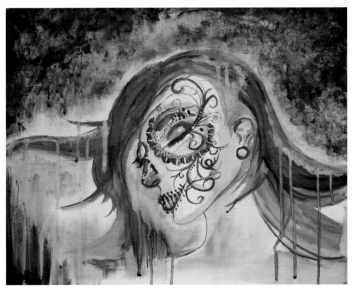

On the Colder Side of Blue, 2011, watercolor, 16 x 20 in.
Photography by Delbert P. Highlands

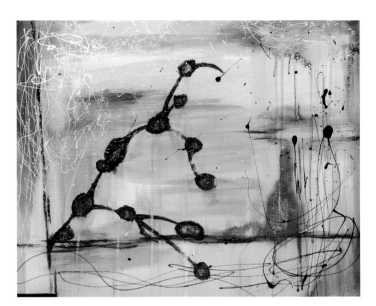

Sugar Tree, 2010, acrylic paint and mixed media, 24 x 30 in.
Photography by Delbert P. Highlands

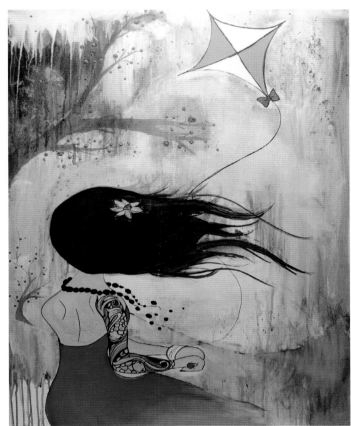

Go Fly a Kite, 2010, watercolor and acrylic 30 x 40 in.
Photography by Delbert P. Highlands

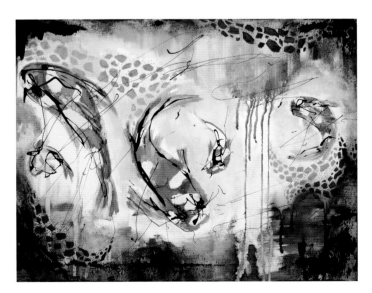

Koi, 2010, watercolor, 16 x 20 in. Photography by Delbert P.
Highlands

Jon Ellis

Royal Palm Beach, Florida, USA
www.jonellisart.com

Jon Ellis, born in Philadelphia in 1959, has always had an unusual perspective of the world. His entertaining, colorful work, often compared to a modern day Rockwell, but with Jon's unique perspective, is both highly detailed and imaginative. Jon's complex range of subject matter is as diverse as his palette. A modern master of acrylic paint, Jon's use of the difficult medium is like no other. Using a laborious layering technique he has developed over the years, he paints exclusively with Liquitex Acrylic Paint on vintage hand-made cold-pressed Italian Fabriano Board from the 1950s. Jon's favorite brush for detail work is the triple zero Windsor Newton Series Seven.

Jon earned a bachelor Degree from the Philadelphia College of Art in 1982. Upon graduating, he moved his studio to New York, where he became an active member of the Society of Illustrators. His accomplished career, which has spanned three decades, has earned him numerous awards, accreditations, and countless highly profiled commissions. Represented by one of New York City's top agents, over the years Jon's work has graced the cover of many popular books, advertisements, and periodicals, including the cover of *Time* magazine.

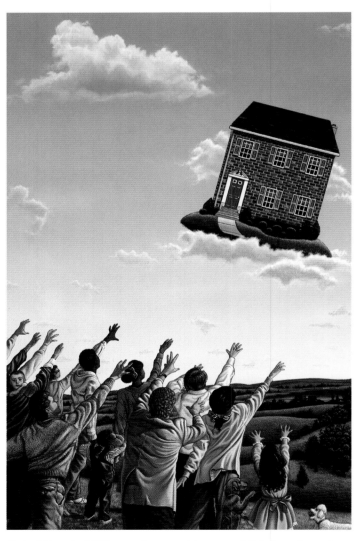

Big Tomato, 1986, acrylic on cold pressed Fabriano board circa 1950, 12.5 x 16 in. Photography by Glen Race

Out of Reach, 1993, acrylic on cold pressed Fabriano board circa 1950, 11 x 16 in. Photography by Lauren Ellis

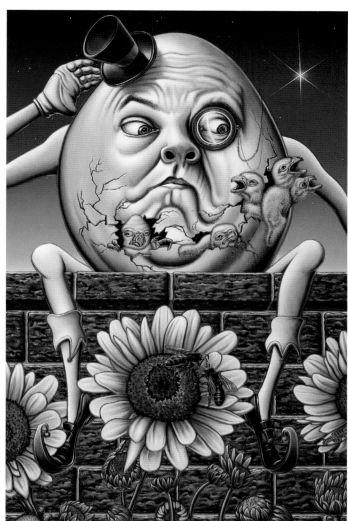

Humpty, 2007, acrylic on cold pressed
Fabriano board circa 1950, 11.5 x 17.5 in.
Photography by Lauren Ellis

Smoker, 1988, acrylic on cold pressed Fabriano board
circa 1950, 11 x 14 ¾ in. Photography by Glen Race

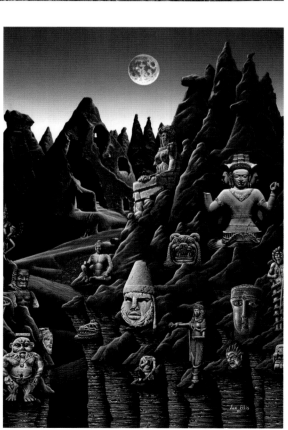

Moon World, 1989, acrylic on cold pressed
Whatman board circa 1945, 16 x 22 in.
Photography by Glen Race

E. Dale Erickson

San Francisco, California, USA

www.bigcrow.com

Born in 1942 in Marquette, Michigan, Erickson attended school of the Art Institute of Chicago from 1960 to 1965, and earned a B.F.A. Degree. He served in the U.S. Army from 1965 to 1967 and traveled in Europe from 1968 to 1969. Erickson attended the San Francisco Art Institute and San Francisco State University from 1969 to 1974, earning an M.A. Degree. He has lived and worked in San Francisco since 1969 living at Project Artaud Corporation, a community for artists, since 1971.

Since 1990 I have been working on a series of paintings that are best described as autobiographical. These paintings are about my friends, family and my surroundings. In these works I want to create a certain type of pictorial space where the viewer feels that he or she is free to step into the painting, walk around in the composition, explore the subject matter and then to make an exit out of the work.

Painting for me has always been a dialogue between the physical flatness of the picture surface and the third dimensional illusion of the picture plane. Therefore, it's important that the painting always retains its flatness and that the viewer is able to exit the illusion of the third dimension and return back to the physical second dimension.

The dialogue between form and content has always interested me. I have never been an abstract, non-objective painter because I have always been interested in a literal subject matter in painting. For me the literal content of painting is always told through the visual language of form, the use of color, paint, value and line. In this respect I am a traditional painter.

It is these concerns towards pictorial space that have dominated western art since the Renaissance. How I relate to this history in my present work and in my everyday life is what my work is all about.

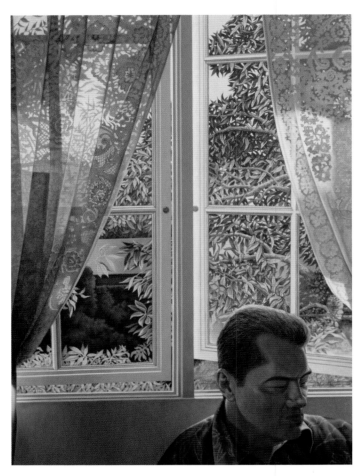

Self Portrait by Open Window, 2009, oil on canvas, 46 x 38 in.
Photography by Dale Erickson

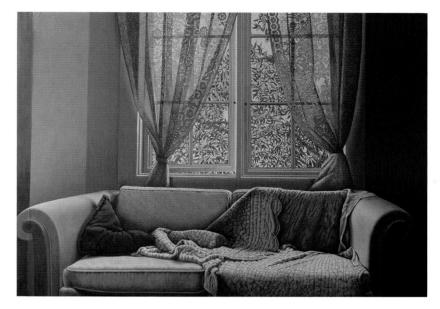

Hawaii Living Room, 2008, oil on canvas, 42 x 48 in. Photography by Dale Erickson

Peppers in Blue Bowl, 1999, oil on canvas, 42 x 48 in. Photography by Dale Erickson

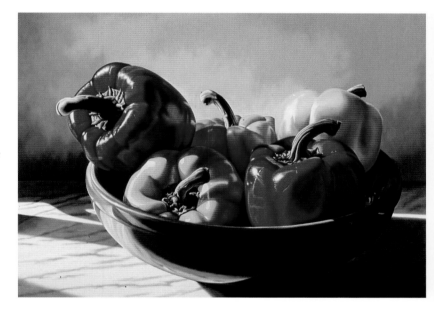

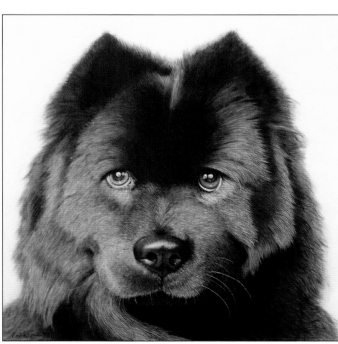

Teddy, 2008, oil on canvas, 42 x 42 in. Photography by Dale Erickson

Lisa Ernst

Nashville, Tennessee, USA
www.lisaernst.com

Lisa Ernst began studying art and painting full time in the mid-90s. Her work has been exhibited in many group and solo exhibitions in both galleries and museums, and she has been featured in *American Artist Magazine*, among others. Her paintings hang in corporate, public and private collections internationally and she frequently accepts large scale commissions. The renowned M.D. Anderson Hospital in Houston has acquired eight of Lisa's large botanical paintings, with the most recent two painting commission completed in 2010. In 2007 she completed a large commission for Northwestern University Medical Center's public collection. Lisa is represented by dealers in the U.S.A. and London.

A colorist and contemporary realist, Lisa uses the vibrancy of acrylic paints to amplify nature's colors and forms. In the mid-1990s she studied intensively with the noted artist Walter Bunn Gray (1934-2002) who had a successful fine arts career in New York City prior to his retirement in Franklin, Tennessee.

The theme of impermanence has been central to my life and my art, perhaps because both of my parents died when I was a teenager. In my art I am most often drawn to express the beauty that exists in the midst of life's impermanence by paintings subjects that are short-lived. Whether a flower, a ripe piece of fruit, or a cluster of sunlit leaves, these offerings of nature spend only a short time in their fully alive form. Through studying and painting these impermanent subjects, I am constantly reminded that life is brief and the time to appreciate my own life is right now.

I paint in a realistic style that captures detail as well as form and color. While I prefer accuracy and tight finishes, I don't strive for fully developed photorealism. I want to leave an impression of my own hand at work and my personal interpretation of nature. This is more easily seen by viewing my works in person.

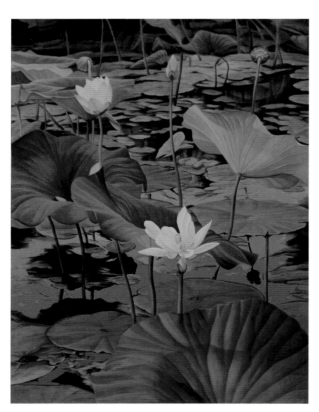

American Lotus, 2010, acrylic on canvas, 48 x 36 in.
Photography by Lisa Ernst

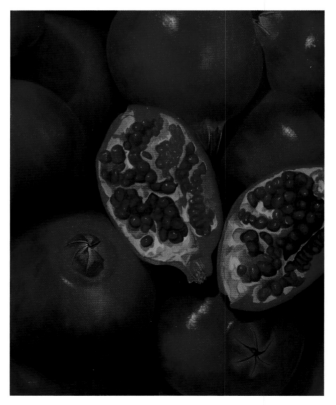

Overlay III, 2007, acrylic on canvas, 32 x 42 in.
Photography by Lisa Ernst

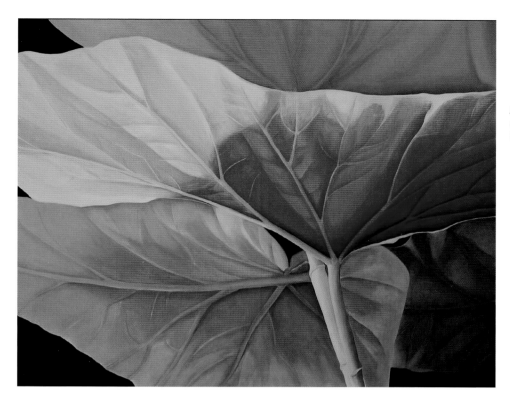

Pomegranates, 2006, acrylic on canvas, 30 x 24 in. Photography by Lisa Ernst

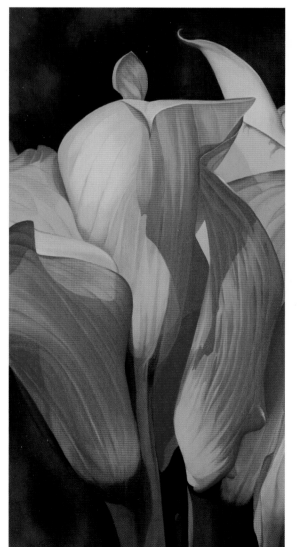

Trumpet Diptych, 2005, acrylic on canvas, 36 x 48 in. Photography by Lisa Ernst

Tall Callas, 2010, acrylic on canvas, 48 x 24 in. Photography by Lisa Ernst

Rob Evans

Wrightsville, Pennsylvania, USA
www.robevansart.net

Rob Evans is an artist and independent curator who lives and works near Wrightsville, Pennsylvania. He received a BFA from Syracuse University in 1981 and has been awarded grants from the Ford Foundation, the Mid-Atlantic Arts Foundation, the Pennsylvania Council on the Arts, the E.D. Foundation, the Eben Demarest Trust, and the Pollock-Krasner Foundation. Evans's meticulous paintings and drawings have been featured in numerous solo and curated group exhibitions in museums throughout the United States and abroad including the Tretyakov Museum, Moscow; Corcoran Museum of Art, Washington, D.C.; Delaware Center for the Contemporary Arts; Contemporary Art Center of Virginia; and an exhibition of American drawings organized by the Smithsonian Institution which toured internationally. Evans' work can be found in many public collections including the Metropolitan Museum of Art, New York City, National Gallery of Art, Washington, D.C., and the Corcoran Museum of Art, Washington, D.C. among others. His paintings have been featured in numerous books, newspapers, and magazines and on public radio and television. As an independent curator Evans recently organized the traveling exhibit, "Visions of the Susquehanna: 250 Years of Paintings by American Masters."

Since my childhood the impulse has always been there to interpret the world in a visual way. As a child, I spent many extraordinary summers exploring the woods around my grandparent's home along the Susquehanna River in York County, Pennsylvania, collecting insects, bones, old bottles and all kinds of interesting artifacts. Our farm, the surrounding natural landscape and my family are starting points for almost all the concepts I explore in my paintings. The plumes of steam from nearby Three Mile Island nuclear power plant, jet trails, power lines and roadways which divide up the surrounding land and skyscape, suggest in my work the imposition of human activity on an increasingly fragile ecosystem, something I live with on a daily basis as urban sprawl continues to creep out into the rural countryside from nearby cities. Over the last decade my paintings have moved increasingly in the direction of dealing metaphorically with these broader themes inspired by real places, experiences and memories.

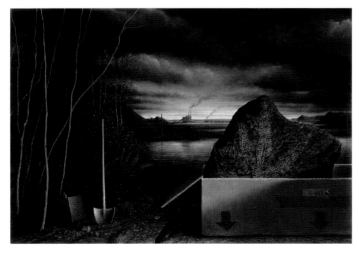

Fossil, 1997, mixed media on paper, 27 x 38 in.
Photography by Rob Evans

Pinata, 2004, acrylic and oil on prepared paper, 26 x 19 in. Photography by Rob Evans, collection of Howard and Judy Tullman, Chicago, IL

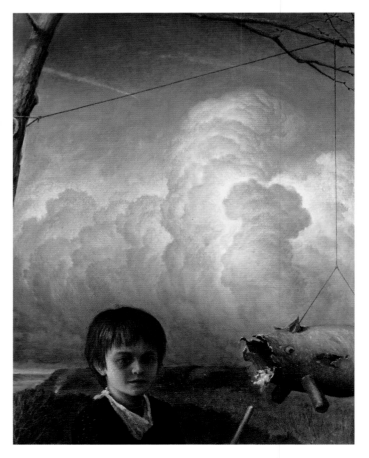

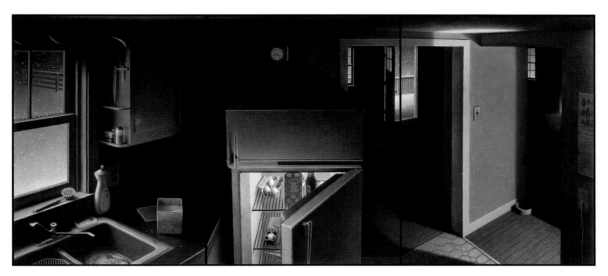

Evening Ritual, 1989, oil on panel, 40 x 90 in. Photography by Rob Evans

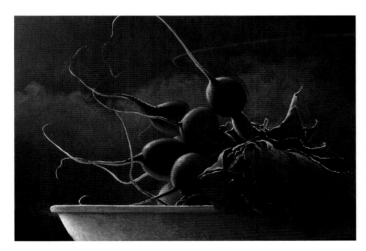

Radishes II, 2010, oil on panel, 30 x 44.75 in.
Photography by Rob Evans

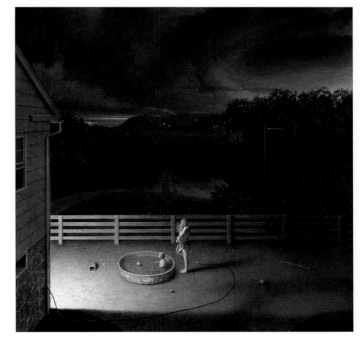

Refuge, 1997, oil on panel, 48 x 48 in. Photography by Rob
Evans, collection of Southern Alleghenies Museum of Art,
Loretto, PA

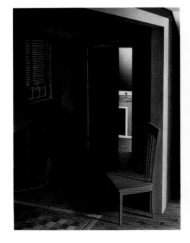
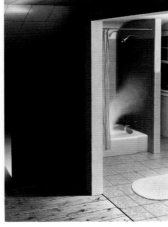

Threshold, 1988, mixed media on paper, 40 x 60 in.
Photography by Rob Evans, collection of Corcoran
Museum of Art, Washington, D.C.

Henryk Fantazos

Hillsborough, North Carolina, USA
www.henrykfantazos.us

I was born in an area of Poland that was soon to become part of the Soviet Empire. I studied painting at Fine Arts Academy in Kraków. In 1975, I received political asylum in America. For decades now I have lived in the south, which is the fecund and fragrant source of my inspiration.

My art intends to tie its moorings to the Flemish protorenaissance and direct observation. My work contains no symbols or any connections with surrealism; rather it builds a poetical language within the image.

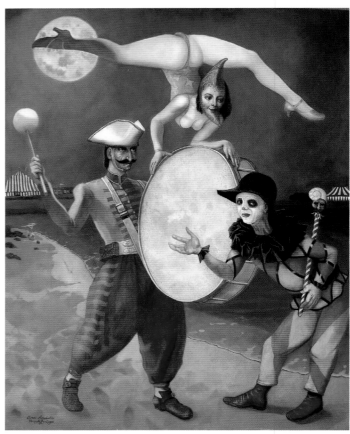

Lunar Acrobatics, 2007, oil on panel, 32 x 27 in.
Photography by Henryk Fantazos

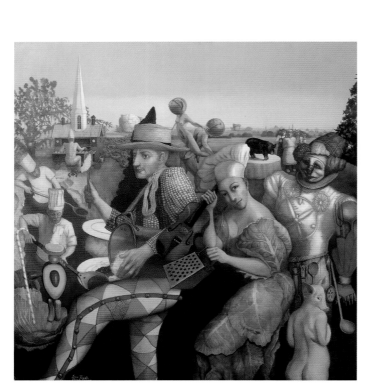

Dixie Fiddle, 2010, oil on panel, 32 x 32 in.
Photography by Henryk Fantazos

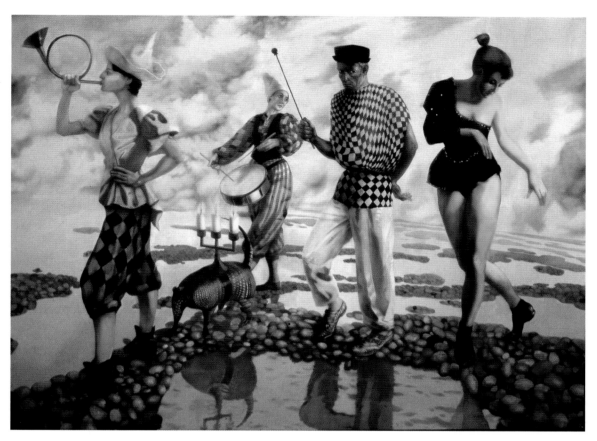

Crossing the Shallows, 2000, oil on canvas, 40 x 50 in. Photography by Henryk Fantazos

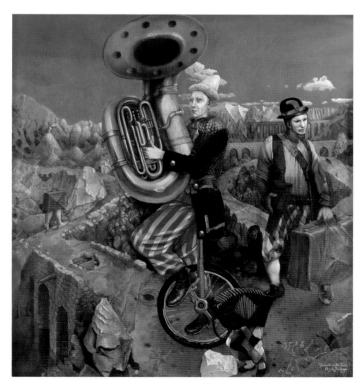

Travels with Tuba, 2001, oil on canvas, 50 x 40 in.
Photography by Henryk Fantazos

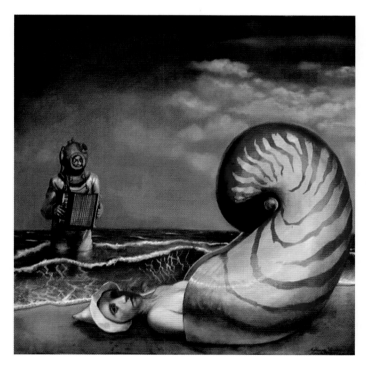

Molluscan Vespers, 2001, oil on wood, 12 x 12 in.
Photography by Henryk Fantazos

Loretta Fasan

Dollard des Ormeaux, Quebec, Canada
www.lorettafasan.com

I have experimented with several painting techniques for the past 15 years. In addition to oils, I have also worked with airbrush, pastels, and acrylics. My paintings have been exhibited in group and solo shows in the United States and Canada, and have been featured on public television. I have produced commissioned artwork for private and public collections.

Giving workshops in gold leaf technique in combination with oils and other media has also been an enjoyable experience.

Capturing expression and character in portrait painting using models and photo references has been a rewarding challenge for me. I have started to photograph nature scenes and animals, and I will be incorporating landscape, floral, and animal imagery into my work.

My paintings are a combination of realism, pattern, trompe l'oeil, and whimsy. I am strongly influenced by Renaissance, and 16th century portraits, and costumes from the past.

I enjoy painting female figures, at times mysterious, humorous, or serene, using intense or subtle colors, textures, and gold patterns in the costumes. There is an iconic aspect to some of the women, which is softened by their expressions. It is exciting to see a character come to life, through a combination of observation, and imagination.

Though most of the work is carefully planned, I try to allow for spontaneity, and the intangible, an element of surprise. My technique is traditional, beginning with an underpainting, and building form and intensity of color gradually, yet always with the potential of adding an unexpected twist. The elaborate beadwork, hairstyles, and ornaments are fun elements which help to create movement, richness, and give a sense of mystery to the paintings.

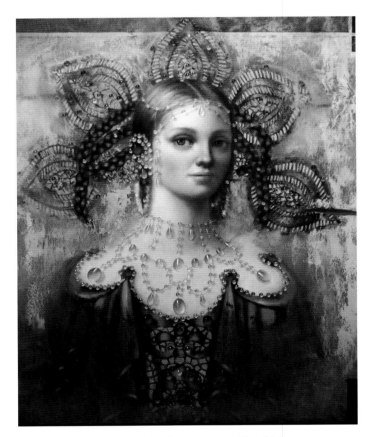

Blue, 2010, oil and gold leaf on canvas, 30 x 30 in.
Photography by Loretta Fasan

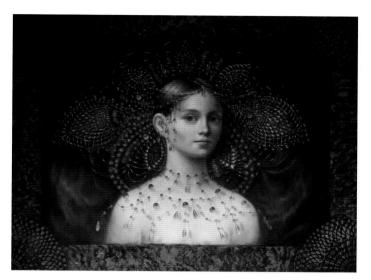

From the Book, 2010, oil on canvas, 24 x 30 in.
Photography by Loretta Fasan

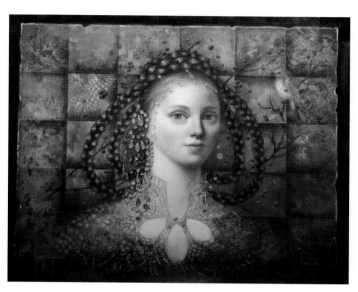

Origami, 2010, oil on canvas, 24 x 30 in.
Photography by Loretta Fasan

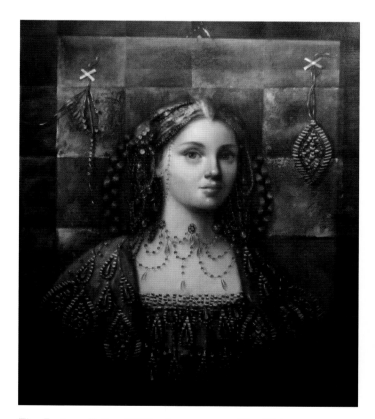

The Fortune Teller, 2010, oil on canvas, 30 x 30 in.
Photography by Loretta Fasan

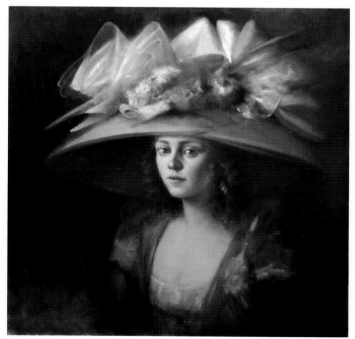

The Hat, 2010, oil on canvas, 30 x 30 in. Photography by
Loretta Fasan

Anthony Flake

Arlington, Tennessee, USA

www.anthony-renardo-flake.artistwebsites.com

I started drawing at age ten and spent may years learning and being inspired by the renaissance artist of the 14th and 15th centuries. My paintings have been featured in many exhibitions. I was awarded *Best of Show* in the National High School Scholastic Contest. I have exhibited works in galleries, auction houses, and cultural centers throughout the United States and the world. I have been invited to exhibit some of my paintings in Paris and London.

I often use contemporary and old renaissance ideas in my works, combined with a strong traditional technique.

I have been a freelance artist for 20 years and I am currently living in Memphis, Tennessee.

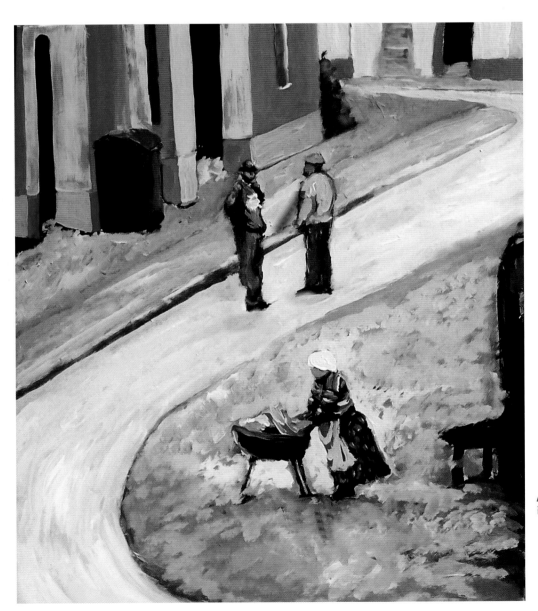

Bygone Days, 2010, acrylic, 24 x 30 in. Photography by Anthony Flake

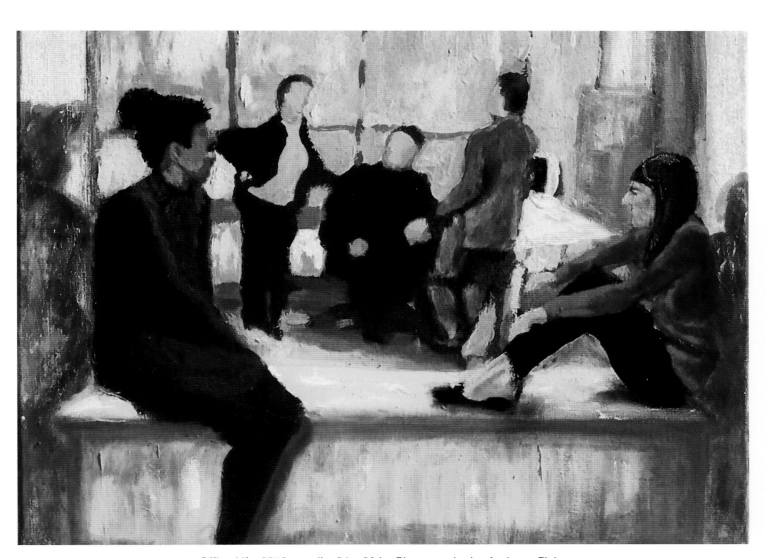

Office Life, 2010, acrylic, 24 x 30 in. Photography by Anthony Flake

Matt Foley

Mylneford, NSW, Australia
www.paintingsilove/artist/mattfoley

Born in Australia in 1959, Matt has traveled and worked for many years in remote areas of Australia. He started drawing and painting in the early 1980s.

Matt paints because he feels a need to express the ideas and images that come to him in dreams or when he is in that brief state between sleep and wakefulness when "imagination reigns free." He tries to communicate ideas, feelings, mood, or atmosphere in his paintings. In particular he likes art to present a different perspective and give the viewer something to think about.

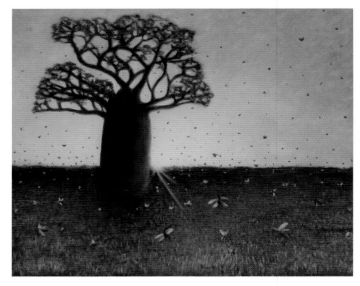

Eterne, 2008, oil on canvas, 30 x 36 in.
Photography by Matt Foley

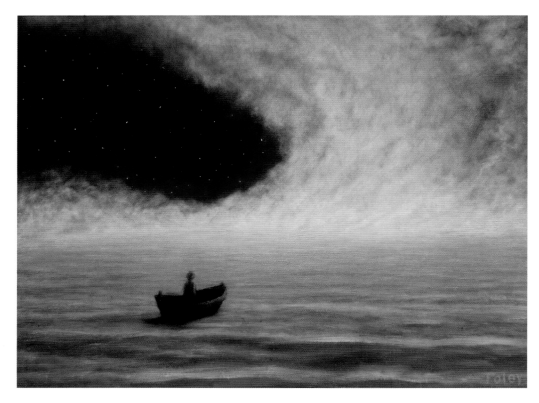

Black Boat on a River of Light,
2010, oil on canvas, 30 x 39 in.
Photography by Matt Foley

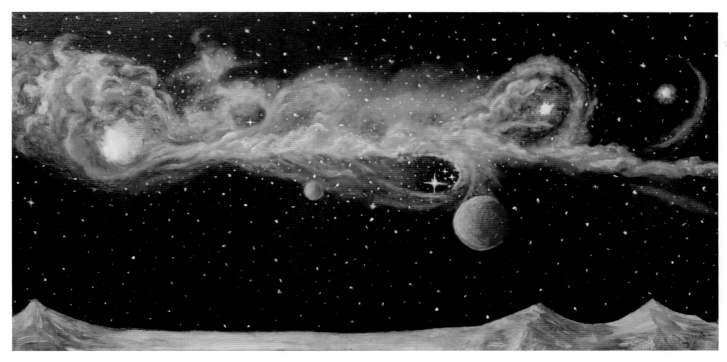

The Flow of the Universe, 2009, oil on canvas, 24 x 48 in. Photography by Matt Foley

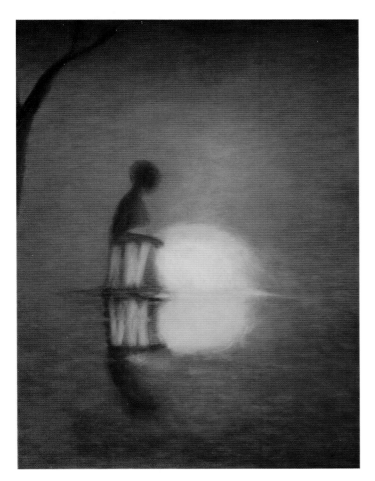

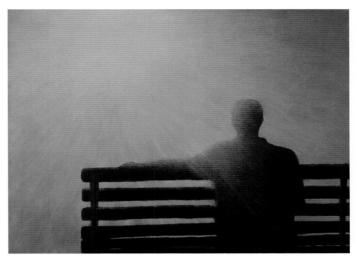

My Day in the Sun – Everyone has Their Day in the Sun, 2010, oil on canvas, 18 x 24 in. Photography by Matt Foley

The Prawn Fisherman, 2008, oil on canvas, 40 x 30 in.
Photography by Matt Foley

Todd Ford

Krum, Texas, USA
www.tford.info

I paint in a style that is similar to, but certainly not, true photorealism. I am much more interested in creating work that is a synthesis of my own vision and sensibilities without the strict confinements of photorealism. I want to show a familiar object in an unfamiliar way, as something that has importance. I want the viewer to be engaged. That is my goal with every painting I create.

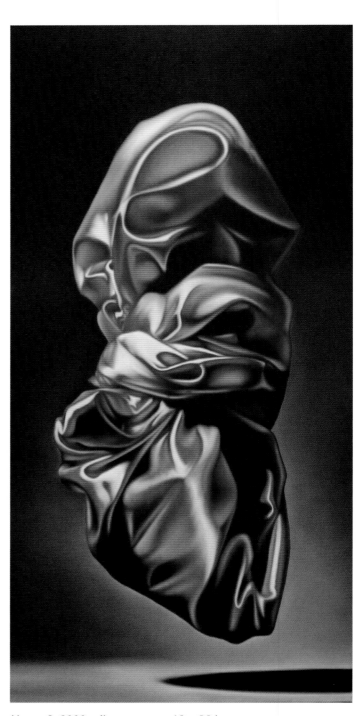

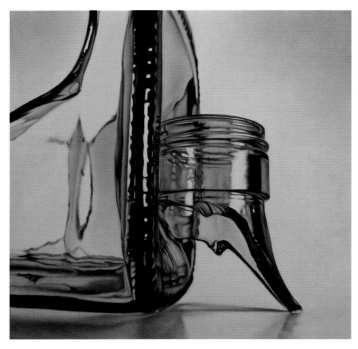

Broken Neck, 2009, oil on canvas, 30 x30 in.
Photography by Todd Ford

Hover 2, 2009, oil on canvas, 18 x 36 in.
Photography by Todd Ford

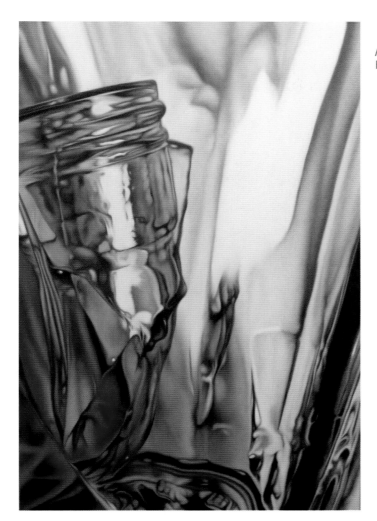

Fall into it, 2010, oil on canvas, 24 x 36 in.
Photography by Todd Ford

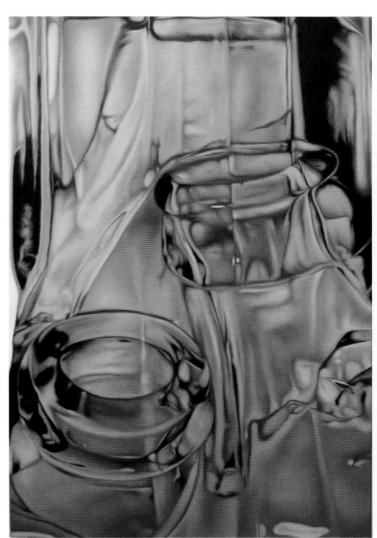

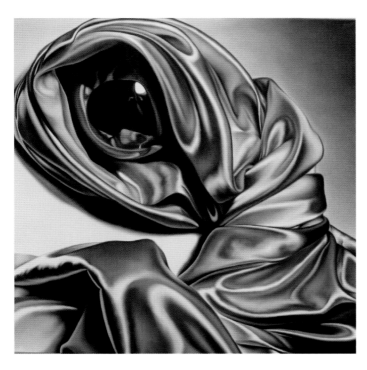

Top Floor, Bottom Buzzer, 2010, oil on canvas, 24 x 36 in.
Photography by Todd Ford

Stink Eye, 2009, oil on canvas, 30 x 30 in.
Photography by Todd Ford

Samuel J. Formica

Philadelphia, Pennsylvania, USA
www.samuelformica.com

Samuel Formica (b. 1964) is a self-taught painter who lives in Philadelphia, Pennsylvania. His personal history is as complex and triumphant as his paintings. Growing up in a trailer park in Elverson, Pennsylvania, a farm town near Reading, Formica loved to draw, but he never considered that becoming an artist was a possibility. As a teenager he became addicted to drugs and found himself homeless and living out of a van. Even when he was at his most strung-out, however, he never stopped drawing. In 1985, Formica was discovered by the late artist agent, Ola Jones, who immediately encouraged Formica to trade in his drugs for brushes. He received his first solo exhibit in 1987 in Pottstown, Pennsylvania. Twenty-two years later, he is still drug-free and his paintings have since been exhibited in more than twenty-five international solo and group shows, published in *Art Now*, *Art Matters*, *The Pew Trust*, and *American History Magazine*, and collected by President George Bush, President Jimmy Carter, and Donald Trump. He was recently honored by the Benjamin Franklin Tercentenary commission and placed in the official Ben Franklin Tercentenary exhibit catalogue, *In Search of a Better World* (Yale University Press).

Like life, the ideas for my paintings flow like dreams, but the work is laborious. Sometimes it takes me years of research and thought before I embark on a new work. Carefully contemplating my subject matter, I first have a vision of a completed painting. These images strike like lighting during a day dream, while sleeping, or during a conversation. I journal these ideas for days or months, moving far within a subject before even sketching anything. Once I feel I am ready to begin translating the image from my mind to the canvas, I expose layer after layer until the thoughts and verbal expressions behind the idea are laid bare, lucid to me and the viewer. I work on that piece exclusively, sometimes for as long as three years, until all of my thoughts have reached the canvas and it looks exactly as I imagined it on the first day in that vision in my head.

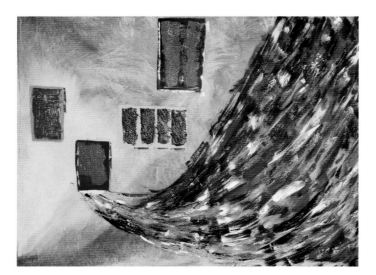

Changing Direction, 2010, oil, 36 x 38 in.
Photography by S. Formica

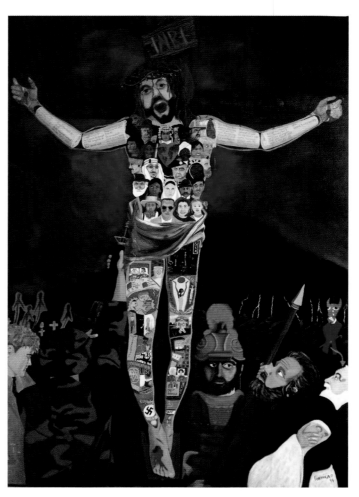

I'll be Back, 1994, oil, 61 x 85 in.
Photography by S. Formica

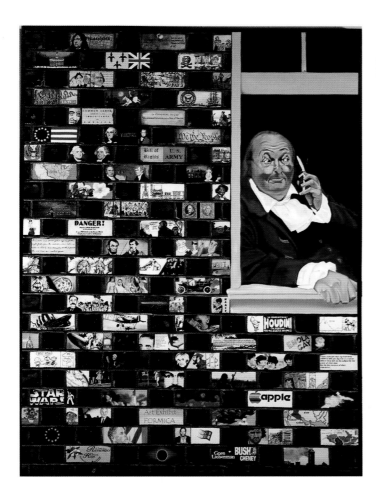

Looking to the Future Back, 2003, oil, 84 x 60 in.
Photography by S. Formica

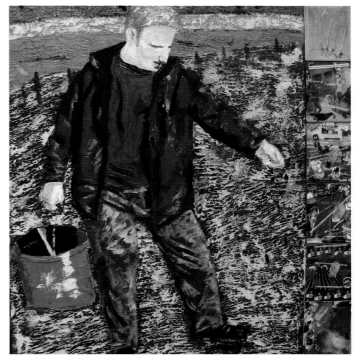

Mark 4, 2009, oil, 28 x 30 in. Photography by S. Formica

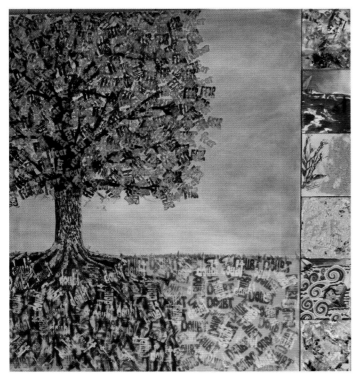

Matthew 14-31, 2009, oil, 28 x 30 in. Photography by S. Formica

Lesta Frank

San Antonio, Texas, USA
www.lestafrank.net

I am a native of San Antonio, Texas. From my first experience with finger painting as a young child was inspired to create art for a lifetime. My heart is overflowing with gratitude to my dear parents who encouraged and facilitated my dream. My mother took my art to shows while I was an art major at the University of Texas. I then spent two years at Cranbrook Academy of Art and also achieved a Master of Fine Art from Rochester Institute of Technology in printmaking .I went back to painting after college and fell in love with the spontaneity of watercolor.

My paintings are my heart's connection with the world around me. Color and the expression of emotion are the key components of my art. The paintings describe the Divine Feminine Archetype which is hidden within our hearts. The intent of my work is to share a profound nurturing energy that awakens the unconditional love and creative fire in the viewer.

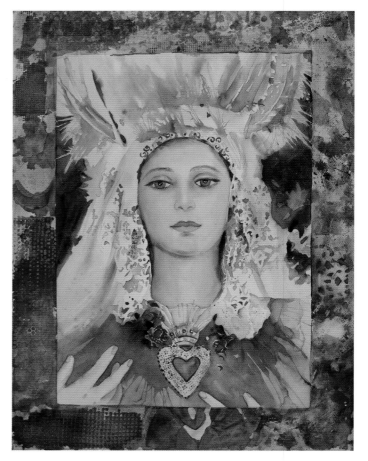

Mother Divine, 2008, watercolor, 22 x 30 in.
Photography by Lee Young

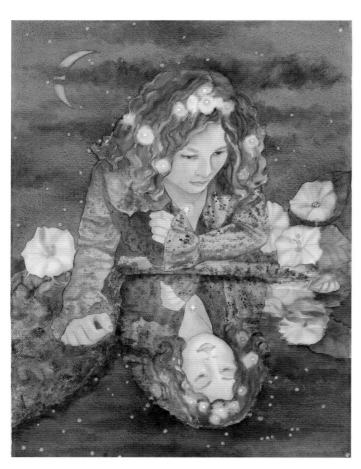

Moon Goddess, 2007, watercolor, 26.75 x 19.25 in.
Photography by Lee Young

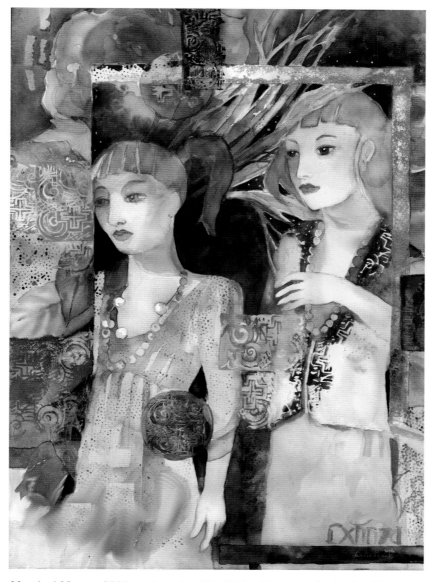

Mystical Muses, 2008, watercolor, 28 x 20 in. Photography by Lee Young

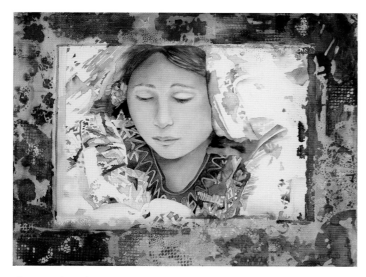

Presencia Infinitia, 2008, watercolor, 22 x 30 in.
Photography by Lee Young

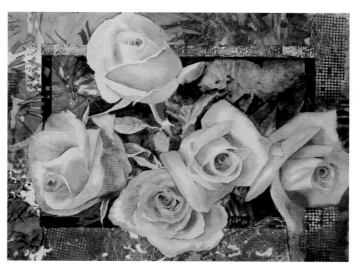

Summer's Joy, 2008, watercolor, 22 x 30 in.
Photography by Dana Butler

Marcel Franquelin

Monmouth Junction, New Jersey, USA
www.artbymarcel.com

Marcel Franquelin received a traditional artistic education in France, at Les Beaux-Arts and the University of Lille, before teaching art and art history in France and later in the United States. After producing copies of masterpieces for five years, he specialized in traditional glazing techniques typical of the nineteenth century masters.

With over 35 years of experience in Realism, Marcel Franquelin now teaches and paints in his atelier near Princeton, New Jersey, where he has several dedicated followers.

"Art is illusion." I have always been fascinated by the visual impact that comes from the works of the Masters; their paintings are magic, bringing you "elsewhere," way past the simple surface of a canvas. I was trained very traditionally at "Les Beaux-Arts" in France, and spent my life studying and teaching art. I understand that realism is not about the truth, but rather the illusion of the truth: paint strokes, along with a well thought palette will bring magic to the viewers, making them want to touch the illusion of a three dimensional object, wonder about the life-like vision of a portrait. I believe it is the artist's mission to make one look "again" at the marvels of our world, to make one stop and contemplate, think, dream, and imagine.

I truly believe that art is not in the content, but in the delivery: an idea, a vision, just like a play for theater, can be either boring or quite entertaining, revealing, or even fascinating. It is all about how well "directed" the representation is.

I do not intend to shock, shake or upset anyone looking at my work, I do not seek stardom, I just share my visual interests and my passion for the arts.

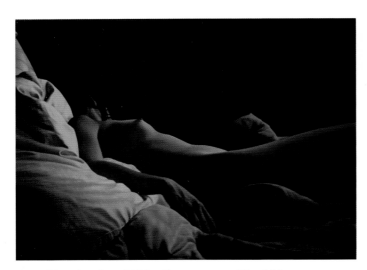

Early Morning Ray, 2009, oil on canvas, 18 x 24 in.
Photography by Marcel Franquelin

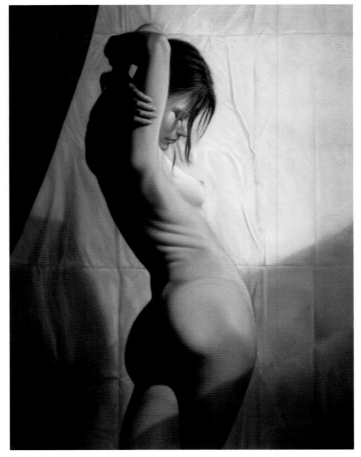

Kika Blue, 2007, oil on canvas, 12 x 16 in.
Photography by Marcel Franquelin

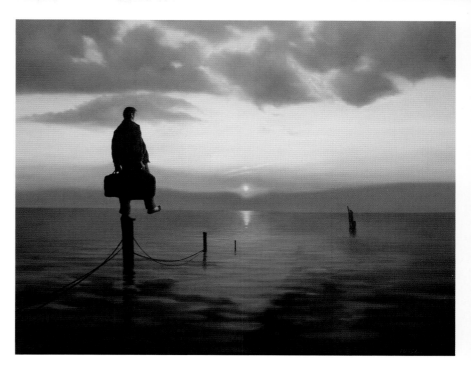

Homesick, 2008, oil on canvas, 32 x 40 in. Photography by Marcel Franquelin

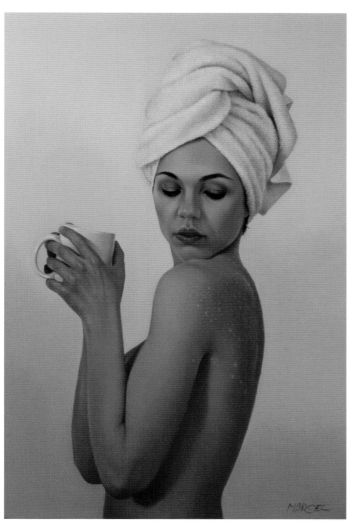

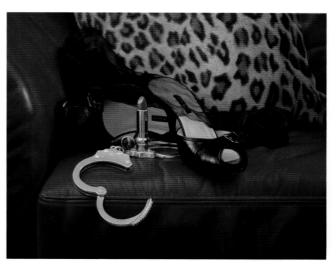

Lust, 2008, oil on canvas, 16 x 20 in. Photography by Marcel Franquelin

Morning Cup, 2009, oil on canvas, 20 x 30 in. Photography by Marcel Franquelin

Night, 2008, oil on canvas, 14 x 20 in. Photography by Marcel Franquelin

Alexandra G

Derby, Derbyshire, England
www.alexandra-g.com

Alexandra G is known for vibrant and dramatic use of color in all her subjects, often created in impasto (heavily applied paint) for texture and even sometimes incorporating paper or fabric for effect. Alexandra has been artistic all her life, an inherent gift from both her parents. Her varied career began with commissioned artwork before progressing to produce original clothing and working in professional musical theatre as set and costume designer.

Alexandra has taught every form of art and enjoys the use of different media. She has received many awards over the years and her paintings have been published and featured on numerous occasions. Her work is exhibited in galleries thoroughout the UK, particularly in London, where she has built an international recognition.

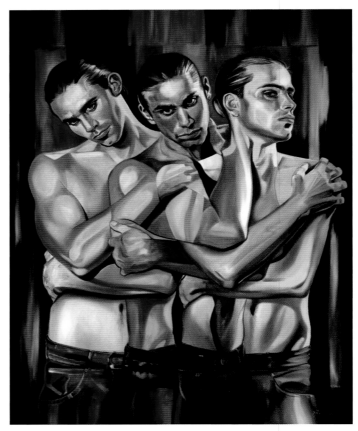

Chameleon, 2010, oil on canvas, 80 x 100 cm.
Photography by Charles Neesham

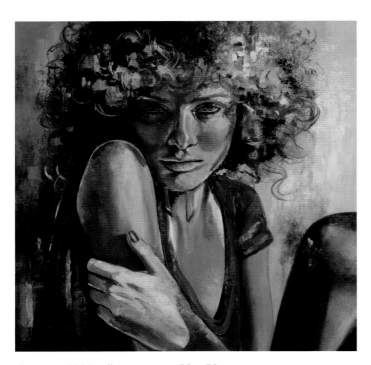

Autumn, 2009, oil on canvas, 50 x 50 cm.
Photography by Charles Neesham

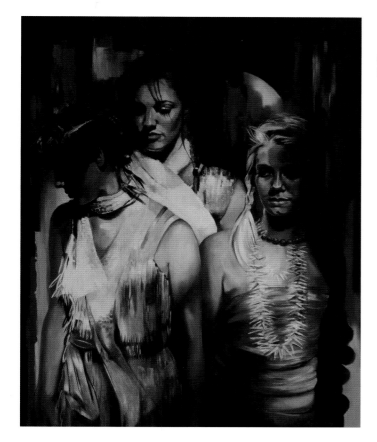

Girls Night Out, 2010, oil on canvas, 80 x 100 cm.
Photography by Charles Neesham

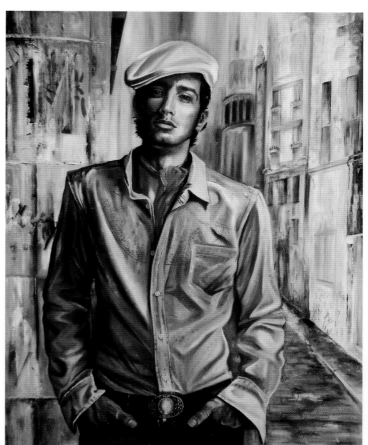

On The Street Where I Live, 2009, oil on canvas, 80 x 100 cm.
Photography by Charles Neesham

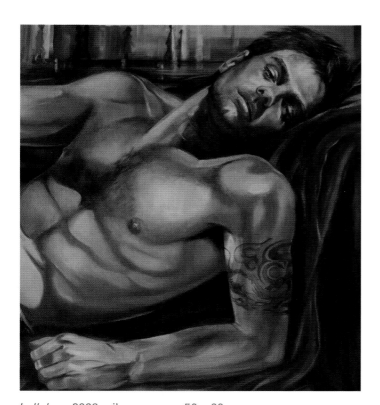

Lullabye, 2009, oil on canvas, 50 x 60 cm.
Photography by Charles Neesham

Fred Gemmell

San Diego, California, USA
www.fredgemmell.com

Fred Gemmell is an artist who is also known for his residential architecture, interiors, and custom furniture design. His paintings are in reverse, applying paint to the backside of special museum coated acrylics and glass to create bold, highly textured images of amazing depth and strong color.

I try to capture with complex detail and bold gestures, the amazing diversity and adaptability of life in all its interaction and beauty. I enjoy creating abstract living forms that are bright and feathered, influenced by my years spent in the tropics of Panama. I love using the tools of composition, color, and detail to create the feeling of a luminous and unfolding mystery.

The work is influenced by my early life in the tropics of Panama and an ongoing fascination with the natural world.

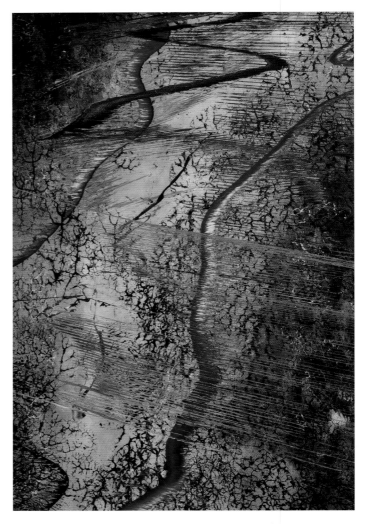

Beyond the Pale, 2010, reverse acrylic, 41 x 71 in.
Photography by Fred Gemmell

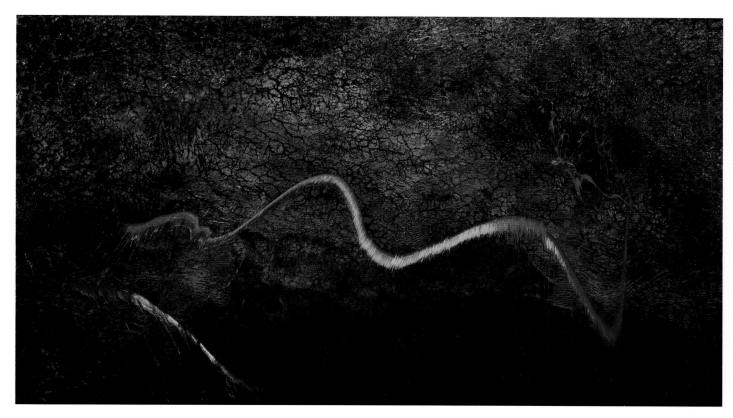

Mahana I, 2009, reverse acrylic, 71 x 41 in. Photography by Fred Gemmell

Tinea. Life Music, 2010, reverse acrylic, 71 x 41 in. Photography by Fred Gemmell

Joy Gilinsky

New Windsor, New York, USA
www.artid.com/members/joygilinsky

Joy Gilinsky is a painter, intuitive artist, illustrator and designer. As a painter, Joy works with oils on large canvasses in a figurative expressionistic style. Bold strokes and bright colors refer to archetypes and myth. Her work blends metaphors and irony with angst and whimsy to present her vision of an ever changing inner and outer reality.

While paint on canvas is a vehicle for Joy to express personal and universal truths, it is also a vehicle for personal clarity and healing. With this understanding and intention, Joy began creating personal mandalas to support others looking for the same. The medium and genre changed from oils to water colors, but the sensibility, symbolism, and intention in both art forms is very similar. Using the ancient mandala archetype, Joy works with it a modern, accessible way. Each commissioned mandala is populated with metaphors, power animals, and symbols that speak directly to the heart of the individual to create one-of-a-kind art that is unique to their needs, creating a powerful tool for healing, meditation, and manifesting. In addition to personal mandalas, Joy creates mandalas and empowerment art for hospitals and healing centers and facilitates mandala and empowerment workshops.

In addition to painting, Joy has a successful career as an illustrator and designer. She lived and worked in Italy and has worked in Asia. Some of her clients include Disney, Warner Brothers, Victoria's Secret, Burberry's, Playtex, Lancome, The Wall Street Journal, Givenchy, Clinique and Liz Claiborne, to name a few, as well as major advertising agencies and publications in the U.S. and Italy. Her projects she have ranged from fashion design and illustration to children's art to packaging and product design and development.

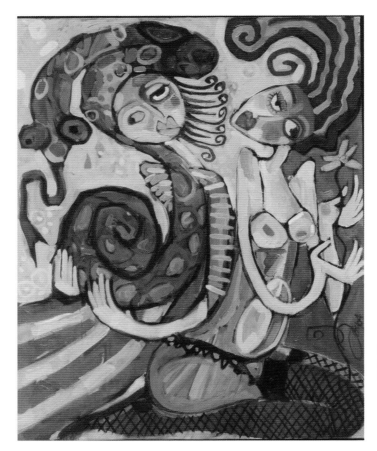

Charmers, 2004, oil on canvas, 50 x 40 in. Photography by Joy Gilinsky

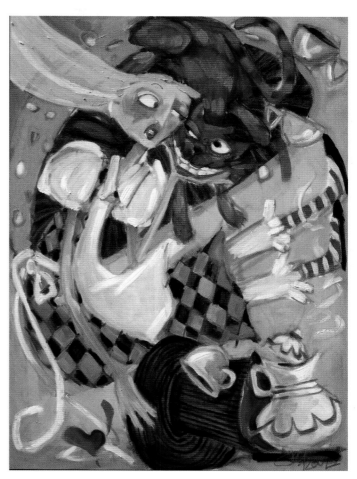

Curiouser & Curiouser , 2001, oil on canvas, 56 x 40 in.
Photography by Joy Gilinsky

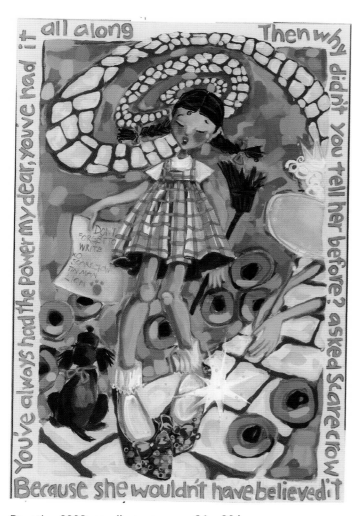

Dorothy, 2008, acrylic on canvas, 24 x 36 in.
Photography by Joy Gilinsky

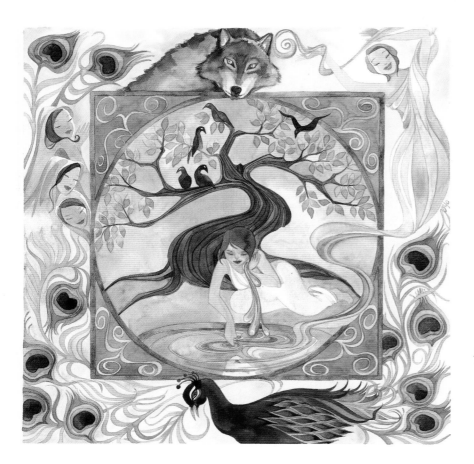

Peacock Mandala, 2010, watercolor on paper, 13 x 13 in. Photography by Joy Gilinsky

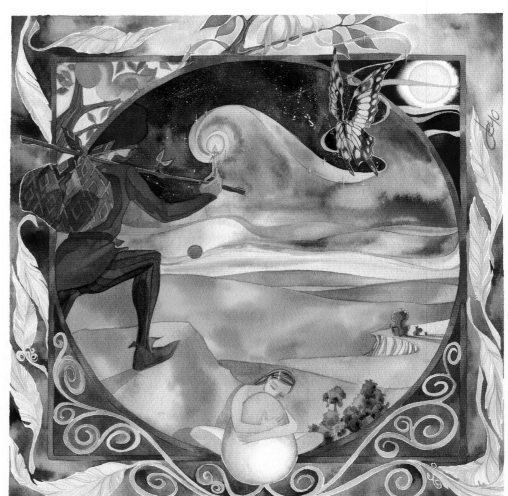

The Leap of Faith, Fool Mandala, 2010, watercolor on paper, 13 x 13 in. Photography by Joy Gilinsky

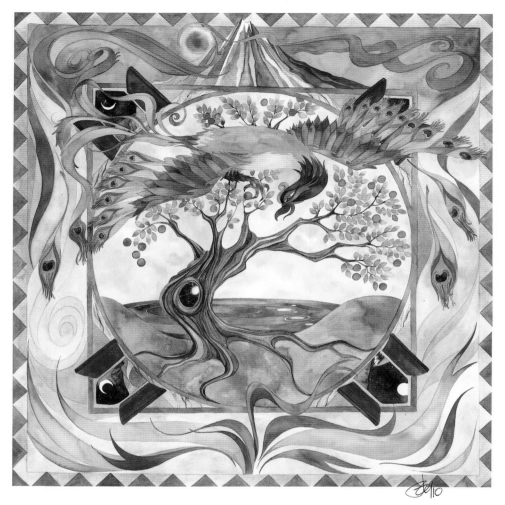

Simurgh Mandala, 2010, watercolor on paper, 22 x 22 in. Photography by Joy Gilinsky

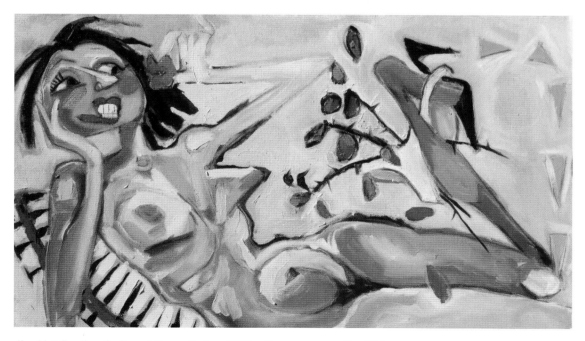

I'm Not Feeling Soft and Fuzzy Today, 2000, oil on canvas, 42 x 25 in.
Photography by Joy Gilinsky

Eleanor Gilpatrick

New York, New York, USA
www.gilpatrickart.com

Eleanor Gilpatrick's first career was as a professor at the School of Health Sciences, Hunter College, City University of New York (CUNY). She had won prizes for painting and draftsmanship in high school and at the Educational Alliance in New York City, but chose to study the social sciences in college and graduate school. She eventually became an expert in health care policy and human resources, authored four books, directed a masters program in health services administration, and pioneered courses in critical thinking and writing.

Her second career is as a contemporary realist painter. An accomplished colorist, she has her own take on content and composition. Above all, her intense energy shows through. Despite commercial pressures, Gilpatrick refuses to make reproductions of her work, a policy greatly appreciated by her collectors. She offers a varied portfolio of landscapes of the United States, Norway, Bulgaria, Italy, Spain, and her home in New York City, as well as nebulae, still lifes, and portraits. People concerned about the human face of war will want to see her anti-war series, including images based on photos originating in Iraq and Afghanistan.

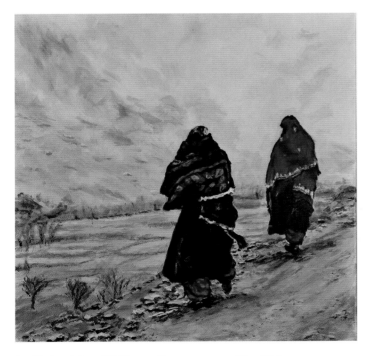

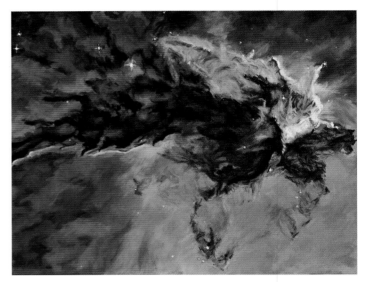

The Eagle Nebula, 2009, acrylic on canvas, 16 x 20 in.
Photography by Eleanor Gilpatrick

In Afghanistan, 2010, acrylic on canvas 20 x 20 in.
Photography by Eleanor Gilpatrick

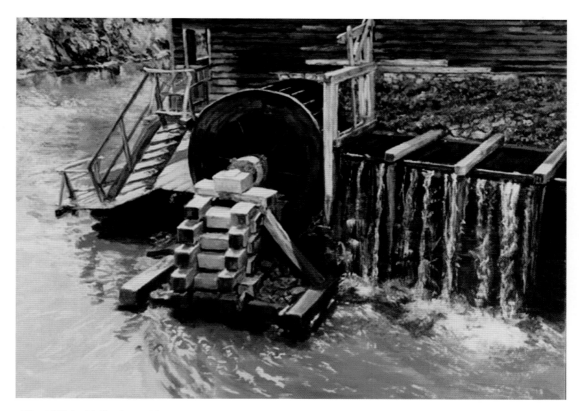

The Mill At Philipsburg Manor, 2006, acrylic on canvas, 22 x 30 in. Photography by Eleanor Gilpatrick

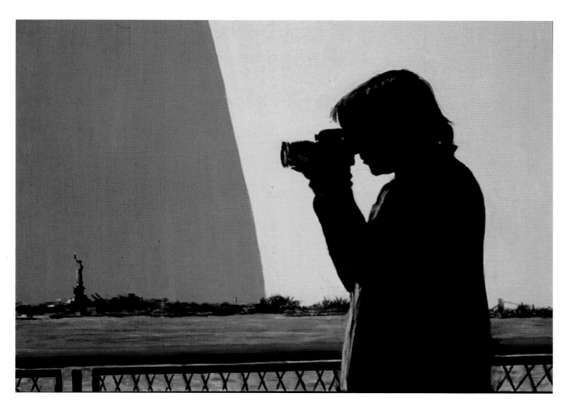

The Viewfinder II, 2005, acrylic on canvas, 25 x 34 in. Photography by Eleanor Gilpatrick

Varvara Harmon

Windham, Maine US
www.VarvaraHarmon.com

Varvara Harmon was born and raised in Volzshk, a small city of 100,000 people that is located in the central European portion of Russia. She began painting in her childhood and was a student at the Volzshk Art School, where she graduated with a Diploma in Art Studies.

Varvara specializes in still life, landscape, and seascape paintings, paints portraits of people, pets, and homes, and accepts commissioned work. She creates in different media — oil, acrylic, watercolor, silk paintings, ink and pencil drawings. Varvara has received numerous awards for her paintings and has been juried into many international and national exhibitions and her paintings have been featured in *The Best of America Artists* book, and *International Artist* and *American Artist* magazines. Her art work is in private collections worldwide.

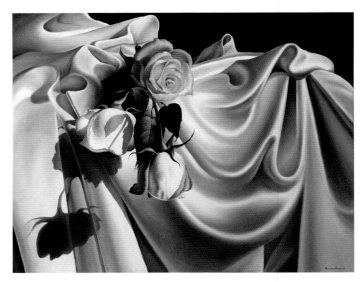

Roses on White Silk, 2008, oil on canvas, 24 x 30 in. Photography by Varvara Harmon

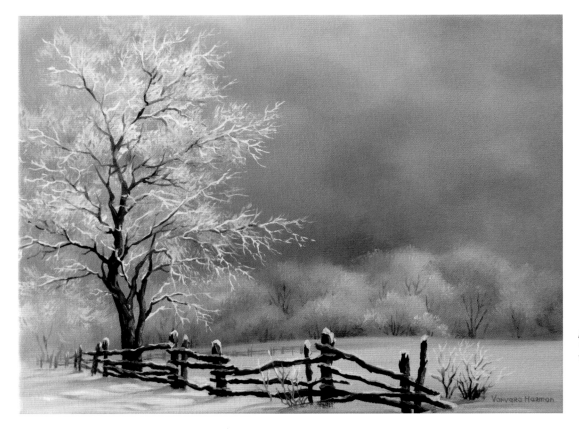

Frosty Day, 2010, oil on canvas, 16 x 12 in. Photography by Varvara Harmon

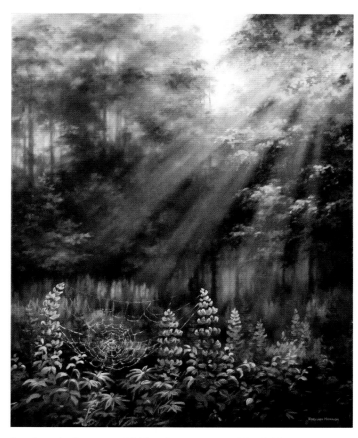

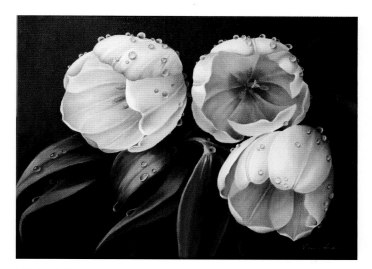

White Tulips, 2011, oil on canvas, 12 x 16 in.
Photography by Varvara Harmon

Lupines in Sunrays, 2010, oil on canvas, 30 x 24 in.
Photography by Varvara Harmon

Autumn Lullaby, 2010, oil on canvas, 18 x 36 in. Photography by Varvara Harmon

Gabrielle Hawkes

St Just, Penzance, Cornwall UK
www.stisa.co.uk/artist-gallery/gabrielle-hawkes

I live and work in Cornwall, UK, and exhibit my work at my studio, The Turn of the Tide in Fore St., St. Just, near Lands End. I show regularly with the St. Ives Society of Artists and with the Association of British Naïve Artists. I am mainly self-taught, taking inspiration from my imagination and from the rich and varied coastal landscape in which I live. I am also drawn to Cornwall's mysterious ancient sites, the stone circles and standing stones, which I see as gateways to unseen worlds.

In my paintings I am a story teller, depicting my lifelong adventures in the country of the psyche, a landscape which often resembles Cornwall but has a magical dimension. Here things are not always as they seem and animals and humans communicate. I am frequently surprised by what emerges when I start to paint and I often allow randomly applied paint to dictate the subject matter. This way I meet up with new characters and am led to new places. I paint the night as well as the day because you cannot have one without the other.

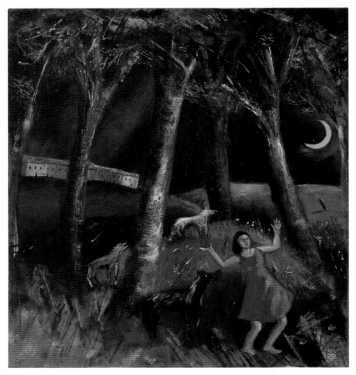

She Danced with Wolves, 2008, oil on board, 17 x 19 in. Photography by Tom Henderson Smith

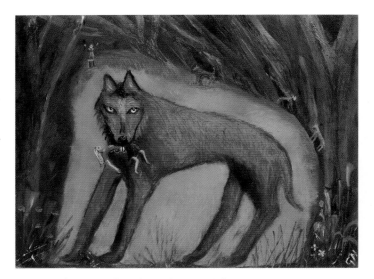

Red Wolf, 2009, oil on board, 14 x 18 in. Photography by Tom Henderson Smith

Travelling Man, 2009, oil on board, 16 x 19 in. Photography by Tom Henderson Smith

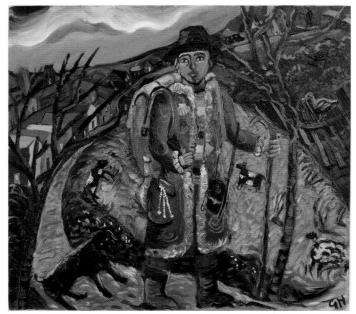

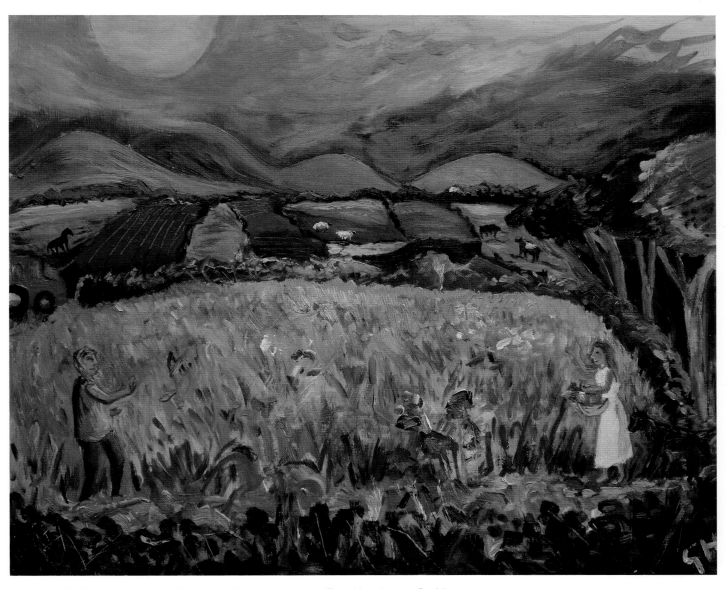

Reunion, 2010, oil on canvas, 17 x 19 in. Photography by Tom Henderson Smith

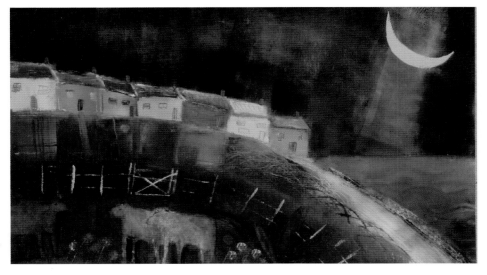

The Houses on the Hill, 2001, oil on board, 12 x 7 in.
Photography by Tom Henderson Smith

Stephen Hawks

Lumpkin, Georgia, USA
www.gshawks.wordpress.com

Stephen Hawks, born in Washington D.C., has lived most of his life in Georgia. After early training in art, music, and theater, he received his BFA from Valdosta State University and a MFA from Florida State University. He was Resident Potter at Westville, a living history museum, for 19 years and an independent artist for over 30 years. He is married and has two grown daughters. He resides with his wife Nancy in Lumpkin Georgia.

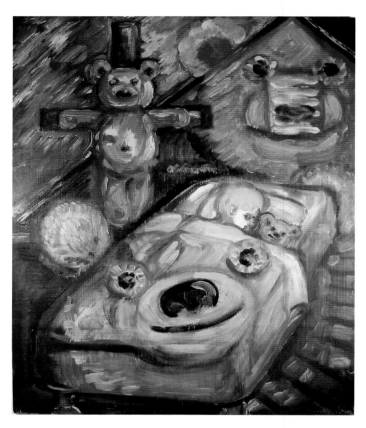

Don't You Know that God is Pooh Bear, 2004, oil on board, 24 x 18 in. Photography by Stephen Hawks

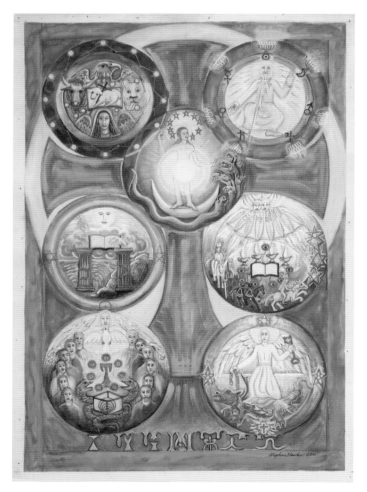

Apocalyptic Seals, watercolor on paper, 3 x 2 ft. Photography by Stephen Hawks

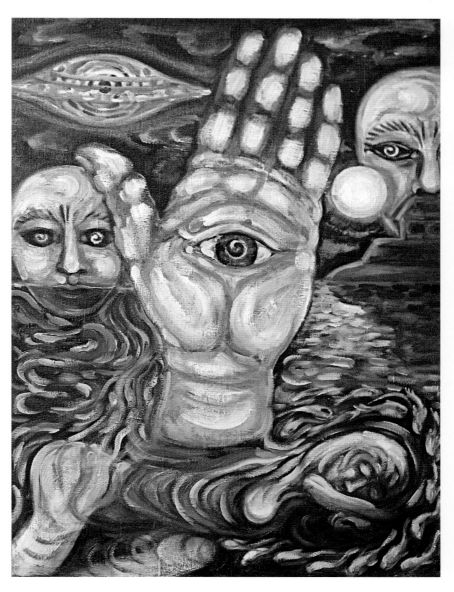

Pensacola, 2008, oil on canvas, 24 x 18 in.
Photography by Stephen Hawks

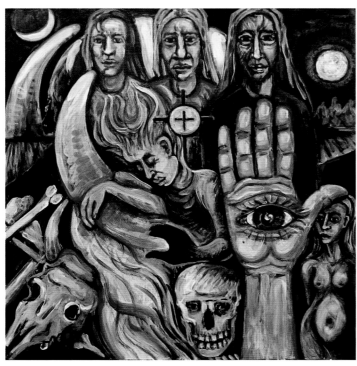

The Watchers, 2008, acrylic on board, 18 x 12 in.
Photography by Stephen Hawks

Gustav Hlinka

Gustav Hlinka was born on June 6, 1947. He graduated from art school in 1969 and in 1972 he graduated from art school in Resita, having studied with the influential professors Peter Schweg and Petru Galis. Gustav's talent is recognized in graphics, modern art, watercolors, and naïve paintings. In recent years Gustav has explored the world of writing as well.

Gustav is involved in many non-profit organizations, including the Romanian Society for Numismatics and the Caraş-Severin Stamp Society. He is a member of the German Culture Association and Adult Education at Adultilor in Resita and the Universale Naive Art Foundation, and is a founding member and vice-president of Naive Art Foundation "Arplana-Vintila." He is an art speaker for the Democratic Forum of German Ethnics from Resita.

Together with his wife Gustav he leads the plastic art group of "Deutsche Kunst Reschitza" and is a member of Romanian Writers League.

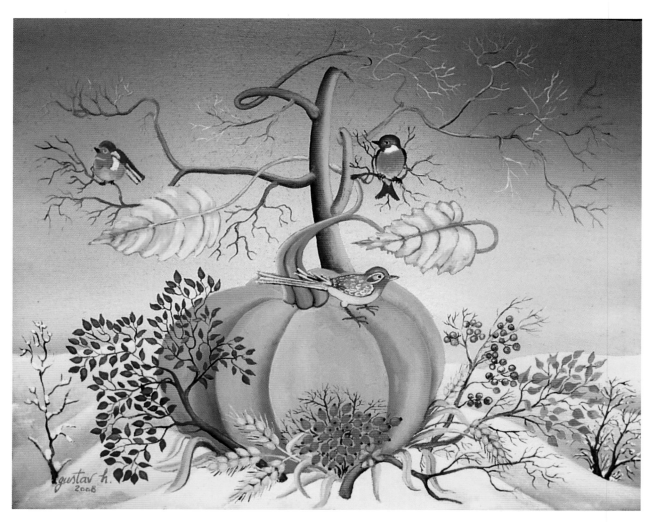

Iarna Pasarelelor, 2008, oil, 40 x 50 cm. Photography by Gustav Hlinka

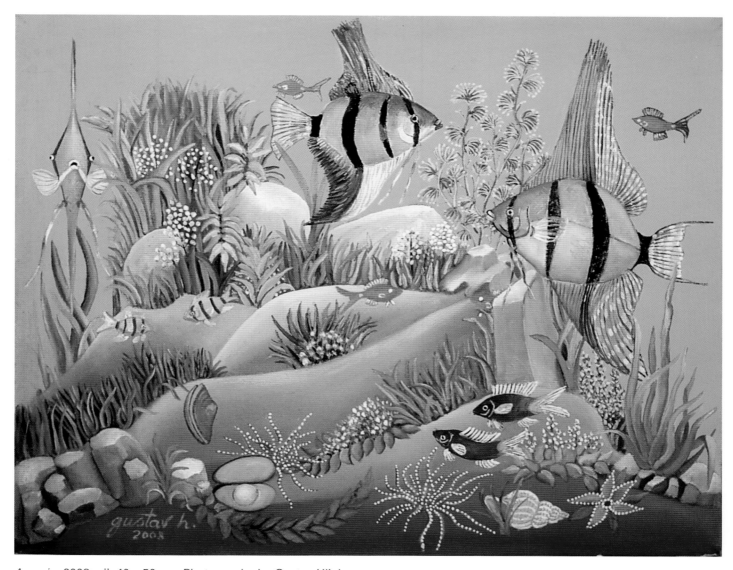

Acvariu, 2008, oil, 40 x 50 cm. Photography by Gustav Hlinka

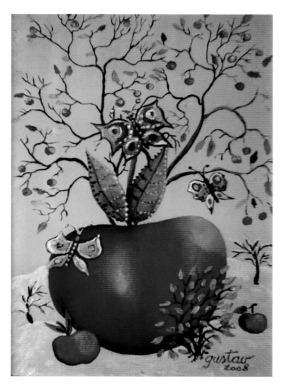

Marul cu Fluturi, 2008, oil, 30 x 45 cm. Photography by Gustav Hlinka

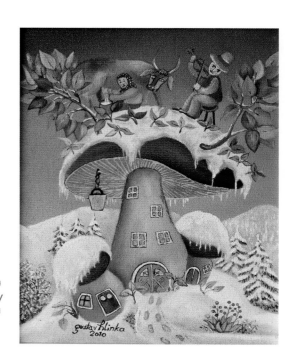

Vaca Melomana, 2010, oil, 30 x 40 cm. Photography by Gustav Hlinka

Debbie Horton

North Tustin, California, USA

www.debbie-horton.fineartamerica.com

As a child, my mother encouraged my creativity by staging the tile floor in my bedroom to support my earliest work — butcher paper as canvas and crayons for color. I drew and dreamed to my hearts content. As an adult, my father further inspired my dreams, as he, at age 70, began to create breathtaking oil paintings. Encouraged at this discovery, I decided to replace (the mouse) with a brush and (20 plus years of computer graphics) with a clean white canvas just begging me to capture an unexpected moment and bring it to life. I often take my canvas and paints out of my studio for a breath of fresh air. As a Southern California native, my garden or the beach, with a tranquil breeze or a splashing fountain, is the perfect stimulation to sooth the soul and bring all things lovely into view.

Ethereal and whimsical by nature, the images I create represent a fascinating exploration of the many facets of women, and even a little of myself. With faces as thoughtful as the "Mona Lisa," each girl draws the viewer in to their dream world. It is a world of exquisite beauty, passionate colors, serenity, romance, and a dash of whimsical fun. I thank God for the ability and vision to create this world of enchantment for others, so they may experience the dreams and enthusiasm I put into my paintings.

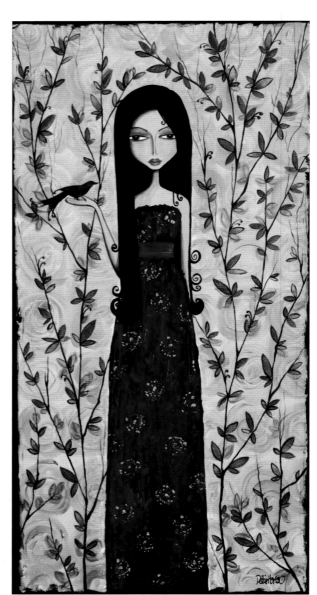

Iridescent Heart, 2011, acrylic on canvas, 15 x 30 in., photograph by Debbie Horton

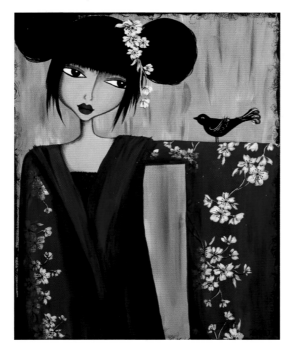

A Song for Suki, 2010, acrylic & marker on canvas, 16 x 20 in., photograph by Debbie Horton

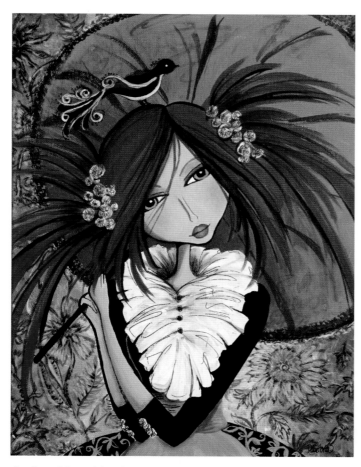

Redhead Sunshine London Rain, acrylic & marker on canvas, 16 x 20 in., photograph by Debbie Horton

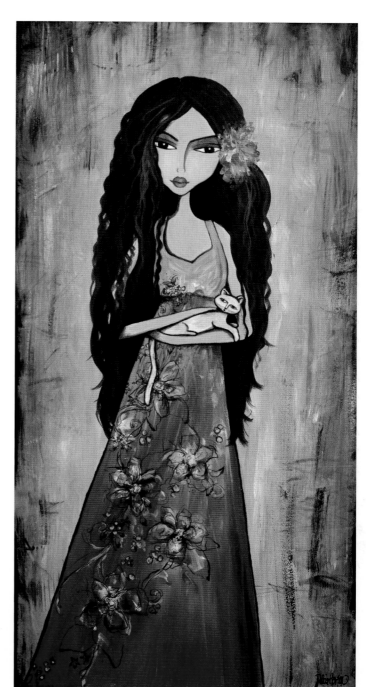

Maya and the Cat, acrylic & marker on canvas, 15 x 30 in., photograph by Debbie Horton

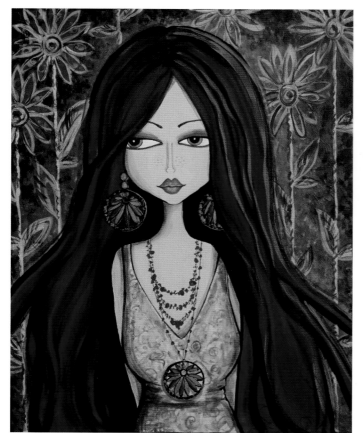

Sofia's Garden, acrylic & marker on canvas, 16 x 20 in., photograph by Debbie Horton

Jane Hunt

Colorado, USA
www.janehuntart.com

Jane Hunt received her B.F.A. from the Cleveland Institute of Art in 1993. She continued her art education by experiencing art communities in France, England, Indonesia, and China while studying various painting techniques. It was during these travels that she discovered her love of the more textural style of painting she works in today.

Originally experimenting with texture as both a challenge and as a means to minimize detail in her paintings, these "two dimensional sculptures" soon became Jane's signature style. The texture, composition and unexpected color all work together in these evocative landscapes and seem to speak of simpler times.

A unique layering process is used to create highly textured paintings with an organic feel. Jane builds layer after layer of texture and acrylic color on a cradled surface, giving the finished product a great deal of depth.

Recently Jane has returned to oil painting and is enjoying finding ways to create texture within this medium.

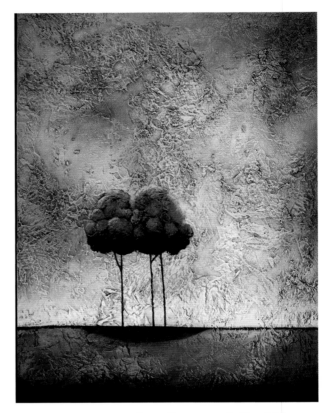

Trees 3, 2009, textured acrylic on panel, 40 x 30 in.
Photography by Ken Sanville

Clusters, 2009, textured acrylic on panel, 24 X 48 in.
Photography by Ken Sanville

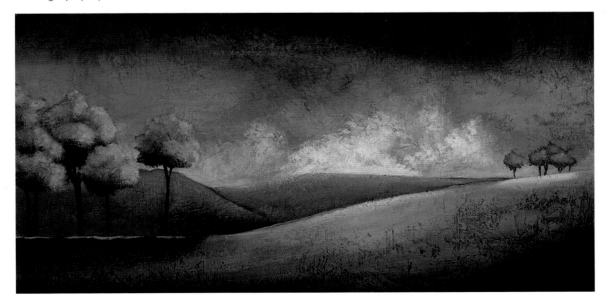

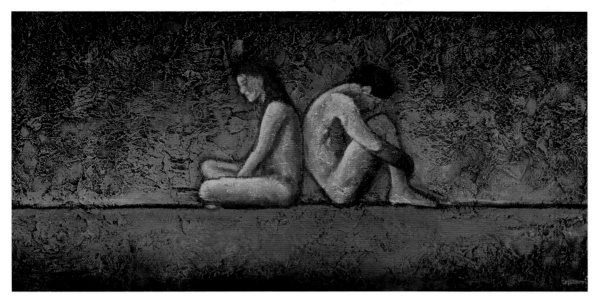

Back up, 2009, textured acrylic on panel, 24 X 48 in. Photography by Ken Sanville

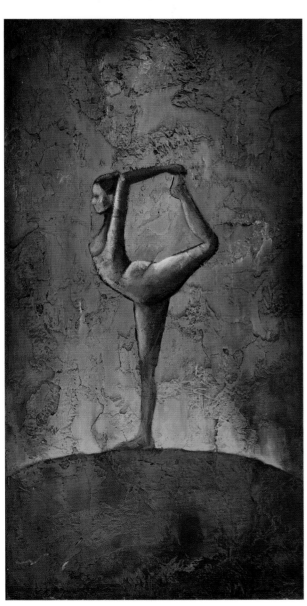

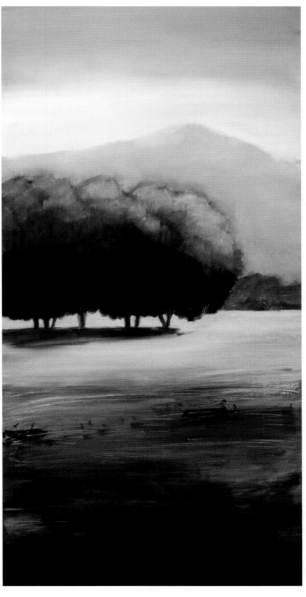

Stretch, 2008, textured acrylic on panel, 48 X 24 in. Photography by Ken Sanville

Serenity, 2010, oil on panel, 24 x 12 in. Photography by Jane Hunt

Birgit Hüttemann-Holz

Grosse Pointe Park, Michigan, USA
www.brightstroke.com

In the studio of her uncle Werner Holz, an outstanding German artist, Birgit Hüttemann-Holz was exposed to Imaginary Realism/*Phantastische Malerei* from early age on. Intrigued by the contradictions of the human psyche she first started to write poetry. While working as a physical therapist, she went to study literature, philosophy, education and media science at the Philipps-University, Marburg, Germany. A sudden change of her life, the move to the USA, triggered a stop to her writings, and a universal language was needed, taking visual form. Birgit Hüttemann-Holz's work is exhibited nationwide and internationally, she lives and works as an artist in the greater Detroit Area.

Wax protects, wax conserves, wax seals everything that is precious to me and adds light to it. I paint from memories, burned-in images that are surfacing right before I fall asleep, in my dreams, or while I wait to finally get to work (daily trance). If every artist visits his or her places of childhood, then you may say I am very influenced by my European roots. I paint both landscapes and inscapes. Although separate topics, the subjects have a relationship in tone and emotion, both are holding nostalgia, mournful tunes, and lyrics. They are sentiments. The inscapes are figurative and act as more narrative translations, while the landscapes tend toward the abstract, acting more as a sanctuary, a retreat. I paint with hot liquid beeswax, pigments, and fire. The beauty of an encaustic paintings lies in its uniquely transparent layers building luminous and lush colors that are sealed in a jade-like surface.

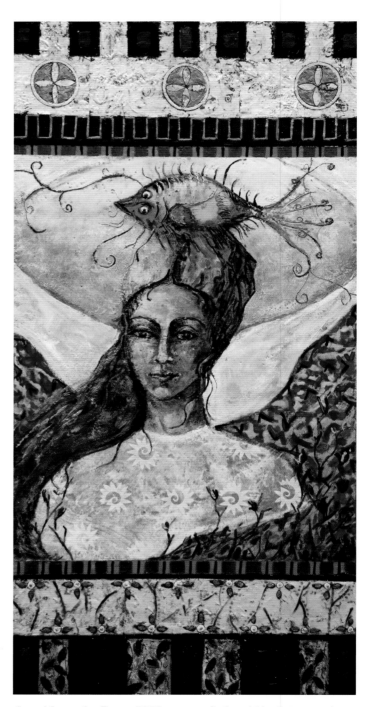

Angel from the Stars, 2010, encaustic & gold leaf on wooden panel, 48 x 24 in. Photography by Birgit Huttemann-Holz

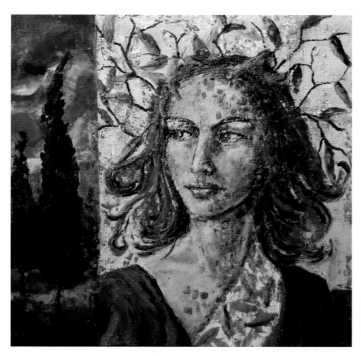

Daphne, 2010, encaustic & gold leaf on wooden panel, 18 x18 in. Photography by Birgit Huttemann-Holz

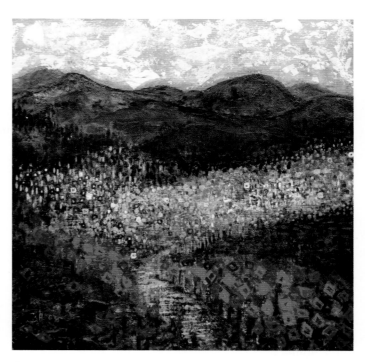

Epiphany, 2009, encaustic & gold leaf on wooden panel, 31.5 x 31.5 in. Photography by Birgit Huttemann-Holz

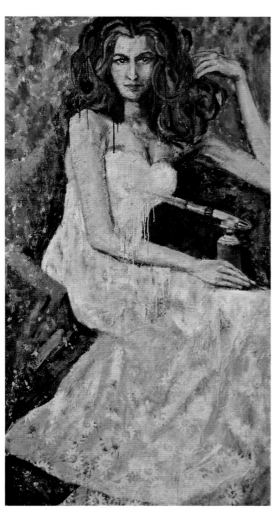

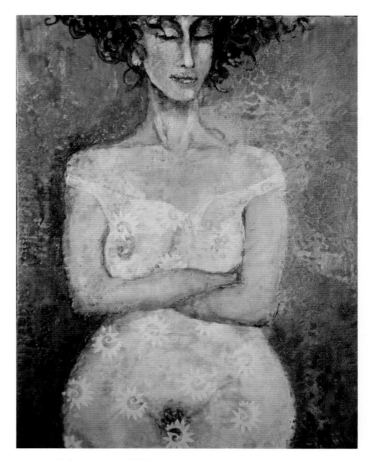

Asteria's Sanctuary, 2010, encaustic on wooden panel, 31 x 24 in. Photography by Birgit Huttemann-Holz

To Burn In- encaustic, 2010, encaustic on wooden panel, 59 x 31.5 in. Photography by Birgit Huttemann-Holz

Martha Iwaski

Santa Fe, New Mexico, USA
www.iwaskicontemporaryart.com

In my art, I am interested in portraying the controversial, the mystery, the joy, the wonder and the spiritual process of life and how we interact with ourselves, each other, the earth and the greater universe. In creating my art I draw on my many life experiences as a director of the Institute of American Indian Arts, and my study of Jungian psychology in Switzerland, of Shamanism in the Amazon, of oriental philosophy and Tibetan Buddhist philosophy. I am interested in so called primitive forms of art because of the ambiguity, the distortion, the dislocation of form — this correlates with modern art. Connection is a classical concept: things go together. Dislocation is a modern one: you try to upset the human experience. I am originally from Santa Fe, New Mexico, and I grew up in northern New Mexico where I still live. My father was an archeologist and I spent many hours as child exploring the Indian ruins around Santa Fe. When I was four years old my father took me study painting with Popovida. Popovida was the son of famed Native American potter Maria Martinez of San Ildefonso Pueblo. Thus my painting career began.

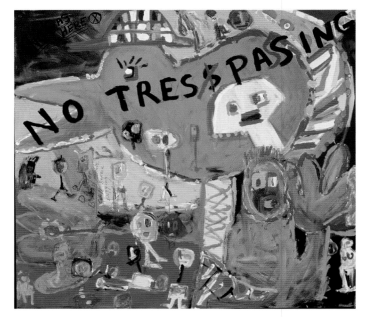

Hero's Journey Jack in the Beanstalk Big Bird in JuJu Land, 2007, acrylic and mixed media on canvas, 72 x72 in. Photography by Eric Swanson

I chose to do images from fairy tales because they are stories from the collective unconscious. A story that has a thread of commonality for all people of all races, fairy tales often appear in the psyche as dreams at important times of transformation, hild to adolescent, adolescent to adult, and adult to elder. They also appear in dreams when life has dried up. When the job is numbing or the marriage doesn't work, the unconscious begins to release images of a psychological death and rebirth. The imaginative stories from the collective unconscious present wonderful images for the visual artist.

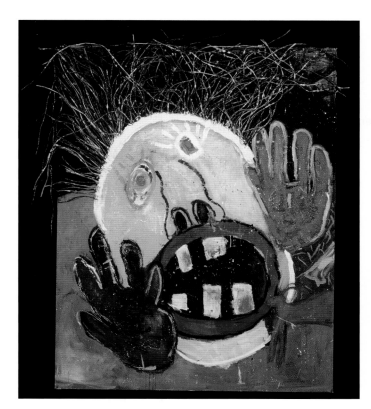

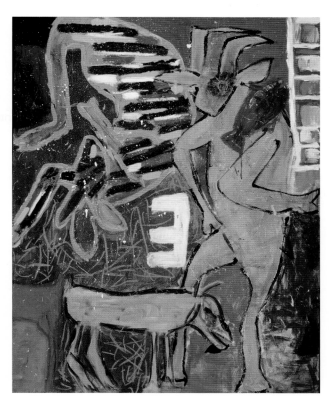

Hero's Journey Billy Goat Gruff Que Cabron, 2007, mixed media
on linen, 72 x 144 in., diptych. Photography by Eric Swanson

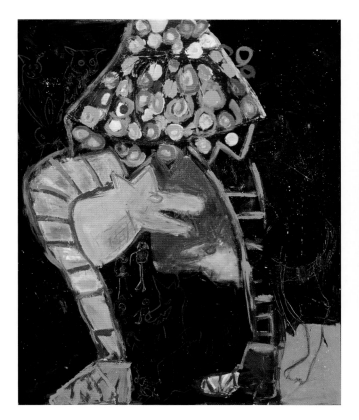

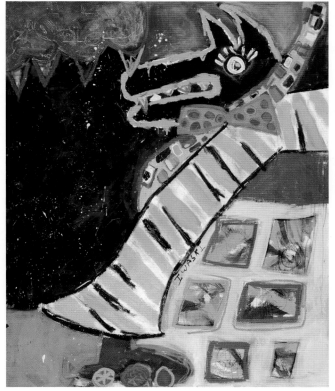

*Hero's Journey Red Ridinghood Red Red Ridinghood Told the Truth Clarence T. Wolf is Out and
About*, 2007, mixed media on linen, 84 x 144 in., diptych. Photography by Eric Swanson (left panel)

Clara Johanssen

London, UK
www.clarajohanssen.com

Clara Johanssen was born in Leicester, England, in 1976. She studied English and Renaissance Studies at Sussex University before starting a career in books, working first in academic publishing and then in children's books. She began to paint in early 2006, following a six-month trip to Latin America, during which she visited Mexico, Guatemala, Nicaragua, and Brazil. On her return to the UK she bought some acrylic paints and canvas and began to experiment at home. Her first paintings tried to celebrate the colorful sights and landscapes of the countries she had visited, taking inspiration from regional folk art and local artists whom she had met on her travels. Since then she has developed her own distinctive style, broadening her subject matter to include motifs and themes inspired by cultures right across the globe. Clara currently combines painting with copywriting for a major children's publisher, and lives in the East End of London. She is a member of the Association of British Naïve Artists and has exhibited across the UK.

Clara's work to date is primarily naïve in style, featuring vibrantly colorful landscapes brought to life by a multitude of playful details. Her main artistic objective is simply to cheer people up, and she likes to celebrate the joy and novelty hidden within the little rituals of everyday life — work, play, festivals, travel, leisure, family life and so on. Her naïve art celebrates a childlike view of the world, and is often blended with fantasy. It tries to capture the innocence of things seen in the ideal, with freedom from the formal rules of logic and perspective. Although her paintings span different times and cultures and show specific, detailed scenes, the kinds of activities shown speak to universal hopes and memories, hinting at a common human heritage which unites us all. In addition to her naïve work, Clara also produces occasional abstract pieces: very simple shapes and landscapes that she describes as "cosmic" paintings, which attempt to capture some of nature's essential forms. Although at first glance her style may appear unschooled, each painting is created with painstaking care and may take many months to complete, with an emphasis on detail, and a richness of color built up during several layers of overpainting.

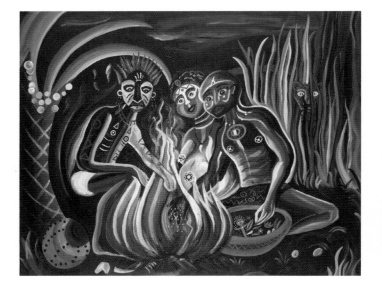

Midnight Ceremony, 2009, acrylic on canvas, 24 x 30 in.
Photography by Clara Johanssen

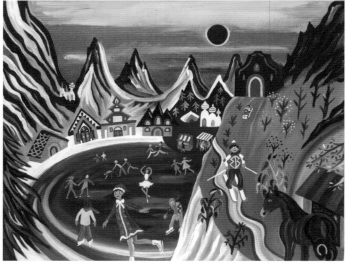

Snowy Games, 2009, acrylic on canvas, 16 x 20 in.
Photography by Clara Johanssen

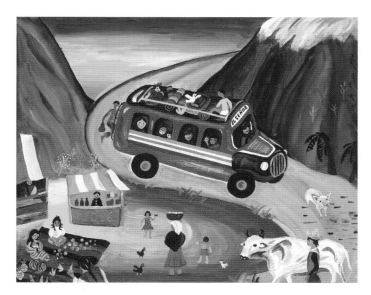

Vamos al Mercado, 2006, acrylic on canvas, 16 x 20 in.
Photography by Clara Johanssen

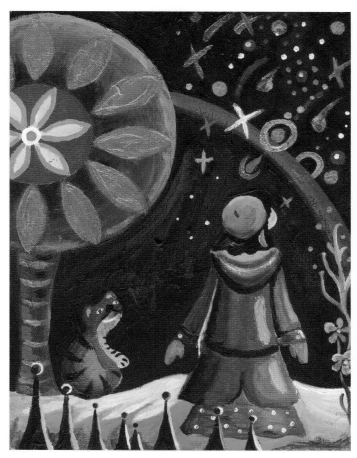

Wonderland, 2007, acrylic on wood board, 8 x 6 in.
Photography by Clara Johanssen

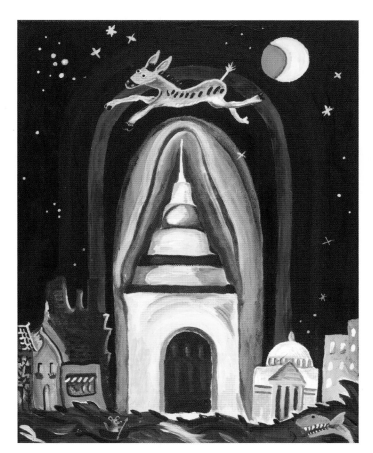

Yee-hah! 2006, acrylic on canvas, 18 x 14 in.
Photography by Clara Johanssen

Once Upon a Story, 2011, acrylic on canvas, Commissioned by
Scholastic UK, 48 x 36 in. Photography by Clara Johanssen

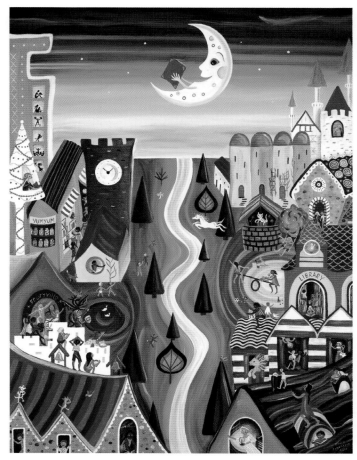

Andrew Johns

New York, New York, USA
www.vampingoartproductions.com

Andrew Johns has designed and built sets for Off-Broadway, stock, etc, made masks for programs at Yale and Vassar as well as several private collections.

I've made about 2,000 small sculptures, which along with my paintings have been in galleries, theatres and boutiques. My work, like life, is improvisational.

I am a playwright (produced & published) and an actor (Broadway, Off-Broadway & Regional) who began painting and sculpting when my other muses left me adrift from time to time. I have a good sense of humor, which I think is evident in a lot of my stuff. I have no scholastic background, but for acting I've not studied any of the arts other than on my own. Someone once told me the people in my paintings and sculptures are caricatures of archetypes; I can see what she meant, but I really just do what I do because it makes me feel good.

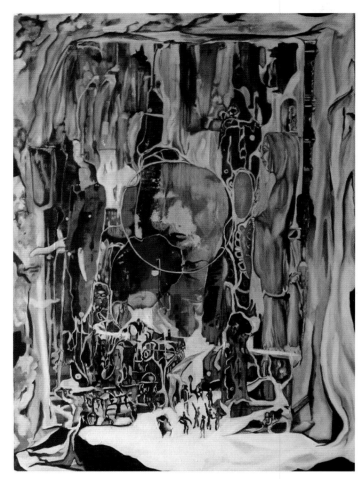

Alice Is At The Glass Again, 2007, acrylic on canvas, 42 x 30 in., Photograph by Ariana Johns

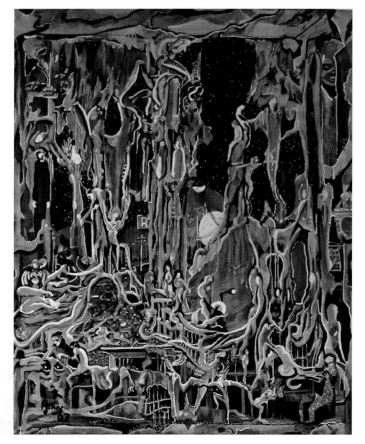

The Place Characters From Unproduced Plays Go To Await Birth Or Occification, 2007, acrylic on canvas, 26 x 20 in., Photograph by Ariana Johns

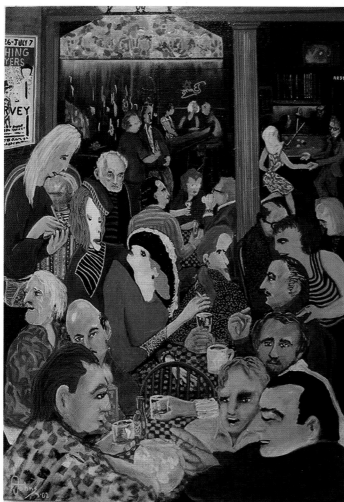

The Place Actors Go After The Show, 2008, oil and acrylic on canvas, 36 x 24 in., Photograph by Ariana Johns

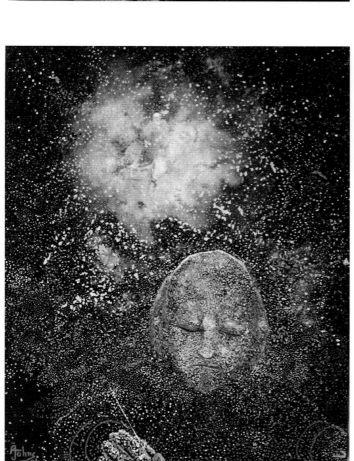

Alternating Muses, 2007, acrylic on canvas, 48 x 30 in., Photograph by Ariana Johns

Will At Work, 2010, oil and acrylic on canvas, 30 x 24 in., Photograph by Ariana Johns

Rob Johns

Everett, Washington, USA
www.robjohnsart.com

A lifetime resident of the Pacific Northwest, I've had art in my life throughout my early schooling. I started painting seriously over 10 years ago, which prompted me to educate myself, acquiring associate degrees in studio arts and graphic arts. I feel I've only begun to tap into spontaneous, collection of colors and shapes that make up my work.

My art ended up in the abstract mainly because there are no rules. I use contrasting colors and various geometric shapes, connecting and overlapping them. My work includes drips, veins, cracks, and various stages of destruction. This sometimes includes a hidden, symbolic meaning, known only by me.

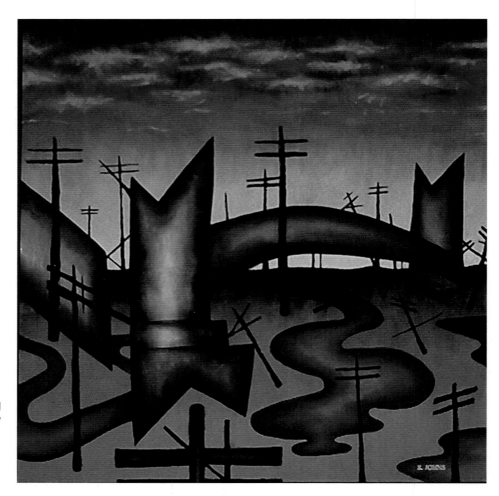

Bridge Over the River Why, 2004, oil on canvas, 24 x 24 in. Photography by Rob Johns

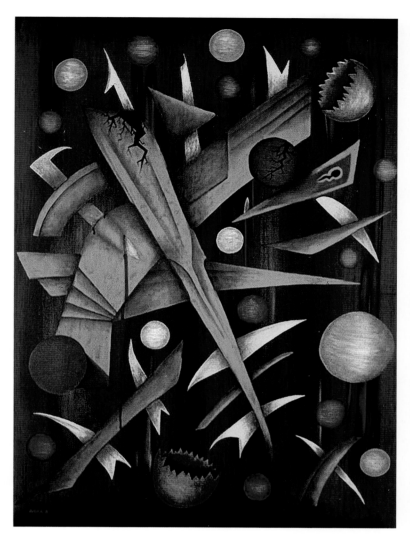

Involuntary Measurement, 1999, oil on canvas, 40 x 30 in. Photography by Rob Johns

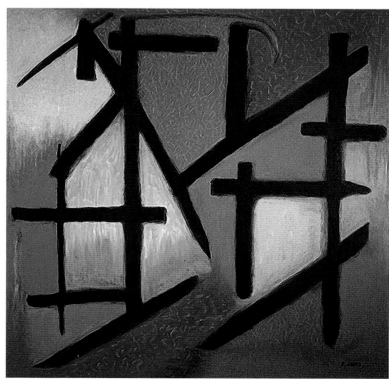

Ode to Bill, 2003, oil on canvas, 36 x 36 in. Photography by Rob Johns

Janne Kearney

Victoria, Australia
www.jannekearney.com

Janne Kearney, born in Geelong, Australia, in 1962, currently resides in Victoria, producing and teaching art from her Geelong West studio. She describes herself as a "painter of stories, people and life."

Predominately a figurative and portrait artist, she is best known for her series of paintings of tattooed people and, at opposite ends of society, a series of senior citizens. Her paintings ask the viewer to disregard preconceptions of people, society, and, at times, reality. Each painting invites you to contemplate, reflect, and reminisce; they are profound, evocative and sometimes humorous.

The works are full of texture and color created in a contemporary realist manner and could be described as iconoclastic. They challenge or overturn traditional beliefs, customs, and values, consciously utilizing both traditional and innovative techniques. Her work explores retro and neo kustome culture.

Preferring to work in oil on canvas applied by brush, palette knife and homemade tools, she experiments with gold, silver, and metallic leaf and a range of metallic paints often feature in her work.

My childhood was interrupted. At the age of 9 my mother died on Christmas eve, leaving me and 4 older siblings. We were from a low socio-economic neighborhood and we had very little. Even though my mother was gone, her love was eternal. She always encouraged me to draw and paint.

I have very few memories or images of my mother. I cannot remember her voice, her touch, or her smell, and have only rippled transparent images of her in my mind. However I do remember her Christmas gift of a paint-by-numbers kit. I find remembering rather a painful thing, but I pay homage to her through my art.

Not unlike my childhood, my adult life was often interrupted along the way, with painting being my only constant and comfort. My life seems at times full of irony and that is often evident in my work, reflecting the importance I place on love and humor.

I work from a converted stable in my Geelong West home, where I also hold private tuition in painting and life drawing.

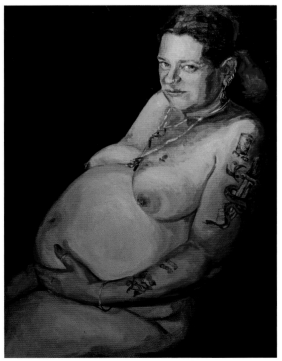

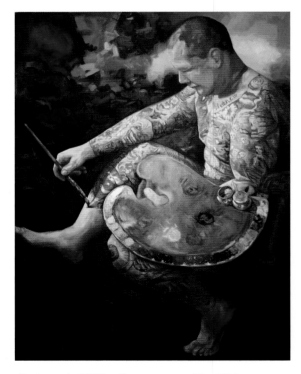

Bodywork, 2010, oil on canvas, 48 x 36 in.
Photography by Janne Kearney

I Am Woman, 2010, oil on canvas, 40 x 30 in.
Photography by Janne Kearney

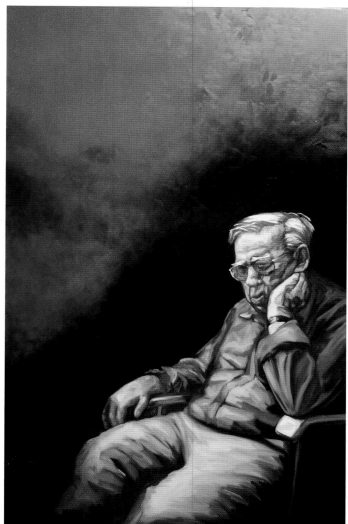

Only the Lonely, 2010, oil on canvas, 40 x 20 in.
Photography by Janne Kearney

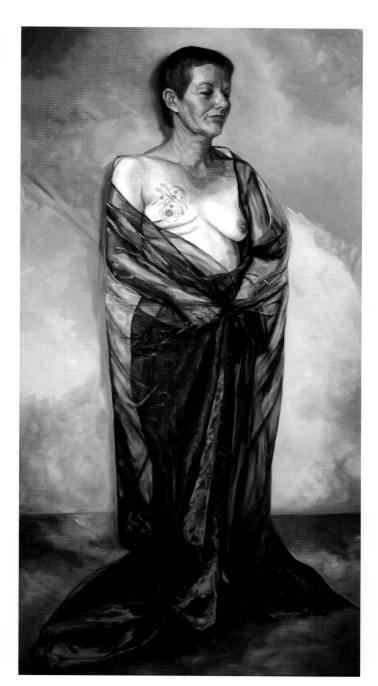

Strength Hope and Beauty, 2010, oil on canvas, 60 x 39 in.
Photography by Janne Kearney

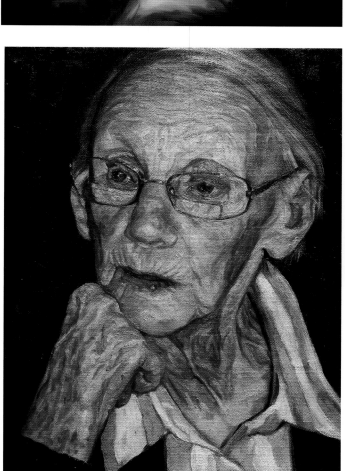

Reflection, 2010, oil on canvas, 10 x 12 in.
Photography by Janne Kearney

Merle Keller

Portland, Oregon, USA
www.merlekellerpaintings.com

The main interest in my work is depicting people, and mostly when they are engaged in their everyday lives. I love trying to capture the energy, motion, and emotion of the people I observe around me as I go through my day. I do a lot of outdoor painting and painting from models, but I rely on photos to catch the quick "slice of life" scenes that I enjoy so much. Portraiture is particularly engaging. In rendering the face, it is possible to realize the emotional essence of a person. These paintings were done from what I saw around me while I was in visiting in New York and living in Los Angeles. I hope that you enjoy looking at them as much as I did painting them.

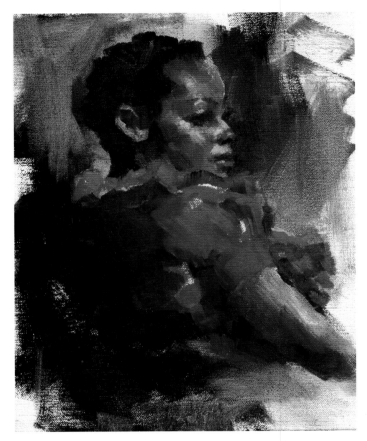

Woman in Red, 2008, oil on canvas, 8 x 10 in.
Photography by Merle Keller

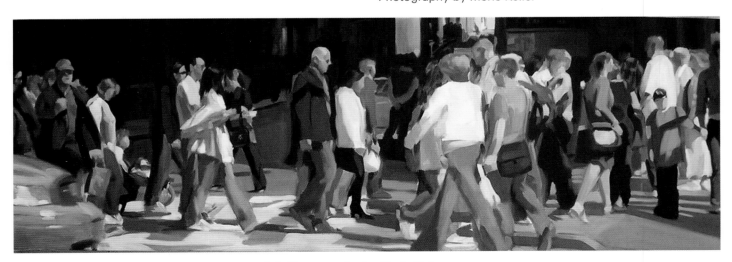

New York Crosswalk, 2007, oil on canvas, 5 x 3 ft. Photography by Merle Keller

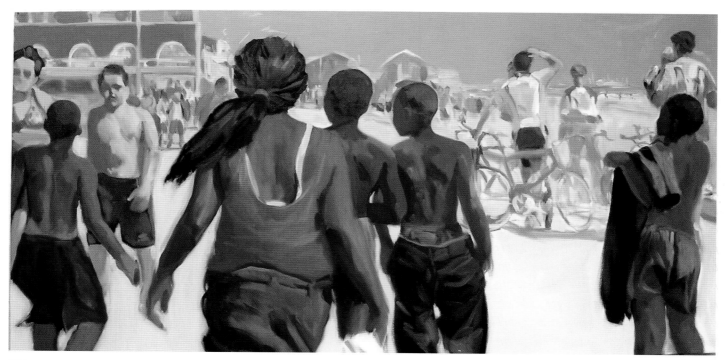

Kids on the Beach, 2006, oil on canvas, 5 x 3 ft. Photography by Merle Keller

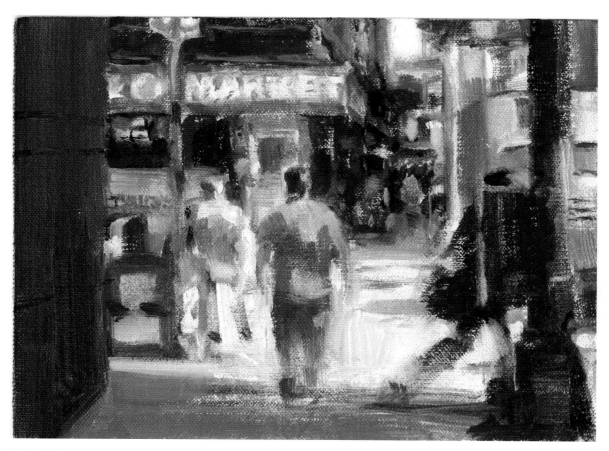

West Village, 2008, oil on canvas, 8 x 6 in. Photography by Merle Keller

Janine Kilty

Chatham, Massachusetts, USA
www.janinekilty.com

Janine Kilty is a Cape Cod representational painter working primarily in oil. Although steeped in "arts" training by way of piano and ballet lessons in her early life, Janine did not discover her talent for painting until her thirties, when her husband, Kurt, prodded her into taking her first life drawing class. She continued her art studies in workshops and at the Pennsylvania Academy of Fine Art, and within a few years she had no doubt that oil was the medium for her.

Janine's studies in the atelier of Wade Schuman shaped her preference for classical (layered) painting techniques. She believes an artist needs to be able to bring to perception some aspect of a subject that changes the way we interpret the world. She strives for a narrative quality in her paintings that she hopes challenges the viewer to reflect on the mystery as well as the beauty in life. Janine's work can be seen at the Bartholomew Gallery on Main Street in Chatham, Massachusetts.

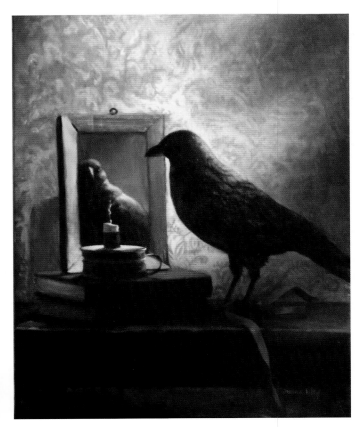

Still Life with Crow, 2009, oil on linen, 20 x 16 in. Photography by Janine Kilty

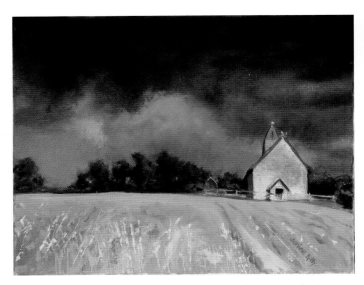

Close Upon, 2008, oil on linen, 11 x 14 in. Photography by Janine Kilty

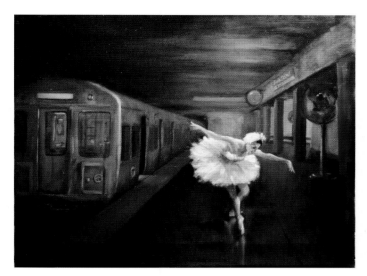

Park Street Dream, 2010, oil on linen, 14 x 18 in.
Photography by Janine Kilty

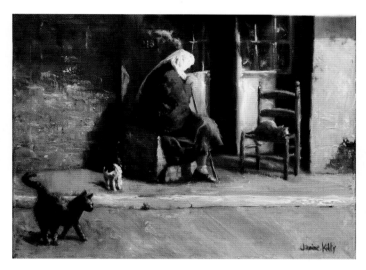

Companions, 2009, oil on linen, 20 x 24 in.
Photography by Janine Kilty

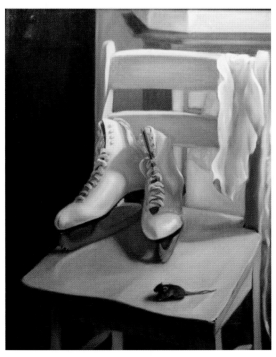

Winter Break, 1998, oil on canvas, 24 x 20 in.
Photography by Janine Kilty

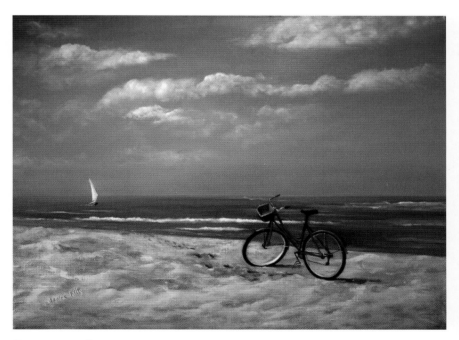

Tryst, 2010, oil on canvas, 30 x 36 in. Photography by Janine Kilty

Kathy Knaus

Denver, Colorado, USA
www.kathyknaus.com

In 2000, Kathy graduated summa cum laude with a BFA from Rocky Mountain College of Art and Design in Denver, Colorado. Kathy exhibits her work in various galleries in the Denver area. Ocean Journey commissioned her to paint a great white shark eating a whale for a large display in the aquarium (2000). She has served on both the Colorado Council on the Arts and the Arvada Center for the Arts and Humanities boards. Although born in Sidney, Nebraska, she considers Colorado her home, since moving to the Metro area when she was 8 years old.

My work explores the relationship between my father's meat market and memories distilled from the experience of working alongside family members. Working with paint is like working with meat. Paradoxically, paint and meat are wet, slimy, and soft. To me, meat appears as sensuous and as beautiful as the human figure. This complicated symmetry between the gross and the sensual is much like the awkward compatibility between beauty and horror. Our primitive brain — that ingrained survivor — sees meat as enticing and seductive, necessary to sustain life, much as the human figure's sexual attractiveness plays its part in human survival. In my paintings, I emphasize this parallel seductive attraction through my use of vivid color combination's, intensity of brushwork and pigment, and placement of shape and form.

Cooler Door #1, 2009, acrylic on canvas, 80 x 43 in. Photography by Kathy Knaus

Cooler Door #2, 2009, acrylic on canvas, 80 x 43 in. Photography by Kathy Knaus

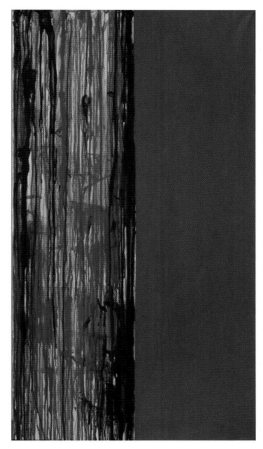

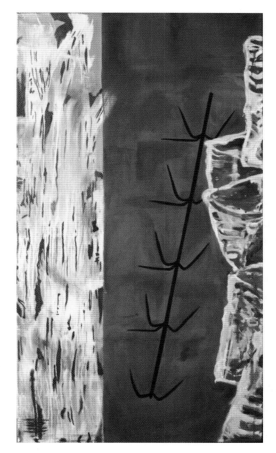

Cooler Door #3, 2009, acrylic on canvas, 80 x 43 in. Photography by Kathy Knaus

Cooler Door #4, 2009, acrylic on canvas, 80 x 43 in. Photography by Kathy Knaus

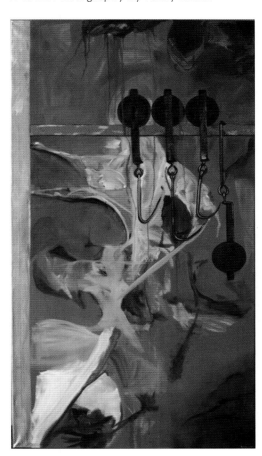

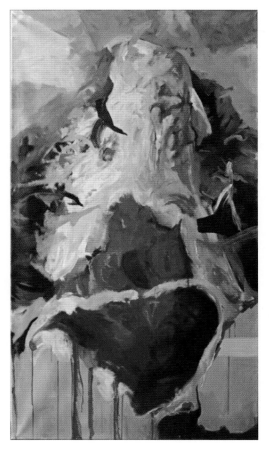

Cooler Door #5, 2009, acrylic on canvas, 80 x 43 in. Photography by Kathy Knaus

Cooler Door #6, 2009, acrylic on canvas, 80 x 43 in. Photography by Kathy Knaus

Akiane Kramarik

Post Falls, Idaho
www.artakiane.com

Considered by many as the youngest and most successful binary prodigy in both realist art and poetry, best selling author Akiane has appeared on almost fifty international television shows and documentaries. Her art exhibitions have been held in museums, galleries, embassies, universities, and corporations across the world.

Inducted into the Kids Hall Of Fame and the World Council for Gifted and Talented Children, Akiane receives almost 200 million hits a year on her internet website.

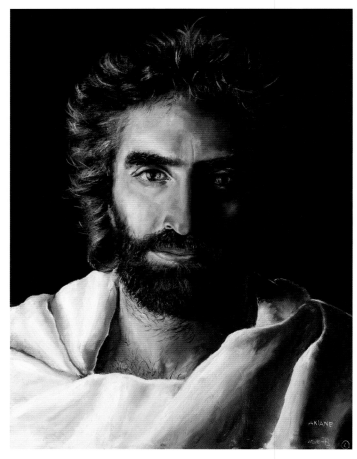

Prince of Peace, 2003, oil on canvas, 36 x 48 in., painted at age 8

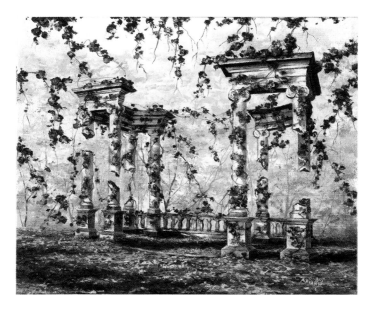

Rebirth, 2010, acrylic on canvas, 24 x 30 in., painted at age 15

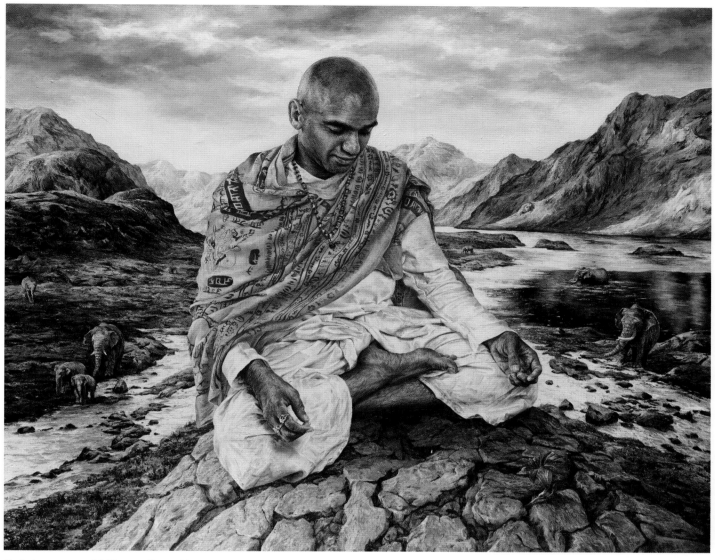

Enlightenment, 2009, acrylic on linen, 48 x 60 in., painted at age14

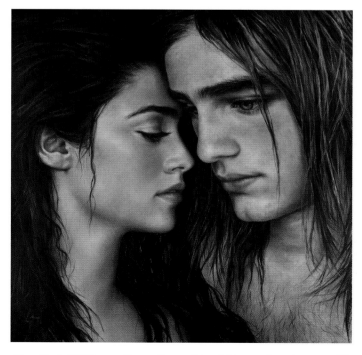

The First, 2010, acrylic on linen, 54 x 54 in., painted at age 15

133

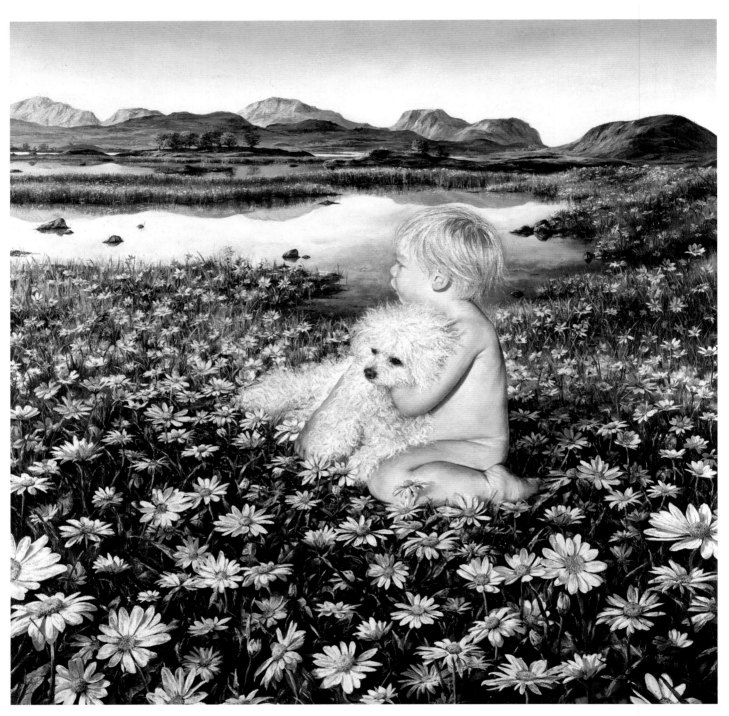

Inseparable, 2010, acrylic on linen, 48 x 48 in., painted at age 15

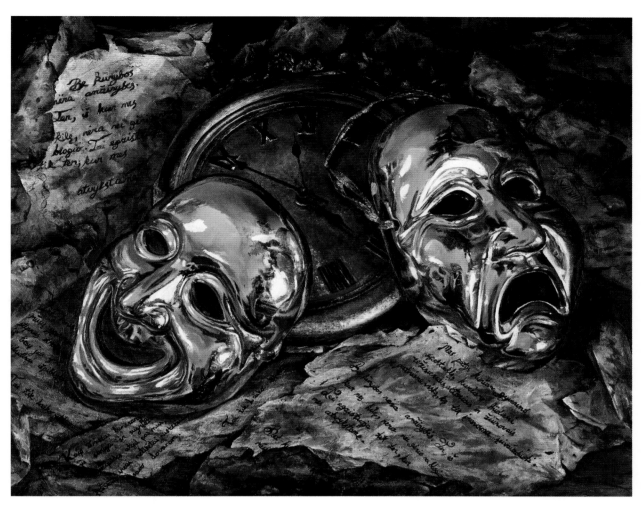

Code, 2010, acrylic on canvas, 24 x 30 in., painted at age 16

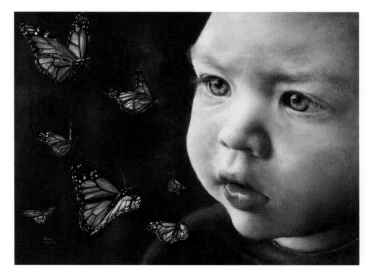

Wonder, 2008, acrylic, 30 x 40 in., painted at age 13

Ilia Kramarik

Rathdrum / Twin Lakes, Idaho, USA
www.iliapoetry.com

Considered the youngest philosopher and conceptual artistic prodigy, nine-year old Ilia Kramarik has dictated over 30 books of the most intricate literary theorems, computations, and observations since the age of 6.

Ilia has been also busy painting, selling, and auctioning his art work around the world. His abstractly painted depiction of quantum worlds is an equally complex adventure of layers of paint hiding under each form. Ilia allows nature to participate in his creation as wind, snow, rain, branches, grass, or gravity is used for the layers of worlds he sees.

The fourth of five children Ilia, is growing up in the gifted family (his sister is Akiane Kramarik) and media exposure. The nine-year-old artist is sometimes called, simply, the boy who hears and paints the footsteps of the future.

Growing as an artist, Ilia has developed an innovative technique. Using a mysterious flow and affect of forms. Ilia's love affair with art is as puzzling as ever. He might splatter half of the pole-barn with paint, spend a $500 a day on his artistic experimentation, a half a year to reworking his creation, another half a year discussing it and exhibiting it in public. Then, if any texture, smell, or viscosity of the paints is not to his liking, he will move mountains to get a new batch of paints and paint it all over again and again. Ilia is a perfectionist to the extreme, and will discard or redo his work until completely pleased.

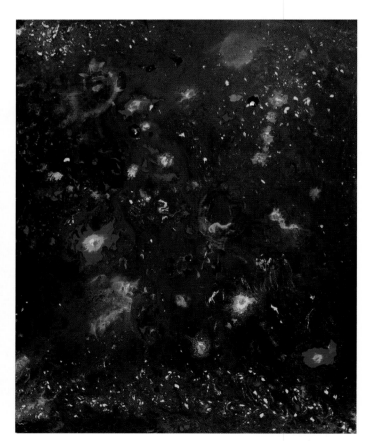

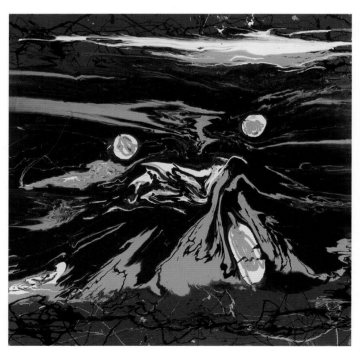

Immortality, 2008, acrylic, 54 x 54 in., painted at age 7

Galaxy, 2009, acrylic, 24 x 40 in., painted at age 8

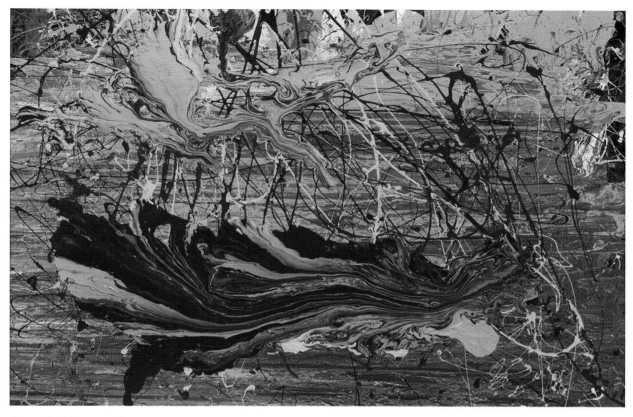

Phoenix, 2008, acrylic, 48 x 60 in., painted at age 7

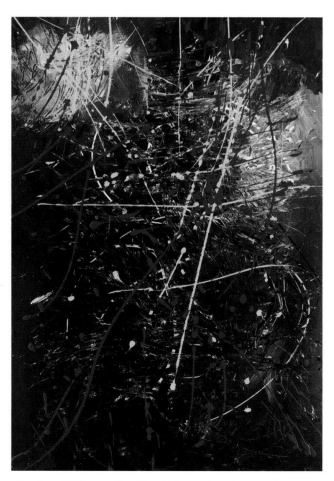

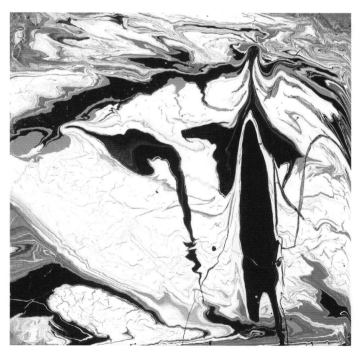

The Angel, 2008, 30 x 30 in., painted at age 7

Illusion, 2008, acrylic, 48 x 40 in., painted at age 7

Craig LaRotonda

Buffalo, New York, USA
www.revelationart.net

Craig LaRotonda works out of his Revelation Studios and his artwork graces the walls of famous homes, including collectors in France, Germany, Norway, Mexico, Canada, and the United States. Through his relationship with Film Art LA, his distinctive art appears prominently in five feature-length motion pictures — including the Academy Award winning film "Traffic" directed by Steven Soderbergh and the 2010 release "The Other Guys" staring Will Ferrell and Mark Wahlberg. His striking and unique illustrations have been featured in *Time* magazine, *The Washington Post*, *The Village Voice*, *The Progressive*, *The New York Times* and numerous other publications. His work has received awards from the Society of Illustrators in New York and Los Angeles, *Communication Arts and Print* magazine. Exhibitions include solo shows in San Francisco, Los Angeles, New York, and Paris.

Craig LaRotonda's provocative and richly layered paintings incorporate mixed media and aging techniques, ultimately creating surreal figurative works with a dark narrative and a grotesque elegance. His distorted creatures are subjects captured in a timeless space, surviving the brutality and beauty of existence.

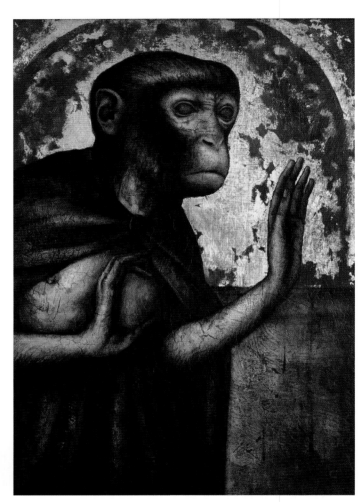

Divinatio, 2011, acrylic gold leaf, and wax on wood, 14 x 20 in. Photography by Craig LaRotonda

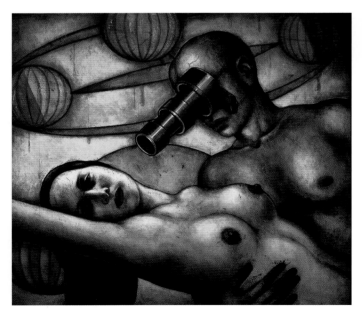

Confuto Basium, 2010, acrylic on wood , 33 x 28 in. Photography by Craig LaRotonda

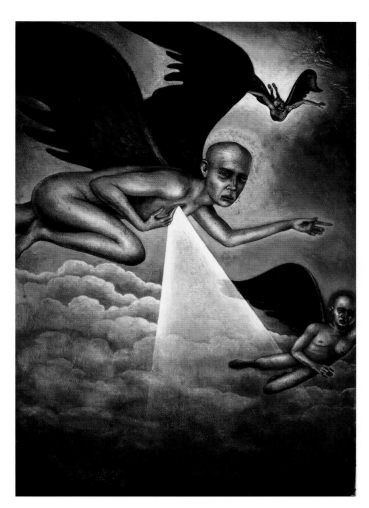

From the Ashes of Angels, 2010, acrylic on wood, 15 x 22 in. Photography by Craig LaRotonda

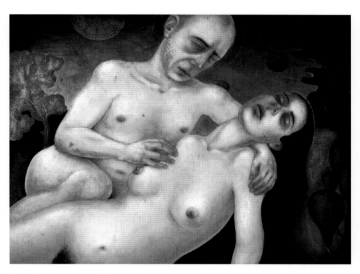

The Glooming, 2004, acrylic and paper on wood panel, 26 x 34 in. Photography by Craig LaRotonda

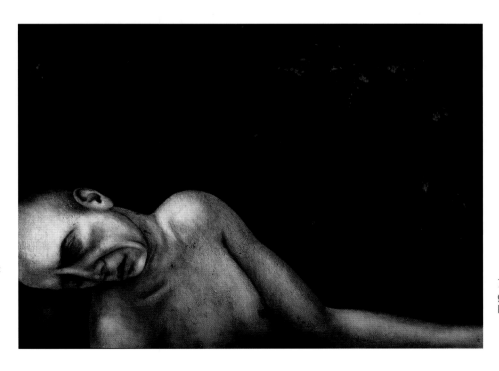

The Resolution, 2010, acrylic and gold leaf on canvas, 24 x 34 in. Photography by Craig LaRotonda

Brian LaSaga

St.George's, Newfoundland, Canada
www.brianlasagarealism.com

Brian LaSaga was born in St.Teresa's, Newfoundland, in 1955, moving to St. George's in 1965. His journey as an artist began when he was very young. Always been a very visual person and with no formal training, his art is instinctual, full of discovery and experimentation. Being somewhat of a perfectionist, Brian has always remained faithful to his subjects, realism, and his imagery. He also believes that it's not the necessarily the medium, but how one manipulates and uses it that matters in the end. Brian prefers to paint familiar experiences and subjects indigenous to his area. Over the years, many have labeled him a wildlife artist or a photo realist. He doesn't seem to dwell on labels or titles, but simply feels he is just a painter, an instrument and student of nature.

Brian's studio is located in his hometown of St. George's, Newfoundland. The island of Newfoundland is Canada's most easterly province and offers the artist a sanctuary for his work. It has rugged coastlines, rivers, forests, wildlife, ponds, and marshes. It has also been the inspiration for Brian's work for over 30 years.

Although he has experimented with watercolors, gouache, egg tempera, and oils, Brian has been using acrylics since 1980. He considers them to be a very versatile and durable medium, and suited his style and technique. Brian paints primarily on masonite panel and prefers acrylics because they dry faster. This allows him to layer rather quickly. His work is greatly influenced by nature, and loves to paint weathered, rustic textures.

Brian's subjects often include rural settings, landscapes, seascapes, and sometimes he may incorporate figures or some form of wildlife into his work. The artist's main interest is in capturing the essence of the subject and breathing life into it in a way that he hopes will connect and inspire his viewers.

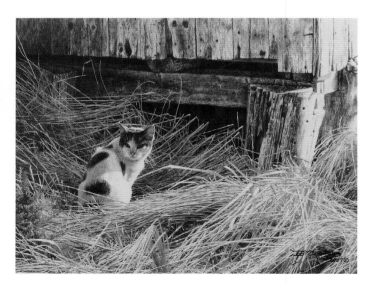

After the Blizzard, 2009, acrylic, 16 x 26 in.
Photography by Brian LaSaga

Corner Refuge, 2007, acrylic, 11 x 14 in.
Photography by Brian LaSaga

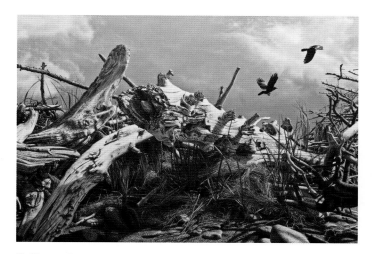

Driftwood, 2008, acrylic, 22 x 32 in.
Photography by Brian LaSaga

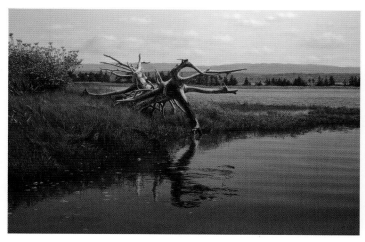

On the Salt Marsh, 2010, acrylic, 32 x 48 in.
Photography by Brian LaSaga

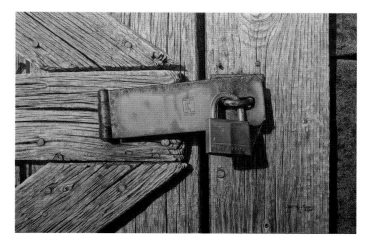

The Barn Door, 2009, acrylic, 16 x 24 in.
Photography by Brian LaSaga

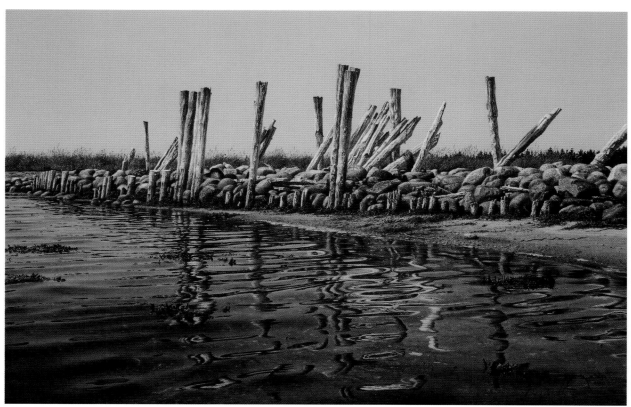

Wretched Breakwater, 2010, acrylic, 17 x 26 in. Photography by Brian LaSaga

Larry Lombardo Jr.

Lebanon, Pennsylvania, USA
www.larrylombardo.net

Larry Lombardo Jr., is an artist who enjoys experiencing life to the fullest and prominently displays that zest for life in each piece of art he creates. Larry credits his parents for installing a strong sense of values in him.

His parents taught him his life has meaning in this world. He shares that same virtue with everyone he meets with his positive outlook on life and the continual praise he gives others. Larry loves to challenge himself continually. He does this not only through his art but also by building custom motorcycles and cars, making videos with powerful messages, and remodeling homes. He loves tackling anything that keeps his brain in problem solving mode. With the strong upbringing from his parents, the love and support of his wife Jen, and his deeply held belief in God, Larry feels each day is an opportunity to make a difference in this world.

Larry's paintings all tell stories of life. He enjoys documenting American culture. His time in college and his love of studying people led him into the field of counseling. He combined his passion for observing people and their various personalities and then put the heart and soul of those very people into his artwork. Working in watercolor gives him the opportunity to show everyday life in a very different and thought provoking way. His strong eye for detail adds to the powerful stories his artwork creates. He credits his parents for his positive view of life today and the impact it has made on his art.

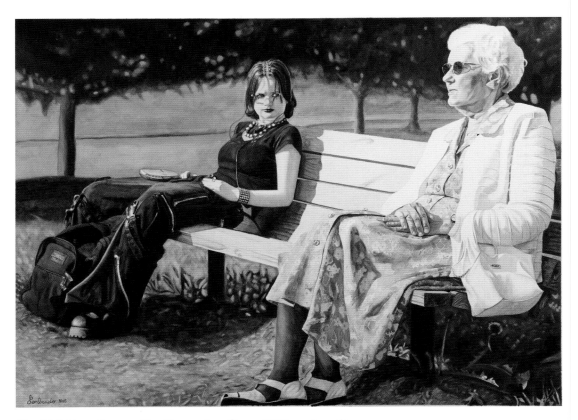

The Child has Grown, The Dream has Gone, 2004, watercolor, 32 x 40 in. Photography by Charles studio, Lancaster, PA

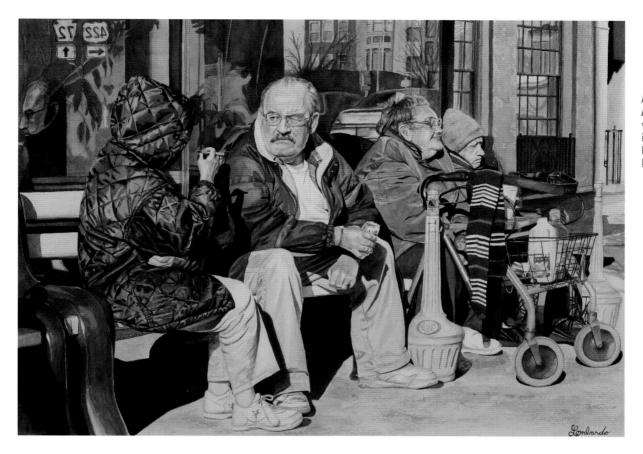

No One Sings Me Lullabies, 2001, watercolor, 23 x 27 in. Photography by Charles studio, Lancaster, PA

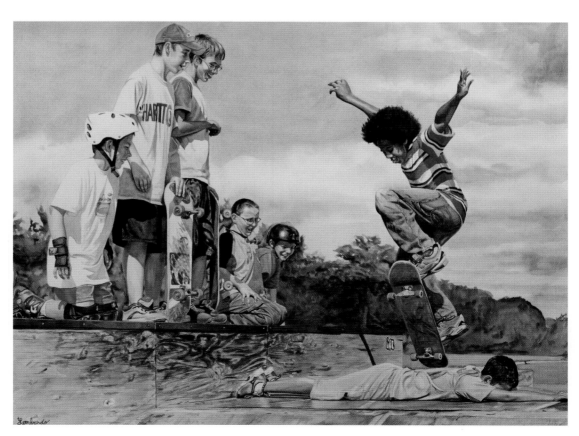

Learning to Fly, 2002, watercolor, 31 x 37 in. Photography by Charles studio, Lancaster, PA

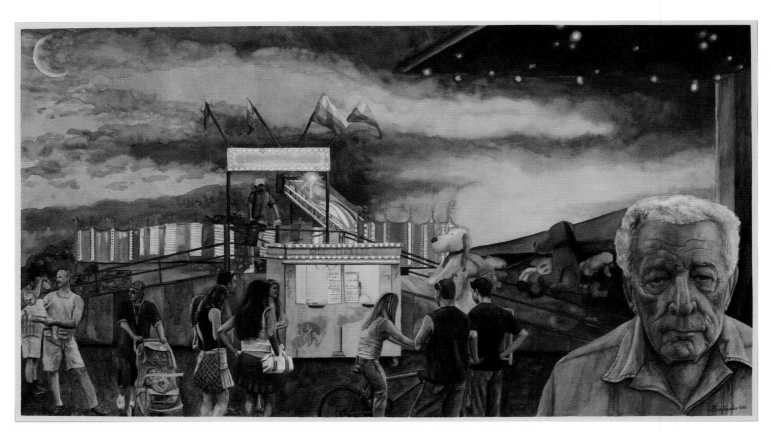

In the End It's All Round and Round, 2008, watercolor, 17 x 31 in.
Photography by Charles studio, Lancaster, PA

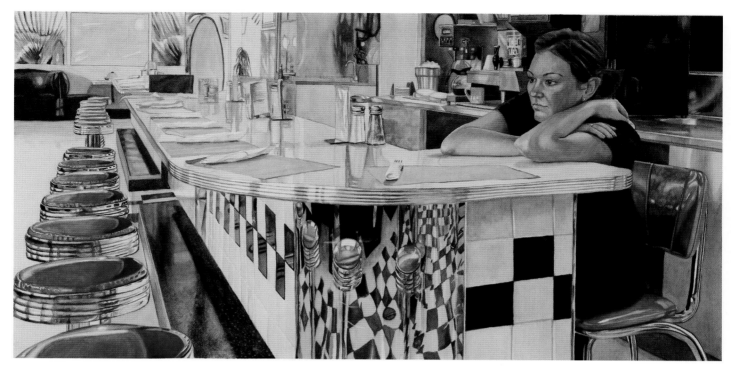

One of these Days, 2008, watercolor, 17 x 32 in. Photography by Charles studio, Lancaster, PA

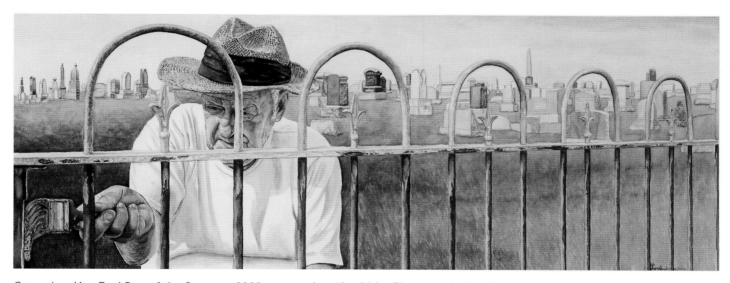

Sometime You Feel Part of the Scenery, 2008, watercolor, 12 x 20 in. Photography by Charles studio, Lancaster, PA

Johan Lowie

Frederick, Maryland, USA
www.johan-lowie.com

I am originally from the Flanders region of Belgium, a region known both for it's appreciation of art and the devastation it endured in World War I, factors that would play a influence on my work. Another ingredient was the frequent visits with my father to a number of artists of the COBRA group. Although strongly influenced by abstract expressionism I decided to follow classical art training, copying the techniques of the Old Masters. I received a MFA from the Academy of Ghent.

Coming from a mix of abstract and classical art, both influences are clearly visible in my paintings. The paintings focus on the human drama, capturing stories and emotions in one image. It is a private view of emotions. The tale of sorrow, happiness or euphoria. The theatre of life in a light of color and composition. The mood or experience overrules the technique. The focus is to relay the feeling with a simple composition rather than the obvious, sometimes lessening the figurative tales to more abstract forms, as long as the sensation reflects the original idea.

The themes are sometimes personal observations or narrations, observations of people in different situations, different angles but in the same close proximity of each other. Dichotomy, contrast between two things that are represented as being opposed or entirely different. Sometimes they reflects the mood of the moment.

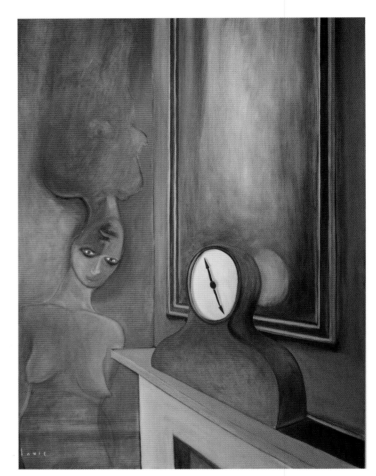

Eternal, 2010, oil on panel, 32 x 44 in.
Photography by Johan Lowie

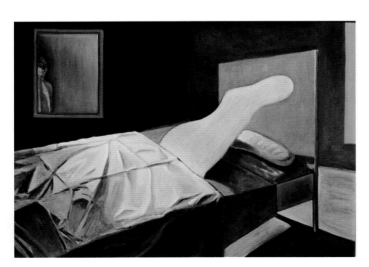

In the Room, 2008, oil on panel 20 x 30 in.
Photography by Johan Lowie

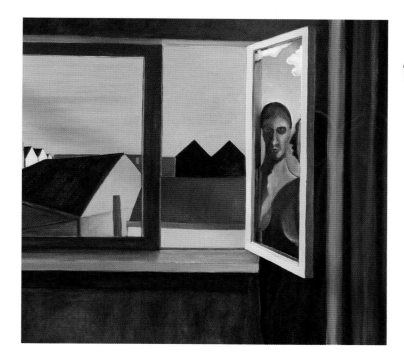

Listener, 2007, oil on panel, 27 x 36 in.
Photography by Johan Lowie

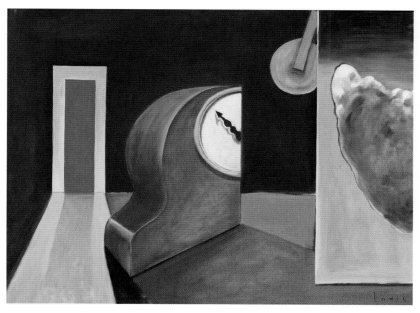

Memories of Sleep, 2010, oil on panel, 24 x 32 in.
Photography by Johan Lowie

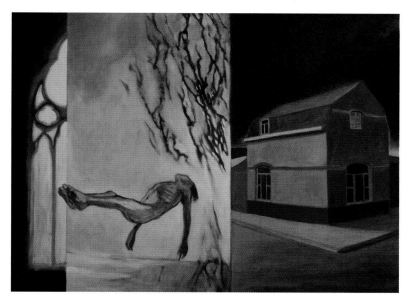

The Tides, 2008 oil on panel 24 x 32 in.
Photography by Johan Lowie

Michael Mararian

Buffalo, New York
www.michaelmararian.com

Rendering traditionally cheerful images and concepts into frightening, yet humorous, tableaus, Michael Mararian often focuses on children as the last bastion of innocence to explore the dark humor behind social and psychological issues. What can on one level be construed as melancholic and cruel, can alternately be viewed as amusing, even charming. He enjoys letting his viewers decide.

He is a graduate of the Art and Theater program at the University of Bridgeport and studied briefly at the Arts Student's League in New York City. His work has been previously shown at Corey Helford Gallery and Thinkspace Gallery in Los Angeles, the Galerie D'Art Yves Laroche in Montreal, the McCaig-Welles Gallery in New York City, and the Antonia Fraunberg Gallery in Dusseldorf, Germany.

Originally from Andover, Massachusetts, Michael currently lives and works from his studios in Brooklyn and Buffalo, New York. He attributes his inspiration to his wife Elizabeth and their (now six!) cats — 99, Mavis, Charlotte, Lola-Pumpkin, Bridgette, and Zoë.

Since the mid-1980s, my work has involved exploring elements of contradiction. I am especially fascinated by our culture's urge to seek humor in situations deemed inappropriate. In my recent work, I deconstruct the American dream touching upon such topics as gross consumerism, school violence, teenage disappointments, pressures, and the slowly growing social isolation that are part of our childhood and adult culture. The use of contradiction is an integral part of my work to magnify the absurdity of any given situation and draw a conflicting reaction from the viewer. Often times these themes are combined using real children as my inspiration from various forms of photography. I give the impression that my subjects are pasted cut-outs, hovering in their environments, skin tones rendered in grey to add to their removed, unearthly state of being. They are part of this vibrant world yet quite alone. Often I use the colors red, white and blue to further reinforce that it is without a doubt the "American" way of life we are examining.

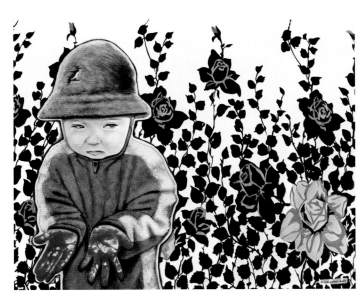

Bad Rue, 2009, acrylic on paper, 16 x 20 in.
Photography by Michael Mararian

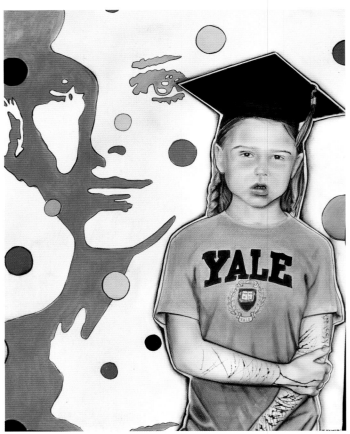

Acceptance, 2009, acrylic on paper, 16 x 20 in.
Photography by Michael Mararian

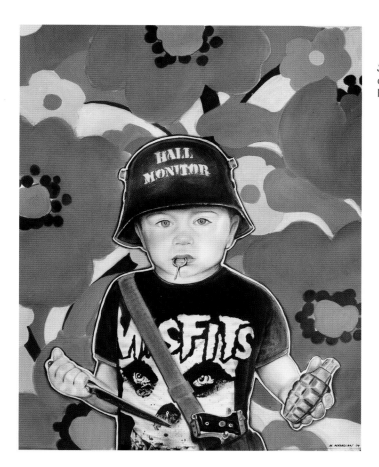

Semper Fi (Hall Monitor), 2009, acrylic on paper, 16 x 20 in. Photography by Michael Mararian

Meat is Murder, 2009, acrylic on paper, 16 x 20 in. Photography by Michael Mararian

Little Man of Steel, 2009, acrylic on paper, 60 x 44 in. Photography by Michael Mararian

Leif Mårdh

Jönköping, Sweden
www.saatchionline.com/art/view/artist/10451/art/461001

Born in 1942 in Sweden, Leif Mårdh studied house planning and design. After serving in the Swedish army, he entered the work force as an engineer and was involved with the Swedish housing program. He started to paint as a hobby in the early 1960s and studied painting in evening classes. Leif's journeys in Spain were influential in his work. His main styles are abstract expressionism and surrealism, but a number of portraits have also been put on canvas. He had various exhibitions in private galleries in the province of Västergötland from 1965 to 1975. Beginning 1975 he took a long hiatus from painting, picking up the brush again in 1999. Leif has had collective exhibitions in Hamburg, 2003, New York, 2004, and Florence, 2005, and various solo exhibitions in Sweden from 2005 to the present.

Brahehus Castle at Lake Vättern, 2010, oil on canvas, 50 x 60 cm. Photography by Leif Mårdh

Discomposed Imagination, 2009, oil on canvas, 80 x 100 cm. Photography by Leif Mårdh

Inquisition, 2009, oil on canvas, 70 x 100 cm. Photography by Leif Mårdh

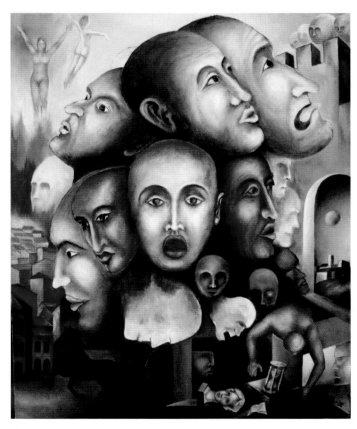

Presage, 2007, oil on canvas, 40 x 50 cm.
Photography by Leif Mårdh

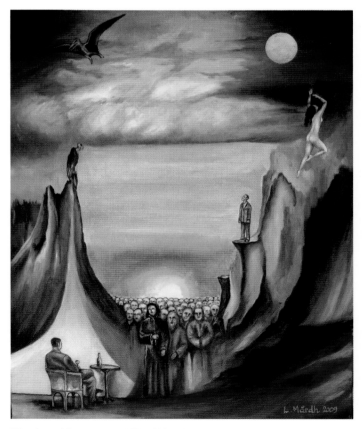

The Last Vintage and The Wanderers, 2009, oil on
canvas, 50 x 60 cm. Photography by Leif Mårdh

Ned Martin

New York, New York, USA
www.nedmartinart.com

Ned Martin is a realist oil painter who lives in New York City. He spent his early life in Maryland. and was an art major at Towson State University, exploring various painting media including acrylics, watercolor, pastels, and gouache. Several years ago, he began painting in oils and furthered his formal art training at The Schuler School of Fine Art in Baltimore, where he learned the traditional oil painting techniques and principles of Jacques Maroger and the Old Masters.

Ned has embraced the Schuler School experience and continues to meticulously prepare his own wood panels and grind his own pigments. While his paintings appear realistic, upon close scrutiny the viewer is delighted with broken impressionistic layers of paint that imply realism. Ned invests considerable time and effort in scrubbing, scratching, and scrapping layers of textured paint until a realistic form reveals itself.

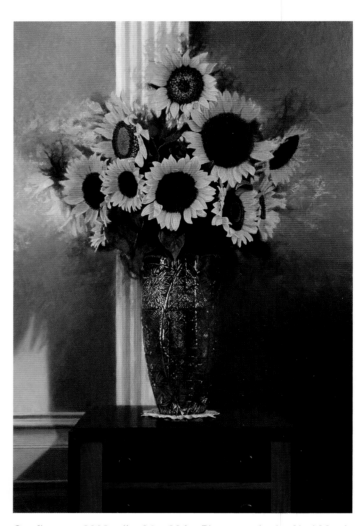

Sunflowers, 2008, oils, 24 x 36 in. Photography by Ned Martin

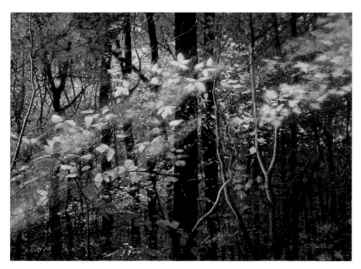

Ascending Intervals, 2009, oils, 36 x 48 in.
Photography by Ned Martin

Awaiting Spring, 2009, oils, 11 x 14 in. Photography by Ned Martin

Ball Jars, 2009, oils, 36 x 48 in. Photography by Ned Martin

Red Door, 2009, oils, 24 x 36 in. Photography by Ned Martin

Reflections, 2008, oils, 36 x 36 in. Photography by Ned Martin

Joachim Marx

New York, New York, USA
www.joachimmarx.com

In most cases I start my paintings by applying acrylic medium, gesso, and pigments in an observing, almost arbitrary manner. I work abstractly, using acrylic, oil and other materials, adding many layers until an illusion of space opens up in the surface. Into this space I place the figure. My figures are usually painted from imagination or occasionally from a drawing done from imagination. I use a lot of clear acrylic medium. The transparent and semi-transparent layers produce the perception of depth. Geometric, constructed perspectives add to this perception. On the flat surface of the canvas I want to suggest a deep but undefined space. There is an interesting tension and contradiction between the flat, textured surface and the illusion of depth. The figures are placed between these material layers and a perceived beyond.

The main theme of my painting is the human experience. My figures are thrown into the painting like humans are thrown into the world, thrown into an existence in a physical body. These figures try to comprehend their being here. They don't follow any given beliefs, but instead observe themselves and their world. All they have is the experience of being alive, the sensations of their body and mind, and their connections and attractions to other human beings.

f80, 2010, mixed media on fabric, 48 x 48 in. Photography by Joachim Marx

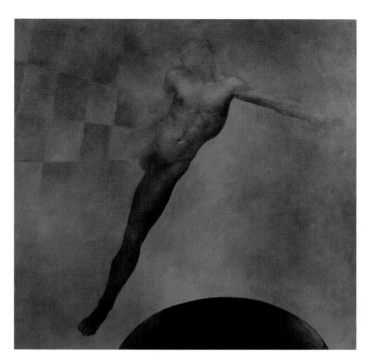

f88, 2008, mixed media on fabric, 48 x 48 in.
Photography by Joachim Marx

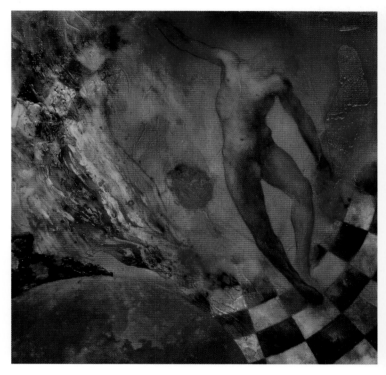

f92, 2007, mixed media on canvas, 36 x 36 in.
Photography by Joachim Marx

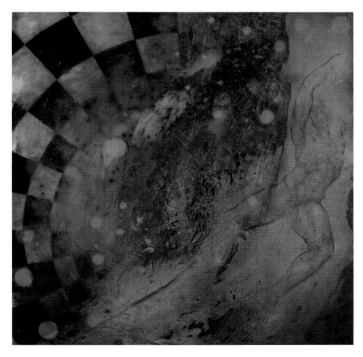

f93, 2010, mixed media on canvas, 36 x 36 in.
Photography by Joachim Marx

Joachim McMillan

Beaverton, Oregon, USA

www.mcmillangallery.com

In 2006, I moved to Oregon and resumed painting as a hobby. Soon my hobby became my passion and I began to approach galleries to show my work. Their favorable response encouraged me to focus my energy on increasing my artistic abilities while developing my own creative style. Today, I paint with a purpose of impacting the art world in a powerful way. I have developed various techniques which I use to create different effects within my paintings, such as the feeling of motion, the illusion of a multi-faceted crystalline surface, or the sense of rich texture and detailed etching. I strive to infuse each painting with a dynamic vitality that excites the viewer and draws them into the piece. I am constantly thinking about new compositions, exploring new styles and experimenting with new techniques. I am inspired by my surroundings, but more significantly by my imagination, my memories and the places I have traveled.

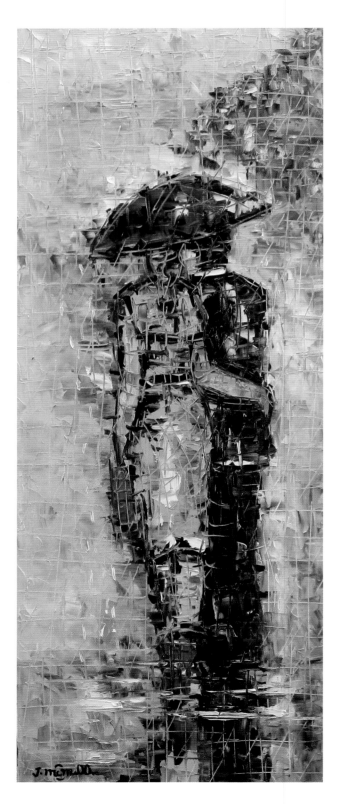

Holding On, 2010, oil, 8 x 36 in.
Photography by Joachim McMillan

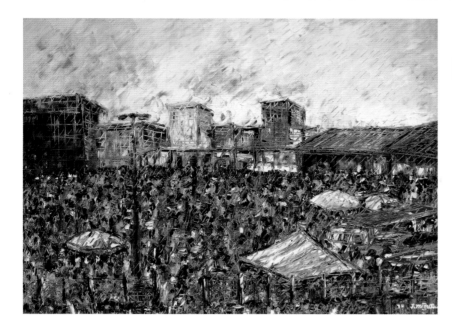

Crowd, 2010, oil, 36 x 48 in.
Photography by Joachim McMillan

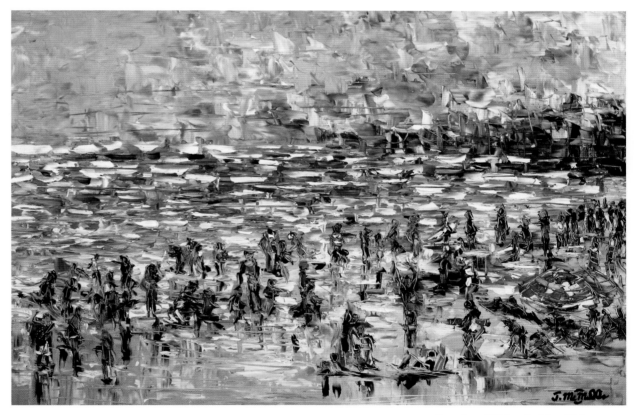

Funplay, 2010, oil, 24 x 36 in.
Photography by Joachim McMillan

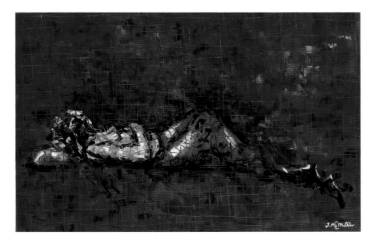

Relax, 2010, oil, 24 x 36 in.
Photography by Joachim McMillan

Alla Melnichenko

Mozyr, Gomel region, Belarus
www.allamel.redbubble.com

I was born, live, and work in southeastern Belarus, in a unique ancient town called Mozyr. I started drawing as a child, then studied at the local arts school. In 1984, I graduated from Arts College in Minsk, the capital of Belarus, and subsequently took master classes from one of the oldest and prominent artists of Belarus, Vladimir Mineiko. He taught me the classical skills of painting based on the legacy of pre-revolutionary Russian artistic movement of Peredvizhniki (realistic painting). I draw my inspiration from the breathtaking scenery of my homeland and emphasize a perfect drawing technique as a prerequisite for artistic excellence.

After graduating from the Arts College, I worked for over 10 years as an industrial designer in my home town. In 1996, I was commissioned by Bishop Peter to produce religious paintings and icons for local churches and this is my job today. In addition, I paint images on birch bark using mixed media. Generally, my images are inspired by the natural beauty of my native Belarus and spiritual dreams. To me painting is much more than art — it is the driving force of my life, my uttermost enjoyment on this earth.

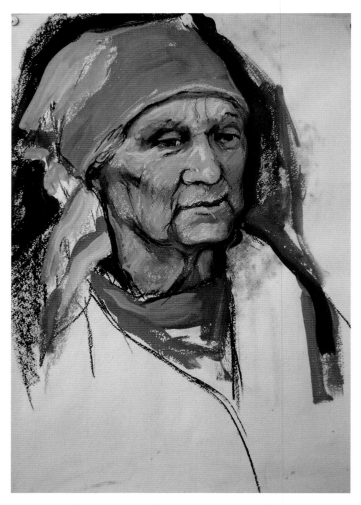

Icon of "Blessed Virgin Mary of Yurovichi," 2005, oil on canvas, 62 x 80 cm. Photography by Alla Melnichenko

Portrait Of My Grandma Nina Semyonovna, 2010, watercolor paper, tempera, charcoal, 60 x 40 cm. Photography by Alla Melnichenko

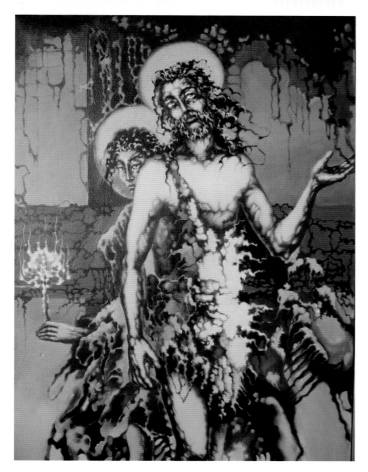

A Different Reality (fragment), 1995, oil on canvas, 64 x 120 cm. Photography by Alla Melnichenko

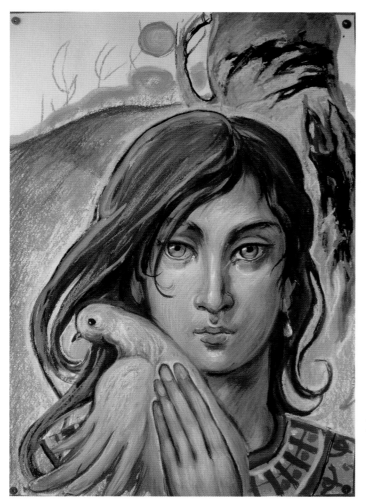

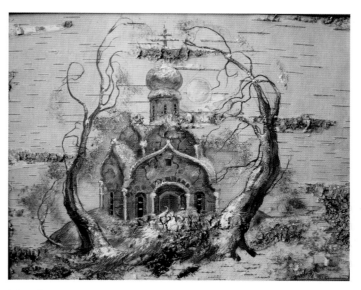

Pink Chapel, 2008, oil painting on birch bark, 50 x 40 cm. Photography by Alla Melnichenko

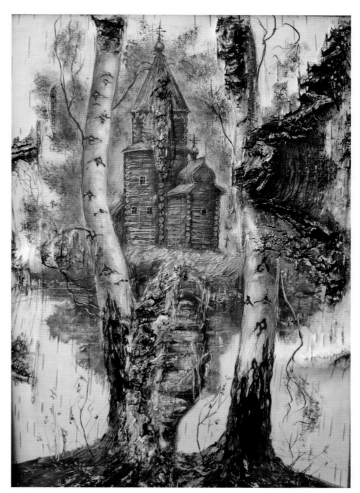

The Island, 2006, oil painting on birch bark, 32 x 45 cm. Photography by Alla Melnichenko

Slavonian Woman, 2010, watercolor paper, tempera, charcoal, soft crayon, 40 x 60 cm. Photography by Alla Melnichenko

Martha Mitchell

Whangarei, Northland, New Zealand
www.marthamitchell.co.nz

I am a South African-born artist living in Whangarei, New Zealand. I have always loved art and grew up in a family that encouraged individuality and creativity. I earned a BA degree at the University of KwaZulu Natal, South Africa, in 1995, with a major in fine art. I started painting seriously in 2004 and have sold paintings in South Africa, as well as Australia and the USA. My family and I immigrated to New Zealand in 2008 and I love the beautiful outdoor environment that this country offers.

My paintings are works of love and passion. If I am not painting, I feel like I'm not truly alive. My favorite subjects are mainly figurative. I strive to improve my ability to paint figures and portraits with practice and I enjoy the challenge of painting water flowing over these forms because of the interesting way in which it distorts them. I am fascinated by people and try to express emotion and ideas that are impossible to express verbally. I am also a deeply spiritual and philosophical person and my thoughts are often expressed through my work. I mainly paint in alkyd oil because it dries quickly and I am still able to blend and rework areas in a single sitting. I want my paintings to be meaningful, philosophical, and symbolic and not just pretty decorations on a wall. I wish to capture the spiritual and psychological aspect of the human soul. Recurring symbols in my work are water as a symbol of life; hands as a symbol of our power of choice to create or destroy, to give or take; and roots, which are symbols of security, attachment and history.

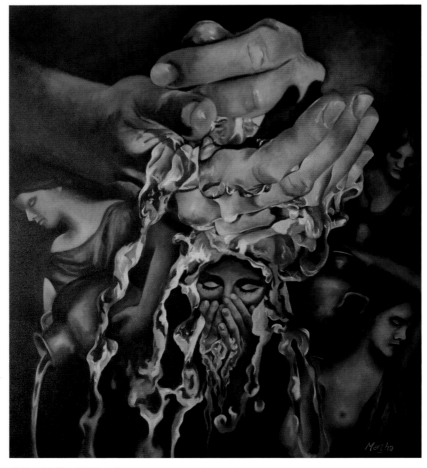

Gift of Life, 2008, oil on canvas, 110 x 110 cm.
Photography by James Mitchell

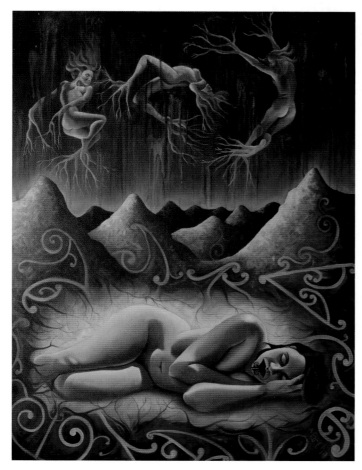

New Land, 2010, alkyd oil on canvas, 101 x 76 cm.
Photography by James Mitchellv

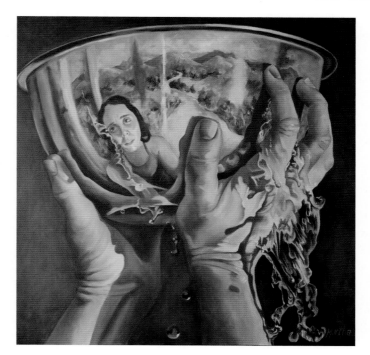

Overflow, 2010, alkyd oil on canvas, 76 x 76 cm.
Photography by James Mitchell

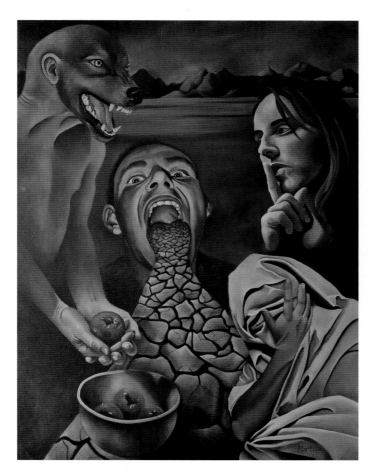

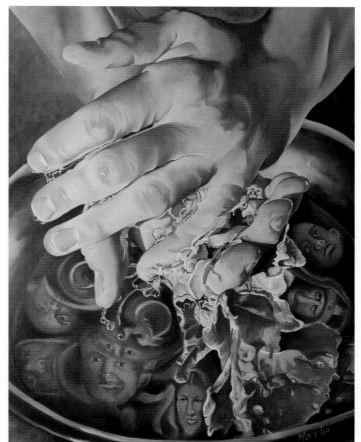

Washing Hands, 2010, alkyd oil on canvas, 101 x 76 cm.
Photography by James Mitchell

The Tongue, 2009, alkyd oil on canvas, 120 x 90 cm.
Photography by James Mitchell

Stacey Neumiller

Coupeville, Washington, USA
www.StaceyNeumiller.com

I live on Whidbey Island in the Puget Sound with my husband, two dogs, one horse, one cat, and five hens. Our two sons are both currently in college. I delight in rural farm life. To me it's the best possible way to live. But not everyone can or wants to live on a farm or in the country. That's where my art comes in. I paint my vision of what rural farm life embodies: animals, birds, crops, fresh air, fragrant grass and of course, red barns. All of these things ground me and make me whole. With my art, it's my goal to share my connection to this pure, simple lifestyle.

My style of painting has grown out of my background as a fine artist, graphic designer, and illustrator. My paintings "break the rules" by combining illustrative realism with naive simplicity. I use rich, bright, oil or acrylic pigments in combination with strong simple composition. My favorite subjects are animals, birds, and plants found in agricultural settings. I enjoy taking my subject, whether it is a cornstalk, rooster, or cow, and making it seem "larger than life." I lift the subject above the ordinary and transform it into art through color and design.

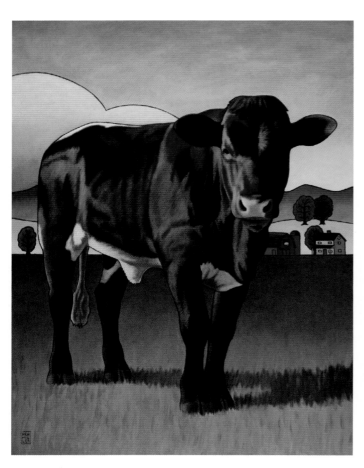

Vintage Crow, 2007, oil on canvas, 36 x 24 in.
Photography by Michael Stadler0

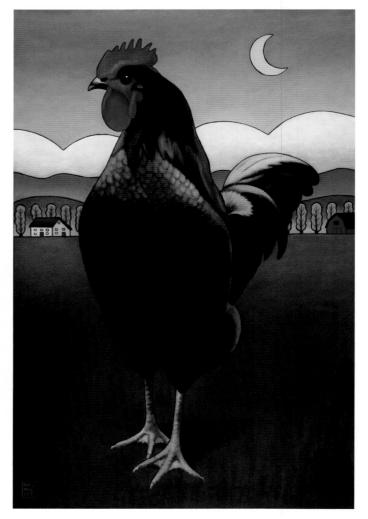

Chanticleer, 2008, acrylic on canvas, 24 x 36 in.
Photography by Michael Stadler

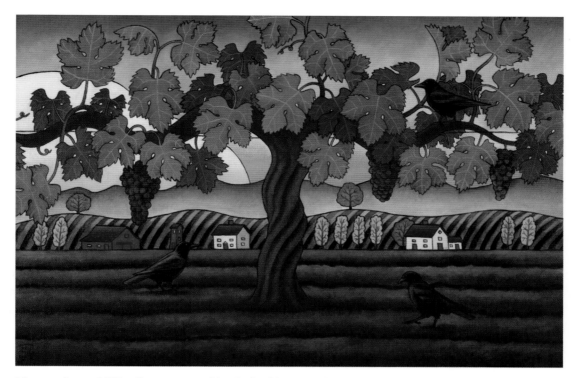

Vintage Crow, 2007, oil on canvas, 36 x 24 in. Photography by Michael Stadler

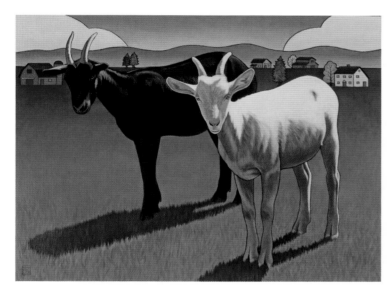

Harold and Maude, 2010, acrylic on canvas, 40 x 30 in.
Photography by John Olsen

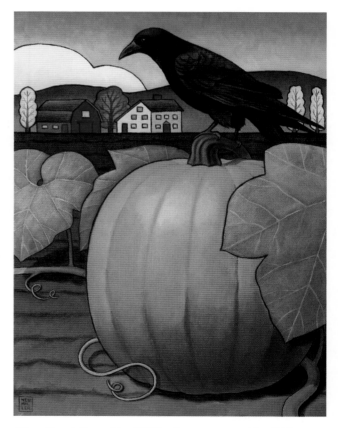

It's a Great Pumpkin, 2005, oil on canvas, 18 x 24 in.
Photography by Michael Stadler

Thu Nguyen

Mukilteo, Washington, USA
www.thunguyenpaintings.com

I was born in Saigon, Vietnam. Being very shy, I spent much of my childhood upstairs making quilts, doll clothes, and painting, instead of playing with other children. My painting won Best of Show prize at a 1974 children's exhibition in Saigon, sponsored by UNICEF. In 1975, my family was split up. I ended up in Hong Kong for a year prior to immigrating to the United States as an orphan. After one very snowy and cold winter in Pennsylvania, I came to Los Angeles, where I had a stint with Hollywood — I got a part in Oliver Stone's Heaven and Earth and followed with a lead role in Elizabeth Hong Yang's Touch Within in China, while working as a fashion model for 4 years. Since then I have lived, worked, and exhibited my work in many parts of the U.S. from Washington to Florida...from Maine to Hawaii.

I received my painting degree from Cal State University, Long Beach. Most recently I have participated in workshop with Bo Bartlett. I'm also a member of Oil Painters of America. I have received grants from the Pollock-Krasner Foundation two times, and three times from the Elizabeth Greenshields Foundation. My work is represented in many public and private collections, coast to coast.

I paint landscape, plantscape, and figures —mostly oil on panel. I love painting because it gives me great enjoyment. I lose myself in time and the day to day worries just vanish...and when I have completed a painting I feel like a part of me will be remain when I am gone.

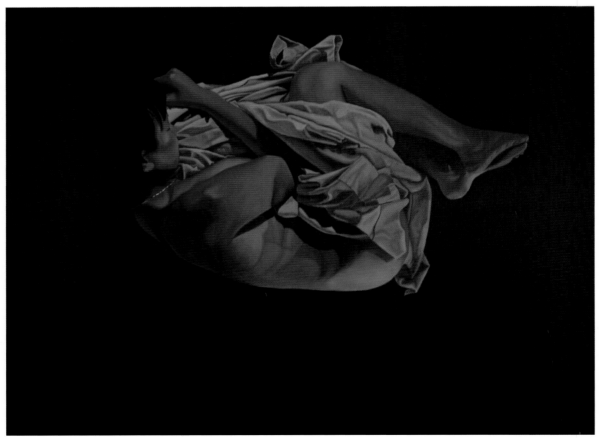

2 A.M., 2007, oil on panel, 23 x 28 in., photograph by Thu Nguyen

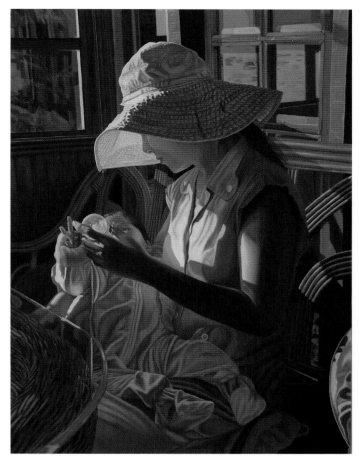

Enfamil at Ha Long Bay, Vietnam, 2009, oil on panel, 24 x 32.25 in., photograph by Thu Nguyen

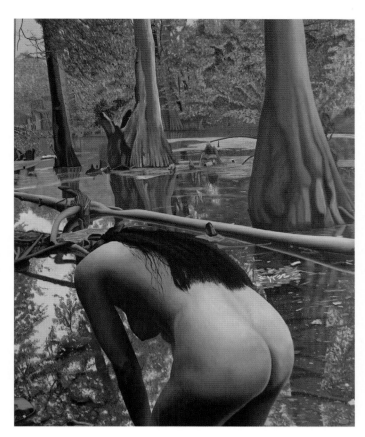

May Morning Arkansas River 2, 2010, oil on panel, 24 x 30 in., photograph by Thu Nguyen

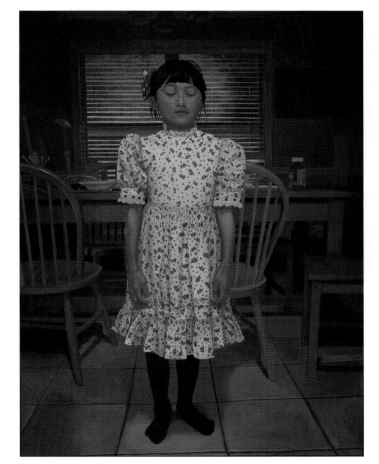

Spring Morning Cabot Arkansas, 2010, oil on panel, 16 x 20 in. photograph by Thu Nguyen

The Valentine Dress, 2009, oil on panel, 24 x 32 in., photograph by Thu Nguyen

Shelley Overton

Orlando, Florida, USA
www.shelleyoverton.com

Shelley Overton is a self-taught fine artist. She has been drawing since she was 7 years old. Shelley has an AS degree in commercial art and a BA from the University of Colorado in communications. She has pursued all forms of art in the past 40 years, from sculpture and photography, to murals, mixed media and jewelry making. Shelley's art is an expression of the whimsy and youthfulness she sees in life. She enjoys finding new ways to use mediums. Shelley's art is a reflection of her being a mother and a strong connection to the idealism and purity of youth. She uses acrylics, watercolors, oils, and other mediums such as glitter, embroidery floss, fabric, and paper. Shelley Overton has shown at local Orlando art festivals and was a pastel portrait artist at Sea World. She was an artist at local iconic restaurant and gallery Café Tutu Tangos between 2009 and December 2010.

Bluebird in a Tree, 2010, acrylic, 16 x 24 in. Photography by Shelley Overton

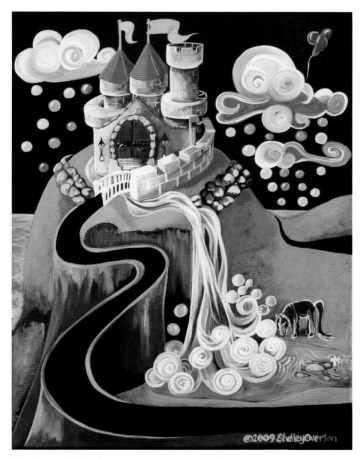

Castle and the Gumdrops, 2009, acrylic, 18 x 24 in.
Photography by Shelley Overton

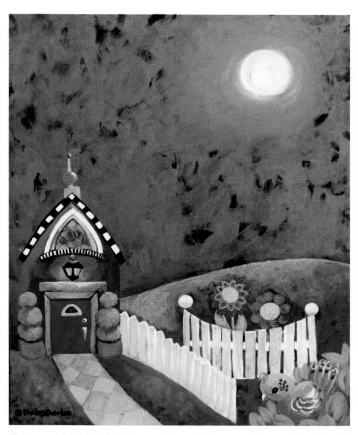

Cottage at Night, 2009, acrylic and Swarovski crystals, 18 x 24 in. Photography by Shelley Overton

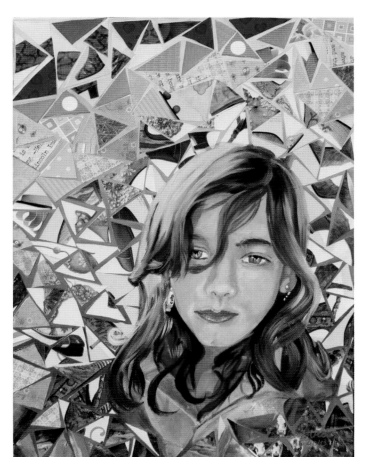

Teapot and the Birdy, 2007, acrylic, 24 x 18 in.
Photography by Shelley Overton

Juliet Mosaic, 2010, oil and acrylic on paper,
18 x 24 in. Photography by Shelley Overton

Eric Palson

Contoocook, New Hampshire, USA
www.ericpalson.com

Eric Palson is an architect who runs a firm in rural New Hampshire. Though both of his parents were artists and art teachers, Palson followed a more technical path studying architecture at MIT and Berkeley. He taught drawing and design at Berkeley, at the University of Wisconsin, and at the Boston Architectural Center before going into practice.

In Cambridge, Massachusetts, Palson spent six years working with Benjamin Thompson Associates on many far-flung projects before relocating to New Hampshire with his young family in the early nineties. He is now president of Sheerr McCrystal Palson Architecture in New London, NH.

This is really quite simple. I paint the things I like to study. I stand in front of them and paint them. I am usually drawn to a scene by aspects of light, texture, color, form, or the juxtaposition of opposites. Sometimes I will paint a subject as a sort of challenge to myself. I try to understand what is really going on or to try to capture an elusive visual effect. When I am painting, I am not operating in a wholly conscious way, but in a sort of autonomous manner that is an escape from the left brain world of my professional life. I get a lot of paint on myself. It's fun.

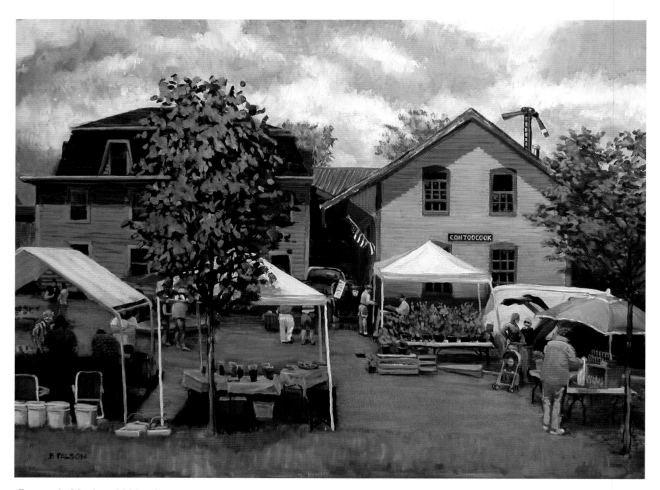

Farmer's Market, 2008, oil on canvas, 30 x 40 in. Photography by Eric Palson

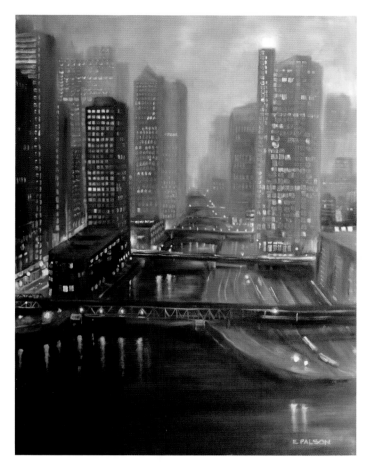

Chicago River, 2009, oil on canvas, 30 x 40 in.
Photography by Eric Palson

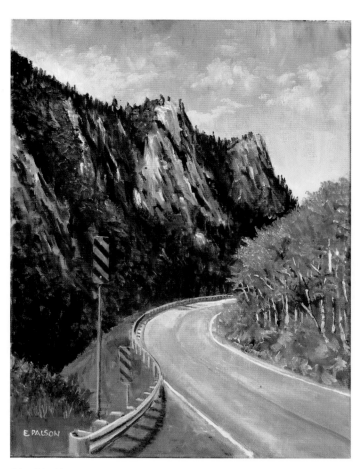

Dixville Notch, 2006, oil on canvas, 16 x 20 in.
Photography by Eric Palson

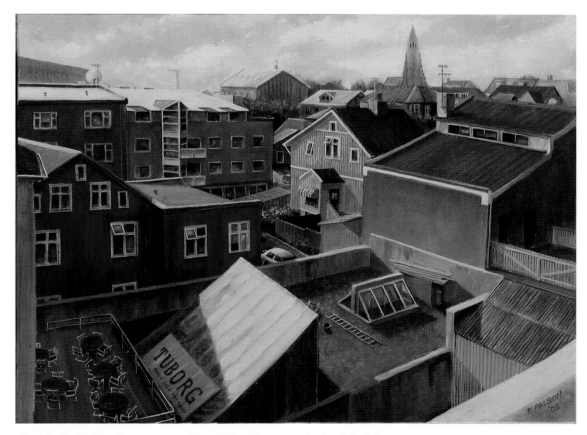

Reykjavik, 2005, oil on canvas, 30 x 40 in. Photography by Eric Palson

Richard Pantell

Bearsville (Woodstock), New York, USA
www.RichardPantell.com

Richard Pantell grew up in New York City's northern borough of the Bronx. During those formative years he became acquainted with the masterworks in the city's art museums and galleries. It was also at this time that the imagery of the city's architecture, subways, billboards, and street life found its way into his earliest drawings and paintings. Pantell studied art at the University of Bridgeport in Connecticut and The Art Students League of New York, but is largely self-taught. He moved to the historic art colony of Woodstock, New York, in 1977, where he continues to maintain his studio. Pantell has been an instructor at the Art Students League of New York since 1996.

My imagery of choice is primarily urban. The architecture above and below street level plays a role that is mainly a stage setting for the urbanite who is the true subject or star of the picture, often isolated in his or her own world during an intimate moment. The star may be a person going to or from work, a skateboarder attempting to become airborne, a musician up on a rooftop or below in the subway, someone spending a quiet yet chaotic moment in his or her own flat, or simply trying to get through a difficult day. I often seek that moment where comedy and tragedy merge together. My aim is to capture a piece of the life of the big city.

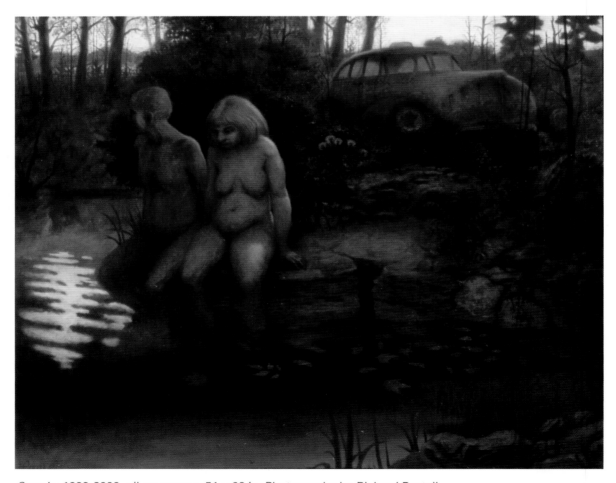

Couple, 1999-2000, oil on canvas, 51 x 62 in. Photography by Richard Pantell

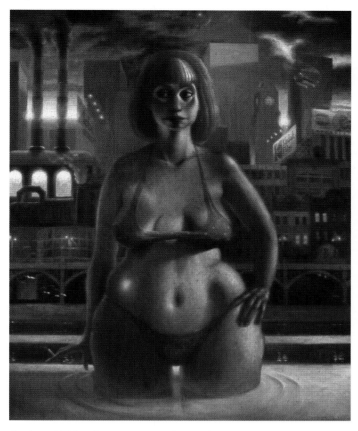

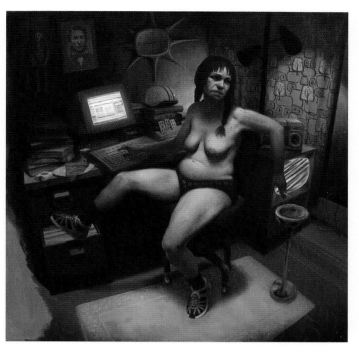

Multitasking, 2010, oil on canvas 50 x 50 in.
Photography by Richard Pantell

Bather, 1986, oil on canvas, 50 x 40 in.
Photography by Richard Pantell

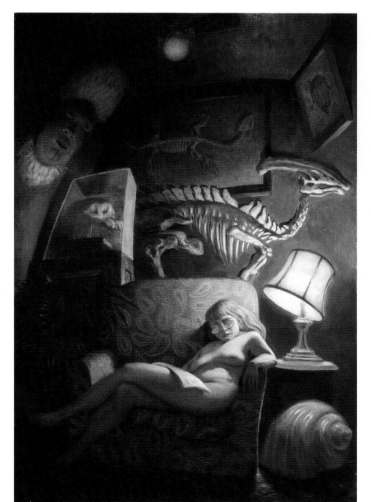

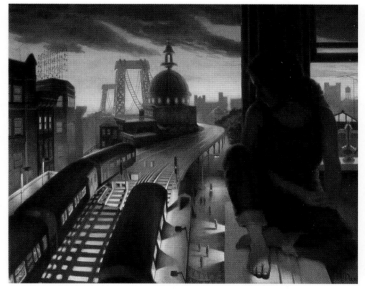

Summer Twilight, 1998, oil on canvas, 40 x 50 in.
Photography by Richard Pantell

Sleeping Paleontologist, 2003, oil on canvas, 36
x 24 in. Photography by Richard Pantell

Michael Lee Patterson

Massachusetts, USA
www.mlpatterson.artspan.com

I was born in the Appalachian Mountains of western Maryland in 1946. I've moved around over the years, Mid-Atlantic suburbia, the Philippines, the deep south, Europe, Los Angeles, the northwest, New England, and I've worked in a variety of situations, music, industrial construction, animation, medical school, sculpture. I identified myself as an artist from childhood and have taken an "unorthodox" approach to an art career. At some point, I learned that my dreams might be more than internal movies for my entertainment; that they are also purposeful, content-packed communiques from my other, unconscious self (the real driver), scripted in a curious symbolic language. I wouldn't pretend to understand the unconscious or what it taps into or where some of the dream stuff could possibly come from, but it can be a rich source of raw material for transposing into works of art. It isn't unusual for me to discover, after the fact, what one of my paintings is about; a painting I couldn't fathom while making it, but felt compelled to make. So, I listen to my unconscious self, though it sometimes scares the hell out of me. It is a key to the art-making process, as I understand it and to my life in general.

Manifestations of the unconscious in dreams, hypnagogic/hypnopompic states, etc., and their artistic expression (i.e., Surrealism) comprise one of the major stylistic traditions I draw on. Others include Mannerism and 17th-century Flemish Baroque painting, especially as practiced by Rubens and his collaborators. I sometimes, facetiously, refer to my painting style as "Flemish Baroque Surrealism." I never met my painting teachers, but I discovered that I could, in a sense, commune with their ghosts through the art they left behind. I've never been phased by the preposterous idea that all "past" art is somehow automatically outmoded, discredited, taboo. I agree with Danto, that there are no longer any "historically mandated directions" for art. The subjects of my paintings plow old collective fields, classical mythology, biblical stories, fairytales, the art of antiquity, human psychology. Most of it treats the traditional themes of sex and death.

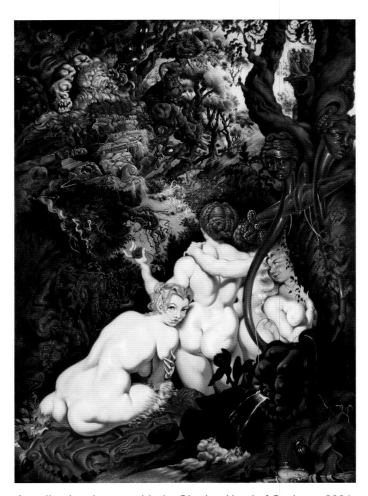

Arcadian Landscape with the Singing Head of Orpheus, 2004, oil on canvas, 31 x 22 in. Photography by Michael L. Patterson

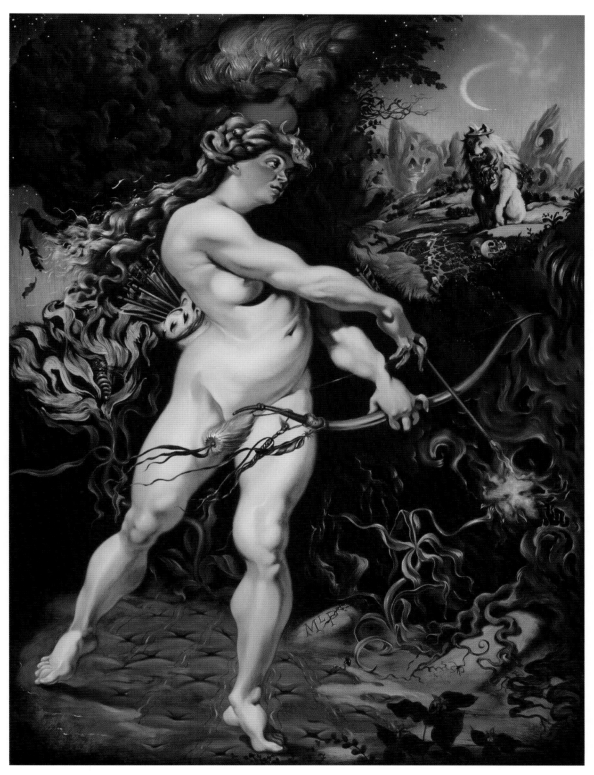

Artemis and Lycaon, 2000, oil on panel, 15.75 x 11.75 in. Photography by Michael L. Patterson

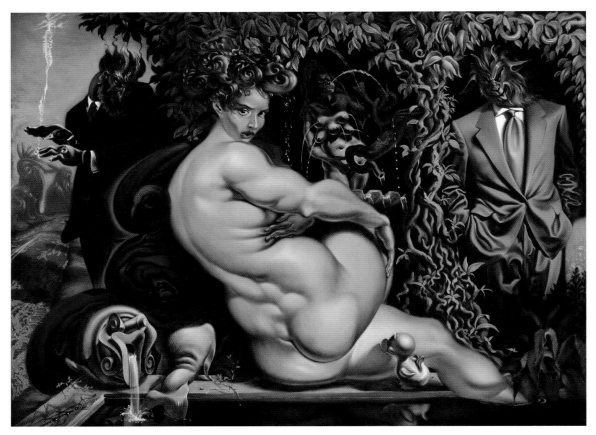

Susanna and the Elders, 2001, oil on panel, 11.75 x
15.75 in. Photography by Michael L. Patterson

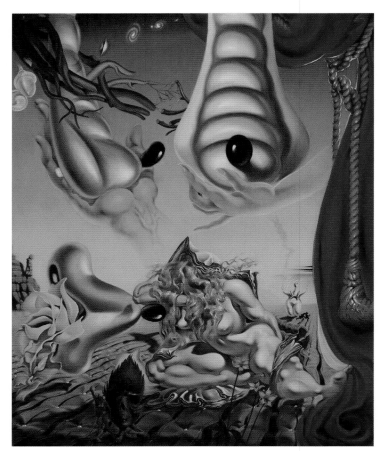

untitled (sleeping Magdalen with three aerial
phenomena), 2010, oil on panel, 13 x 10.5 in.
Photography by Michael L. Patterson

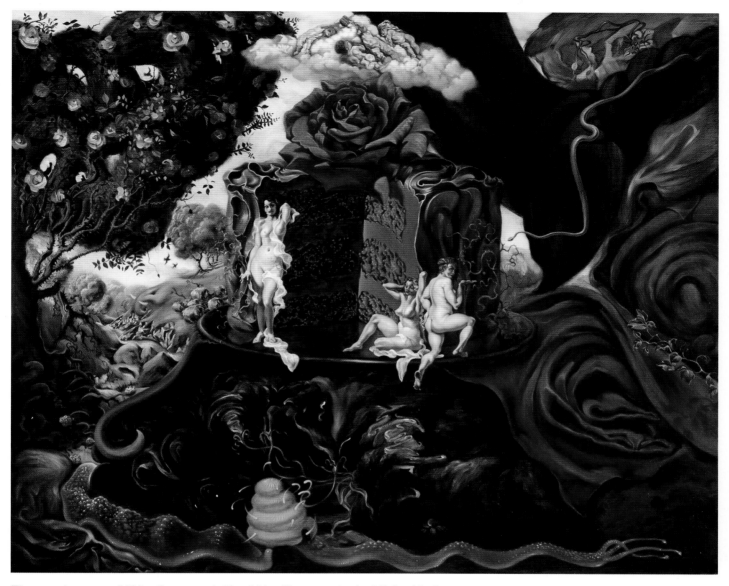

Thesmophantasm, 2003, oil on panel, 19 x 23 in. Photography by Michael L. Patterson

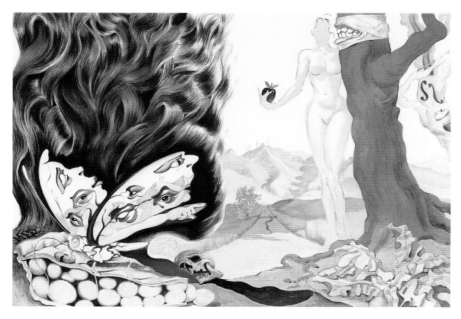

Lilith, Seen from Behind, Regarding Eve, Tree, etc., 2008, watercolor on blue tinted paper, 9 x 13 in. Photography by Michael L. Patterson

Steve Perrault

Harrisburg, Pennsylvania, USA
www.sjperrault.com

Steve Perrault's background in art, philosophy, theology, and clinical psychology (B.A. and three graduate degrees) creates a mysterious connection and deep appreciation of the incongruent aspects of life. Born and raised in Minneapolis, at age 17 Perrault entered Catholic seminary. For 13 years he lived in the context of seminary and monastic life, working in ministerial settings in five states, including three years as chaplain of a New York jail. This was followed by 10 years in clinical work as a psychotherapist in Chicago. These experiences provided the artist with the opportunity to experience environments of architecture with light and darkness, containment and expansion. A full-time painter for the last 13 years, Perrault currently resides in Portland, Oregon.

His work resides in important collections around the world, including the Smithsonian, the Environmental Protection Agency National Headquarters, Academy Award-winning film director William Friedkin (*The French Connection* and *The Exorcist*) and Paramount Pictures Chairman Emeritus, Sherry Lansing. He has been featured in over 40 publications including *The New York Times Magazine; ARTnews;* and *American Art Collector.* He is represented by galleries in London, New York, Houston and San Francisco.

Perrault's paintings are instantly recognizable, each with its architectural space opening to the natural landscape, and its iconic red bench. Every picture stands alone, and draws the viewer in with its beauty and its powerful serenity. But the real power of Perrault's artistry is evident in the whole body of his work. From canvas to canvas, the color and direction of the light changes, the interior architectural shapes are altered, the landscape is challenging or benign, and the red bench morphs from square to elongated, taking positions of varying safety and exposure in the composition. Every image carries its own meaning and its own mood, and it is clear that Perrault's meditative journey is rich and authentic and alive.

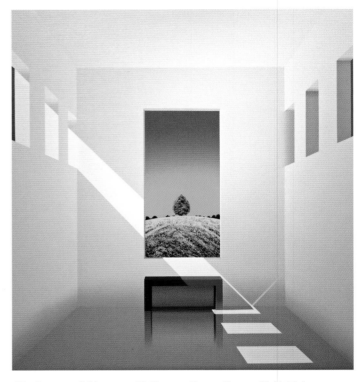

Challenge of Change, 2010, acrylic on linen, 40 X 36 in.
Photography by Stephen Perrault

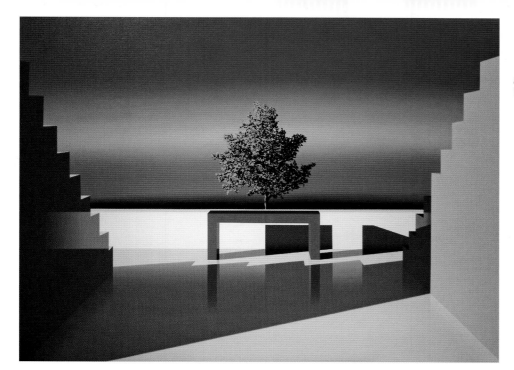

Hope, 2009, acrylic on linen, 36 X 48 in. Photography by Stephen Perrault

Integrity, 2010, acrylic on linen, 36 X 48 in. Photography by Stephen Perrault

Single Moment, 2010, acrylic on linen, 40 X 36 in. Photography by Stephen Perrault

The Call, 2010, acrylic on linen, 36 X 40 in. Photography by Stephen Perrault

Vicki Peterson

Torrance, California, USA
www.vickipeterson.net

Vicki Peterson is a native of southern California. A self-taught artist who experiments in color and line to push the boundaries of modern figurative art, she loves painting and drawing figures that capture human emotion in a original way.

A modern expressionism & intuitive art style that is rich in intense color and line, when combined with the beautiful impressionistic backgrounds and designs of artist (and boyfriend) Kris Wallace on the collaborative works, take modern art to a new, intense level.

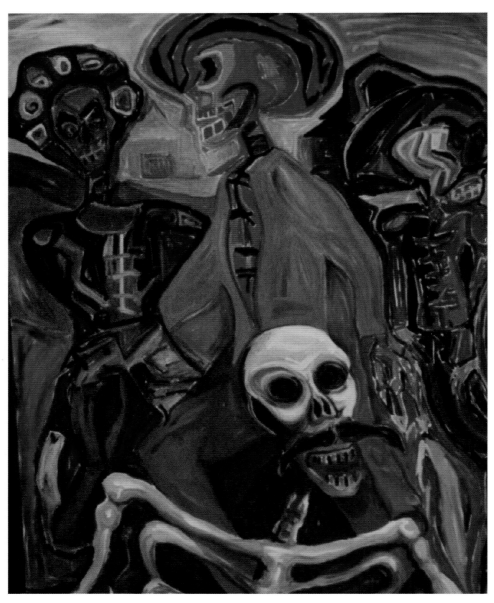

Grand Reunion, 1997, collaboration with Kris Wallace, oil on canvas, 36 x 46 in. Photography by Vicki Peterson and Kris Wallace

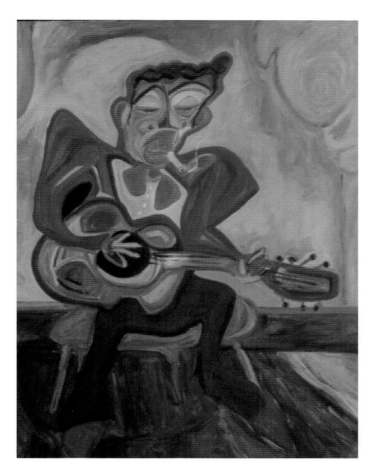

Guitarman in Blue, 1999, collaboration with Kris Wallace, oil on canvas, 36 x 47 in. Photography by Vicki Peterson and Kris Wallace

Jazz Piano Man, 1999, gouache and acrylic on paper, 18 x 24 in. Photography by Vicki Peterson

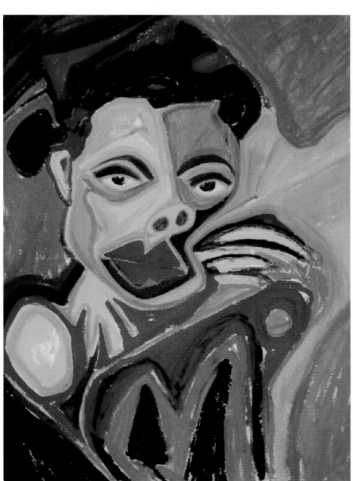

Yellow Dahlia, 1999, gouache and acrylic on paper, 18 x 24 in. Photography by Vicki Peterson

Lee Reams

Tulsa, Oklahoma, USA
www.ArtisticLee.net

Lee began painting as a child and sold her first work at the age of 9. Although her joy of painting and studies of fine art have never stopped, she comes from a background of commercial art and worked several years in advertising and television.

Lee paints with oils and prefers larger size canvas or linen surfaces. Her work can be identified by the exclusive use of palette knives. At times she implements a pointillist style and also works in the realm of linear dimensionality, using her own "knife striking" technique. Her work has evolved and her talent has been refined as she became more adept in the experience and use of her "knives." She is able to implement any number of texture styles to integrate and enhance the final image with the depths that often invite the viewer to take a closer look with the temptation to touch. Her paintings have a remarkable range of subject matter, the similarities lie in the varied palette knife textures.

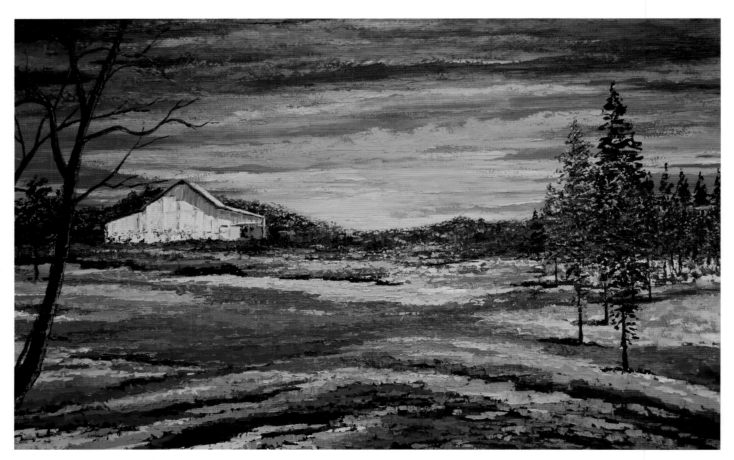

Evening Shades, 2009, oil on canvas, executed with palette knives, 36 x 48 in.
Photography by Lee Reams

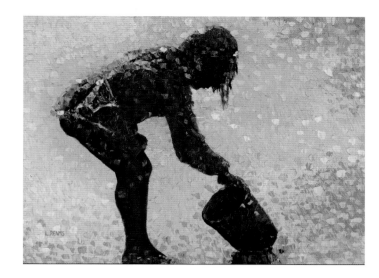

Girl with Pail in the Sun, 2008, oil on canvas, executed with palette knives, 30 x 40 in. Photography by Lee Reams

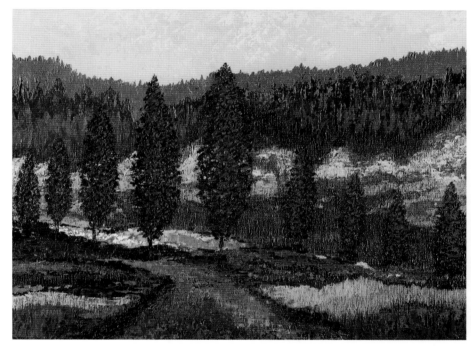

Montenegro, 2010, oil on canvas, executed with palette knives, 30 x 40 in. Photography by Lee Reams

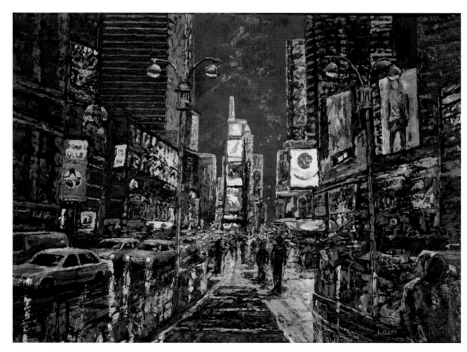

NYC Times Square, 2010, oil on canvas, executed with palette knives, 30 x 40 in. Photography by Lee Reams

Eric Robin

Hannut, Belgium
www.robinart.be

A native of Belgium, I create portraits that are rich with the hues and textures of life. With a Fauvist use of color my paintings are psychologically compelling with concentrated, painterly backgrounds suggesting that the subject's mood has generated an aura around them.

The figures are presented solitarily, locked in a world of unknown forces, alone and without escape. My range of tones and handling of paint serve to infuse each work with a strong sense of drama.

The colorful, stylized faces become masks with striking eyes that peer through you. The expression of the eyes is where I believe you can read the mind of the soul inside the head.

Since 2006, I have been working on a new painting project I call "Isis : 77 mothers." I am painting 77 portraits of women, "Mothers of humanity." In a certain sense a mother has carried humanity within her; she has suffered while giving birth. Often she becomes an impotent witness of mankind. As to me there's a source of pure beauty in this motherhood...

I have been delighted presenting my works widely through Europe and the United States.

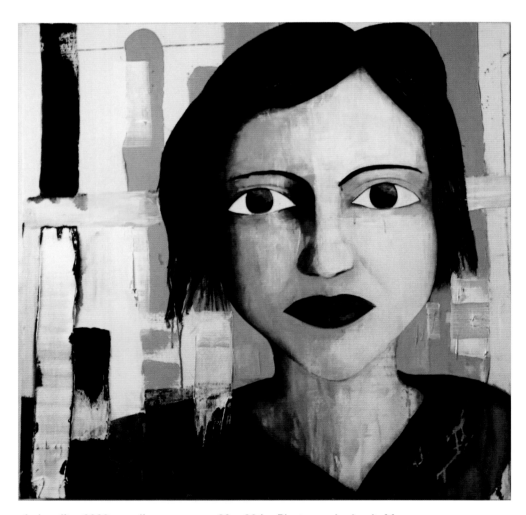

Aphrodite, 2009, acrylic on canvas, 22 x 39 in. Photography by A. Mayence

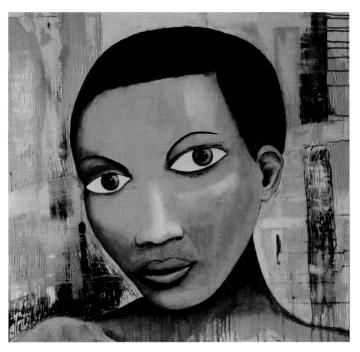

Fatou, 2010, acrylic on canvas, 22 x 39 in.
Photography by A. Mayence

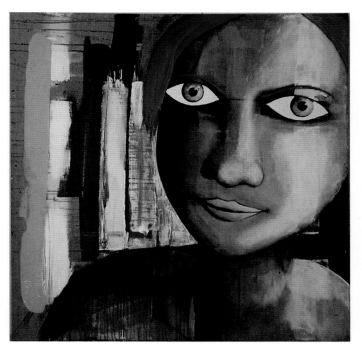

Mira, 2010, acrylic on canvas, 22 x 39 in.
Photography by A. Mayence

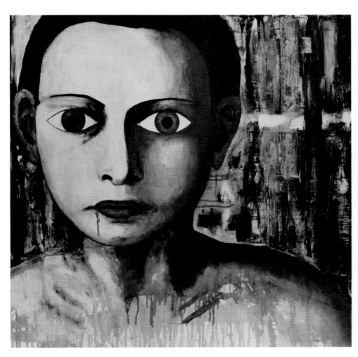

Rosalie, 2008, acrylic on canvas, 22 x 39 in.
Photography by K Longly

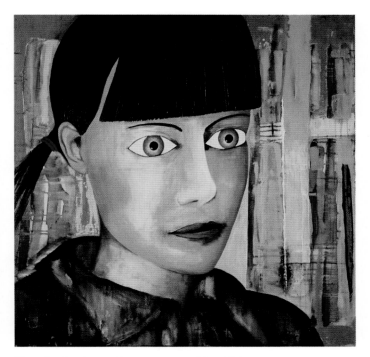

Yasmin, 2010, acrylic on canvas, 22 x 39 in.
Photography by A. Mayence

Shahla Rosa

Southern California, USA
www.shahlarosa.com

Shahla loved art from early childhood. Her father was an amateur painter, and tried to transfer his gift to her. She won several national prizes in her teenage years, and this recognition inspired her to pursue painting as a career despite family opposition.

She moved to Europe where she could explore art further and paint in the manner she wished. She studied at the Kunst Academy in Dusseldorf, Germany, and then at the Instituto Europeo in Florence as well as in Southern California. While in Europe and United States of America, her work was displayed in several successful exhibitions and appeared in catalogues, newspapers and books.

Each time I started a new painting, it's like emerging in surrealist art as a spectator at the birth of the movement. In my paintings each character is the being that projects the greatest shadow or the greatest light into my dreams, or is the love as a means of creation and a source of revelation. I try to release my desire into the world in an image of every personality's beauty both ethereal and fragmentary.

I believe both scientist and artist arrive at the same understanding of the unconscious. I always find my way to surrealism through personal, often romantic connection with my imaginary members of a group. It's kind of freedom. The surrealist cause, in art as in life, is the cause of freedom itself.

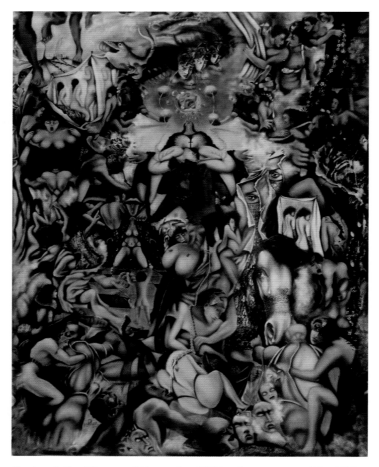

Breton & the Theme of Sexuality, 2007, oil on canvas, 56 x 73 in. Photography by Shahla Rosa.

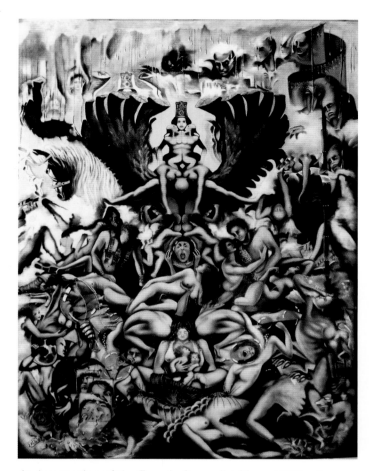

An Incarnation of the Female Surrealist Muse, 2007, oil on canvas, 56 x 73 in. Photography by Shahla Rosa

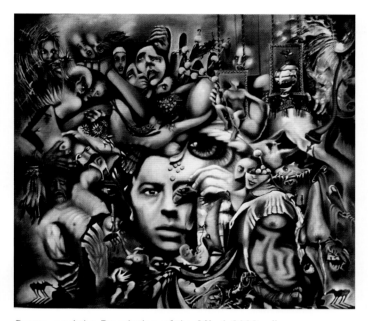

Breton and the Revolution of the Mind, 2008, oil on canvas, 25 x 26 in. Photography by Shahla Rosa

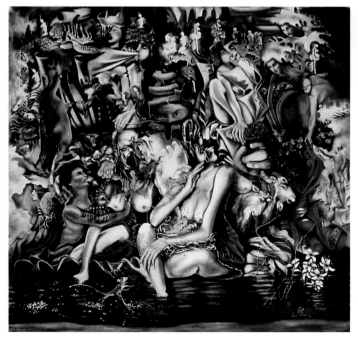

Breton's Crises of Objects and Bilisic Lizard, 2010, oil on canvas, 46 x 47 in. Photography by Shahla Rosa

Don Roth

Menifee, California, USA
www.kool-kats.com

This Southern California artist comes to the world of fine art from an extensive background as a designer and technical illustrator, spending fifteen years illustrating commercial aircraft interior design proposals with Boeing and McDonnell Douglas, for Air Force One, and the king of Saudi Arabia's personal airplane. His world famous "Kool-Kat Kollection," an on-going series, can be seen on greeting cards, jigsaw puzzles, pet mats, and as limited edition prints available through the artist's web site. Executed in acrylic paint, these highly detailed images often take several months to complete, incorporating the use of an airbrush for added precision, these light-hearted, whimsical paintings are a wonder to be hold, and are guaranteed to bring a smile!

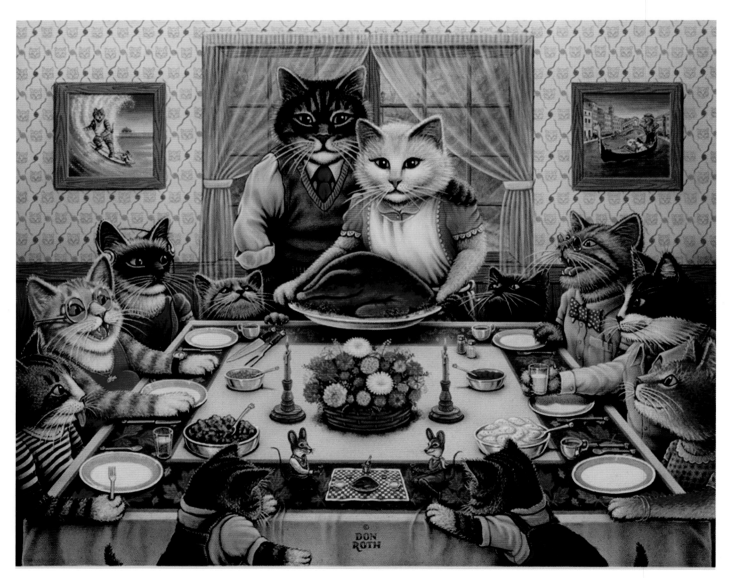

Feline Family Feast, 2005, acrylic on canvas, 24 x 30in. Photography by Loomis Consulting of Costa Mesa, Ca.

K-9 Fire Dept, 2010, acrylic on canvas, 16 x 24 in.
Photography by Loomis Consulting of Costa Mesa, Ca.

Kool-Kat Kuisine, 2010, acrylic on canvas, 24 x 30in.
Photography by Loomis Consulting of Costa Mesa, Ca.

Mariachi Meow-Sic, 2008, acrylic on canvas, 24 x 30in.
Photography by Loomis Consulting of Costa Mesa, Ca.

Tabby Road, 2009, acrylic on canvas, 24 x 30in.
Photography by Loomis Consulting of Costa
Mesa, Ca.

Allen Schmertzler

Portland, Oregon, USA
www.allenschmertzler-artist.com

As a kid growing up in New York City I was surrounded by the magic of art. Attending Saturday morning Art Academy Drawing sessions at the Brooklyn Museum of Art and later in life finding artists generous enough to mentor me, solidified my earlier passion for animation, caricature, and comic book art. By the age of 10, I knew art would always be my center. A 35-year teaching career married my desires for learning and sharing, to traveling and creating, to my fascination with the human experience. Humans in all of our grace and disgrace, the figure, the face, the mood, the gaze, and our hidden psychological-sociological-political dimensions emerged as the heart of my art.

My drawing skill provides me with a visual language for depicting the figure in loose, gestural, expressive quick renderings that capture the gestalt of a person. I then layer and sculpt in the more painful process that reveals deeper issues of the human condition. With the cartoon, a certain rhythm is established by a repetition of shapes, and by its very nature, a cartoon is a departure from exactness. Cartoons are given life through exaggeration and dynamic lines. When I layer upon the gesture with paint, I look for analogies of the effects of life's experiences and how it becomes married to a person's complex personality somewhere in the web of one's nature and nurture.

I prefer to work with live models to stimulate a point of expression and departure. I love the flesh that drapes the human form and hides the secrets, but suggests bones, sinews, muscles, erotica, pain, and the psychological and sociological dimensions of people. Part of me wants to glorify life in beauty and perfection, part of me wants to reveal the absurdities, foibles, blemishes, and humor that we are. And so, it seems natural for me to continue to create images by combining my early childhood fascinations with magical moving linear cartoons (so-called low art), to lush colorful paint (so-called high art), and my academic training in the behavioral sciences.

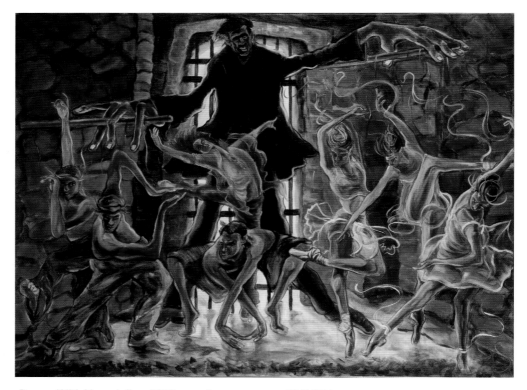

Dance With Your Jailor, 2006, acrylic on canvas, 40 X 30 in.
Photography by Patrick Smith

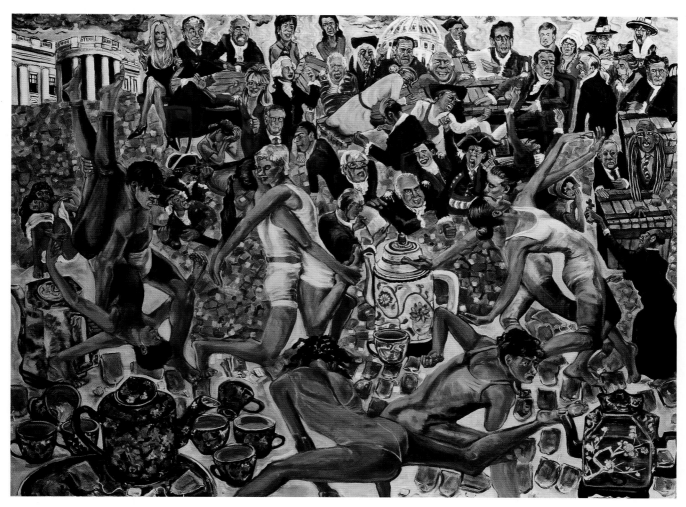

Tea Party, 2010, acrylic on canvas, 40 X 30 in. Photography by Patrick Smith

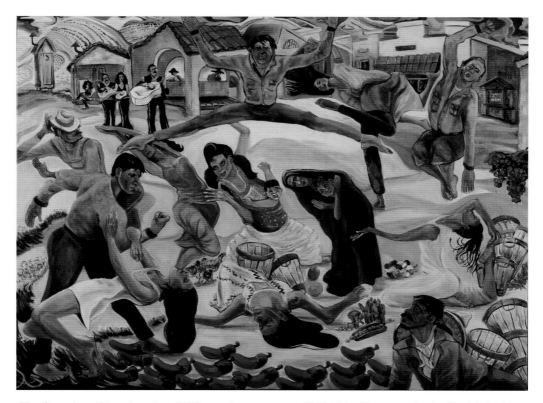

The Question of Immigration, 2008, acrylic on canvas, 40 X 30 in. Photography by Patrick Smith

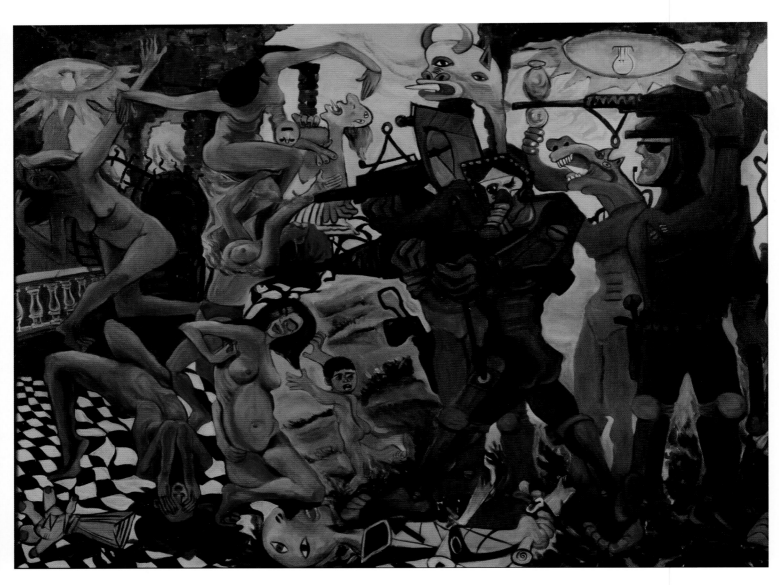

The Surge: Picasso and I Would Agree, 2007, acrylic on canvas, 40 X 30 in. Photography by Patrick Smith

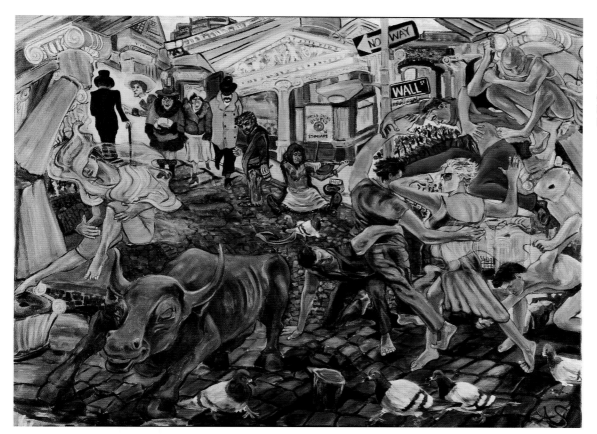

Wall Street Boogie-Woogie, 2009, acrylic on canvas, 40 X 30 in. Photography by Patrick Smith

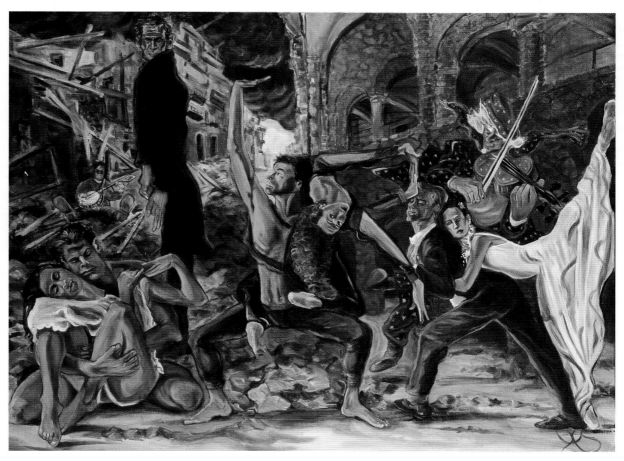

Whoever Fights Monsters, 2006, acrylic on canvas, 40 X 30 in. Photography by Patrick Smith

Suzy Schultz

Atlanta, Georgia, USA,
www.suzyschultz.net

Suzy Schultz has little formal art training, but was exposed to art at an early age through her mother, who is a painter. She graduated from Auburn University with a degree in mathematics and taught high school for 4-1/2 years. Taking a leave of absence, she spent a year overseas with Campus Crusade's Short-Term International program in Poland. On returning, she did some part-time graphic design work for Mission to the World, and was eventually hired to help with their publications. There she was mentored and nurtured in her artistic talent, and encouraged to paint for illustrations used in the magazine. When her mentor and boss left to go on the mission field six years later, she was told she needed to leave her job and paint full time, which she did. She has painted full-time since 1996, and has won many awards for her work.

There is a first innocence — a beauty that is young, unmarred, untested.

There is a second innocence — one in which the beauty is a result of the scars borne from the battles of life. I am interested in this second innocence.

I work the surface. I sand, layer, and scar, wanting to reproduce a piece that has a patina of age, and it is out of these surfaces that figures emerge. I seek figures, faces that seem to be familiar with the tensions of life, that bear some battle scars, and yet have victory, even if a crippled or limping one.

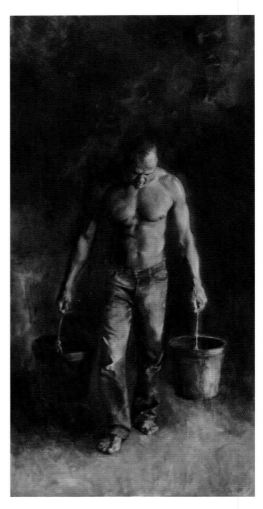

Holding the Nest, 2009, oil on panel, 21 x 16 in.
Photography by Suzy Schultz

Water Carrier, 2010, oil on panel, 60 x 36 in.
Photography by Suzy Schultz

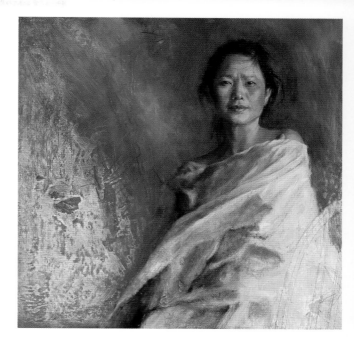

Wind, 2008, oil on panel, 12 x 12 in.
Photography by Suzy Schultz

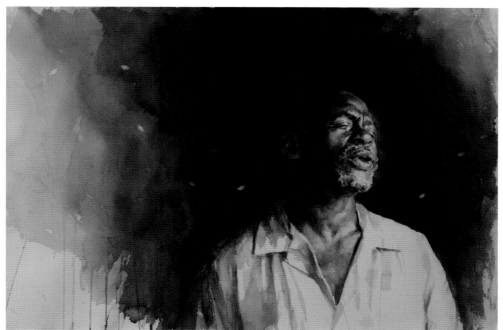

The Singer, 2010, watercolor, 14.5 x
19 in. Photography by Suzy Schultz

Song, 2010, oil on panel, 36 x 48 in.
Photography by Suzy Schultz

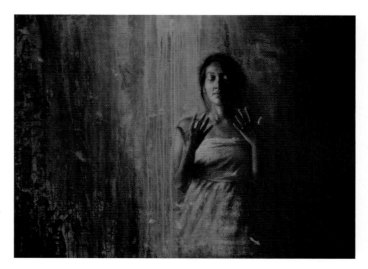

De Es Schwertberger

Vienna, Austria
www.dees.at

De Es Schwertberger was born in 1942 in Gresten, Lower Austria, into a family of teachers. He studied the painting technique of the Old Masters in Vienna with Ernst Fuchs and has been an independent artist since 1962. De Es lived three years in Switzerland and twelve years in New York City. He now resides and works in Vienna, where he has been since 1986. He has been featured in numerous shows and publications.

The artist considers himself to be a seeker, who shows what he has found through "the language of the images." His message of "meaning and transformation" finds clear and intense expression in his paintings through a precise use of space, light, and texture. Schwertberger's themes evolve continuously, reflecting the rapid transformations of the human "self-image."

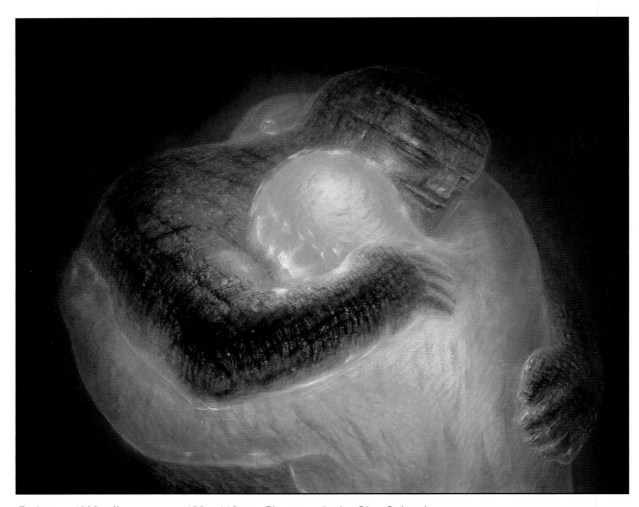

Embrace, 1980, oil on canvas, 133 x 112 cm. Photography by Olga Spiegel

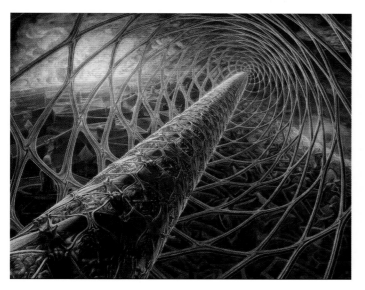

No End, 1964, oil on board, 113 x 99 cm.
Photography by Franz Schachinger

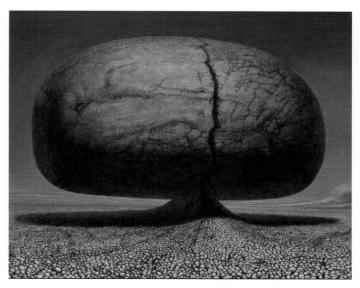

Origin, 1974, oil on board, 120 x 95 cm.
Photography by Franz Schachinger

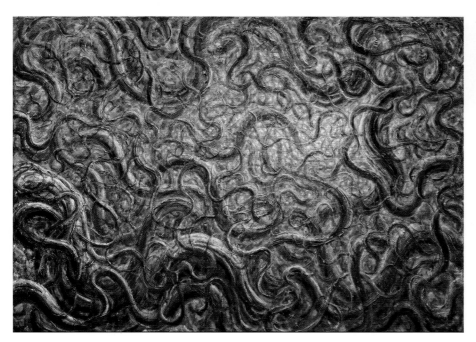

Stringworld, 2009, oil on canvas, 140 x 100 cm.
Photography by Helfried Valenta

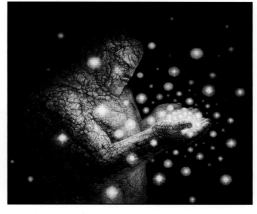

Starfather, 1978, oil on canvas, 107 x 97 cm.
Photography by Olga Spiegel

Yuriy Shevchuk

Prague, Czech Republic
www.shevchukart.com

Born in Kiev, Ukraine in 1961, Yuri Shevchuk attended the Kiev Art School and later the prestigious Kiev Architectural Academy. Yuriy has adopted the practice of recording his own experiences in his artworks: his three passions, painting, jazz and historical cars have become the focus of his paintings. Since 1993 Shevchuk has been living in Prague, which he depicts in many of his paintings and also where he exhibits his work widely. He has been described as an accomplished master, full of artistic and intellectual energy. Bewitched with jazz music he skillfully and rapidly sketches the cool and charming figures of musicians in action, showing the positive mood of jazz and the stunning spiritual intensity of this bright magical world. His lively and spontaneous paintings expertly translate the atmosphere and verve of the music, using dripping, seeping paints and pastels. Another one of his interests is retro cars. He does not paint cars as such, but tries to depict his emotional perception of retro style; the observer can feel spirit of the past on his works. Shevchuk, an associate member of the Pastels Society of America, has participated in numerous exhibitions and his work is held in collections all over the world. The clarity, harmony, the refined palette of color and line attract sophisticated art and music lovers worldwide. In the presence of Yuriy's paintings one can almost hear the blues, feel the beguiling emotions and impassioned feelings of the musicians translated through the artist. Such intoxication supports the belief that Yuriy Shevchuk is among the leading contemporary artists exhibiting in the Czech Republic today.

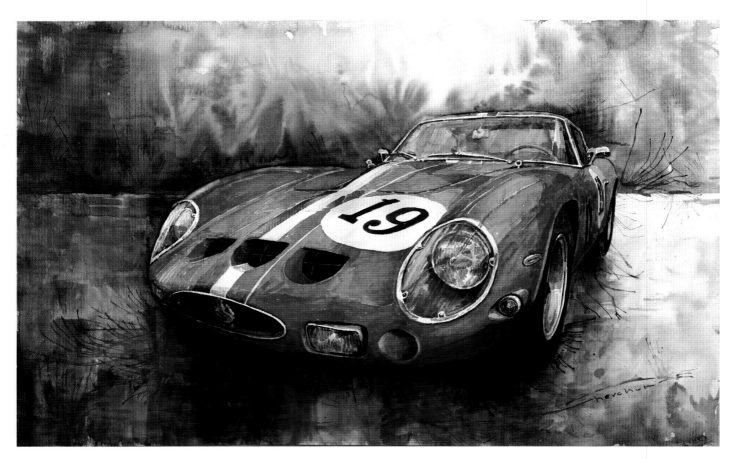

Ferrari 250 GTO, 1963, watercolor on paper, 45 x 70 cm. Photography by Yuriy Shevchuk

Miles Davis, oil on canvas, 60 x 100 cm.
Photography by Yuriy Shevchuk

Jazz Guitarist Last Accord, watercolor on paper, 45 x 70 cm.
Photography by Yuriy Shevchuk

Prague Historical Tram,
watercolor on paper, 35 x 50
cm. Photography by Yuriy
Shevchuk

*Prague Old Town Square Astronomical
Clock*, watercolor on paper, 35 x 55 cm.
Photography by Yuriy Shevchuk

Susan Meyer Sinyai

Asheville, North Carolina, USA
www.susanmeyersinyai.com

In 1987, when her children were still young, Susan Sinyai decided wh0at she wanted to be when she grew up. She enrolled in the Art Department at UNC-Asheville to embark on a second career; she completed the BFA in 1994. Since that time, she has been a working artist, exhibiting and winning awards in numerous local and national shows. Susan was commissioned in 2000 by UNCA to paint the portrait of former Chancellor Samuel Shuman. She collaborated with Tucker Cooke and other artists on a life-sized reproduction of Raphael's "School of Athens," which hangs at UNCA. She has taught art at a local school as well as through the Swananoa Valley Art League. She is an active participant in several local art organizations. Currently she is represented by Blackbird Art Gallery, in Asheville, North Carolina

I've been painting with purpose for a number of years, focusing on the figure and the still life, avoiding the landscape at all costs, it seemed. Thus it was much to my surprise that about five years ago, I discovered that painting the landscape was exactly what was missing for me as an artist, that it is a richest of tapestries, offering an endless and bountiful source of material to inspire. Particularly, it is the quality of light that I seek to explore and capture, the manner in which it describes form, manipulates color, but most importantly, how it can evoke mood and memory. Although I find oil to be a beautifully expressive medium, it is pastel, with its mouthwatering lusciousness and brilliance that provides me with the perfect means to express my response (and appreciation) to the exceptional and transcendent beauty of the physical world.

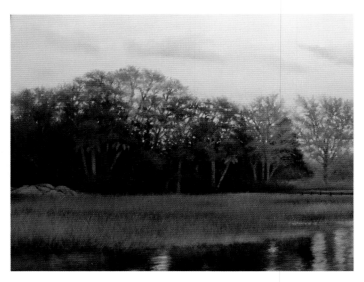

Jaune Brilliante, 2010, pastel, 16 x 20 in. Photography by Susan Sinyai

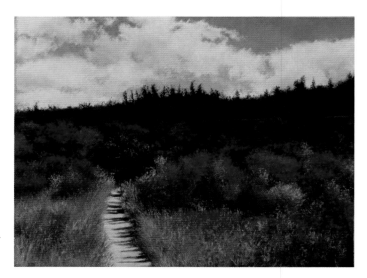

A Hike Through Graveyard Fields, 2009, pastel, 11 x 14 in. Photography by Susan Sinyai

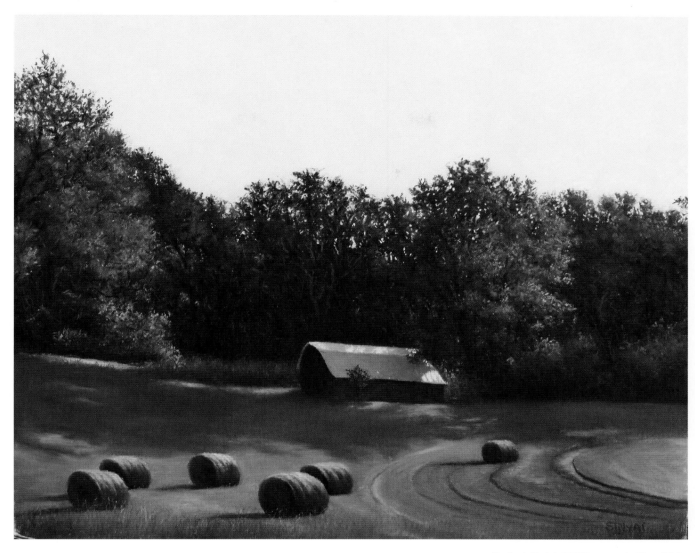

Rolled Gold, 2007, pastel, 18 x 22 in.
Photography by Susan Sinyai

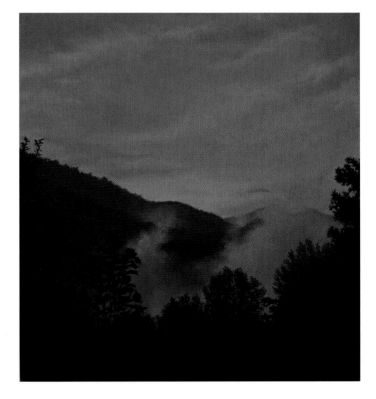

Spiritual Journey, 2010, pastel, 20 x 18 in.
Photography by Susan Sinyai

Tom Henderson Smith

Penzance, Cornwall, UK
www.hendersonsmith.co.uk

Tom Henderson Smith's formative years were spent in equatorial Africa, followed by school in Yorkshire and a Fine Art Degree at Newcastle-upon Tyne University. Awarded a Bunzl travel scholarship, he then spent two further years travelling and studying art in Europe while based in Florence. Settling back in the United Kingdom then led to a twenty-four year career teaching art. Having moved to Cornwall in 1980 he now operates from his studio near Lands End.

His approach to painting is based, he feels, on the coming together of his sensuous enjoyment of color, which stems from those early childhood memories of Africa, with a sense of design that was confirmed by the experience of Italy. He now makes paintings inspired by Cornwall's landscape and culture, bathed as it is in an over-arching quality of maritime light. It is this that has enabled him to bring together the two aspects of color and design into a unified and celebratory style.

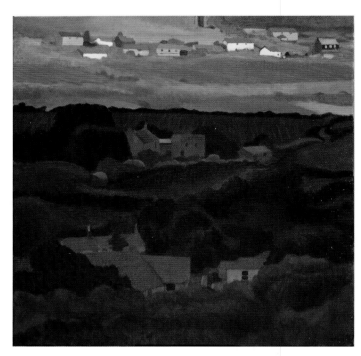

Farms in sun and shade, 2010, acrylic on canvas, 61 x 61 cm. Photography by Tom Henderson Smith

Summer Evening, Towards Lands End, 2006, acrylic on canvas, 51 x 102 cm. Photography by Tom Henderson Smith

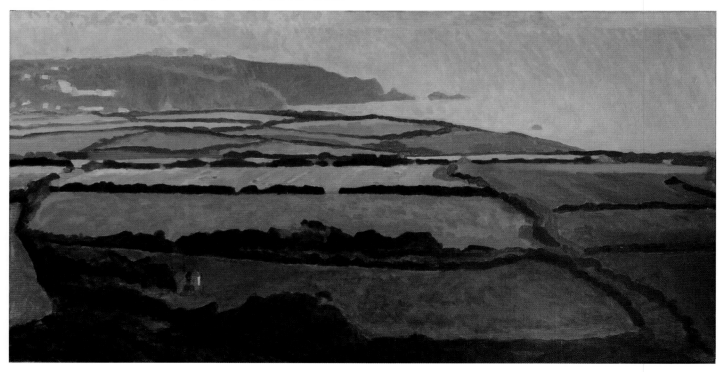

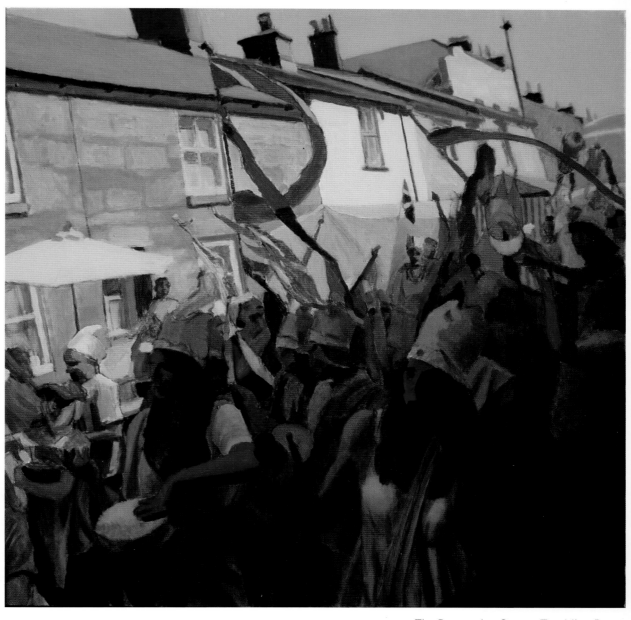

The Procession Comes Tumbling Down the Street, Lafrowda Day, 2008, acrylic on canvas, 80 x 80 cm. Photography by Tom Henderson Smith

Up the street and into the morning light, 2008, acrylic on canvas, 40 x 40 cm. Photography by Tom Henderson Smith

Alexandra Suarez

Miami Beach, Florida, USA
www.alexandrasuarez.com

Alexandra Suarez was born into a Colombian family divided by political ideology. Her mother's side belongs to the conservative right party with several high ranking military officials in the family. Her father's side belongs to the liberal left party and was integral to the formation of the leftist groups in the seventies. Because of her upbringing, politics and religion are essential to her work. She has spent her whole life living in both Colombia and the United States which has broadened her view of the world and increased her awareness of social injustice. Her approach to her work is completely humanistic and is an ongoing questioning of our nature and our purpose as human beings.

My work is a philosophical journey inspired by emotion, deep thought, and reflections on our human condition. I begin with a certain emotion or vision of my composition and start building up by applying layers of texture that include paper, symbols, writings, etc. Many found objects and everyday discarded items are used in the formation of the work, as if they were a continuation of existence. Everything changes but does not cease to exist.

I view each work as a fearless act of creation and a constant exploration of the soul.

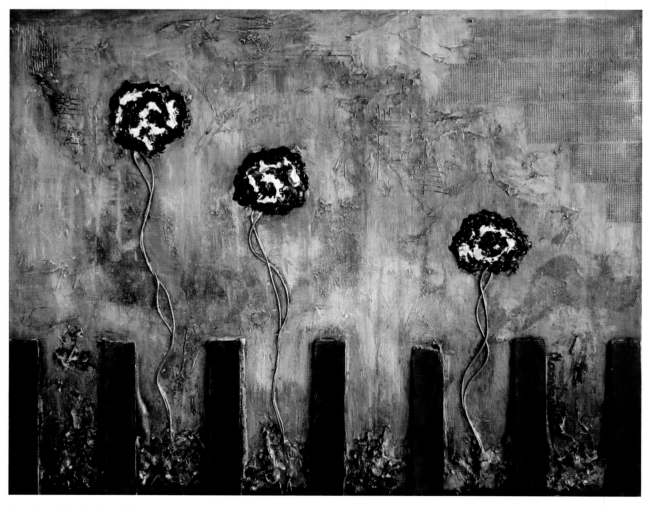

Garden in Palestine, 2004, acrylic and mixed media on canvas, 24 x 30 in. Photography by Alexandra Suarez

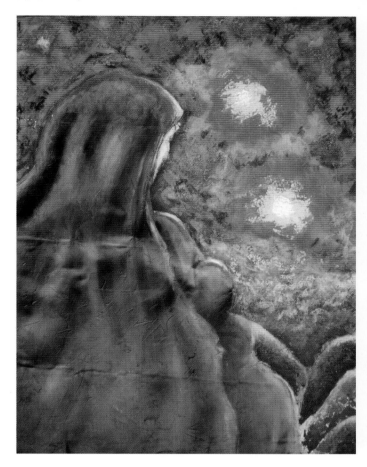

Bombing the Innocent, 2003, acrylic on canvas, 40 x 30 in. Photography by Alexandra Suarez

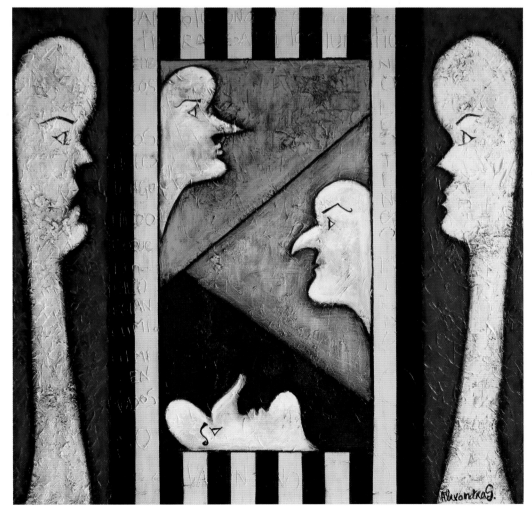

Lunaticos II, 2005, acrylic on canvas, 48 x 48 in. Photography by Alexandra Suarez

John Szabo

Trenton, New Jersey, USA

www.paintingsilove.com/artist/johnszabo

For as far back as I can remember I have always been interested in using visual images to portray my emotions, ideas, and life views. I have always enjoyed anything artistic and knew I would, in some way, make creating my way of life. I have worked as a conceptual artist designing P.O.P. displays as a main source of income for 25 years, while pursuing a career in fine arts as my life's passion. I have two teenagers that I have raised by myself and they are artistically inclined as well. We will often enjoy hours of creativity together.

My approach to creating my artwork is to use symbolism and surrealism to convey my theories on life, religion, politics, and humanity. While I have never been successful at expressing myself verbally (written or aloud), I find that the ideas I have seem to flow out of me in a steady stream when I am behind a canvas or in front of a drawing. Time seems to stand still and all outside distractions will go away while I transform my ideas into art. I find that this type of expression suits me because I've never been the type of person to force my ideas onto anyone. In this way, people can either view my work and enjoy it, drawing their own conclusions, or simply decide it is not for them without feeling confronted.

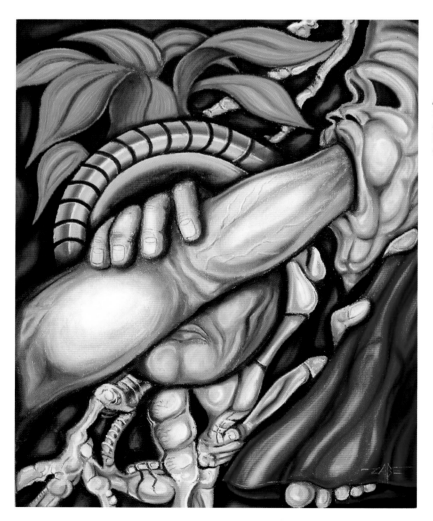

Rude Awakening, 2006, oil pastels on board, 19 x 24 in. Photography by Colorest

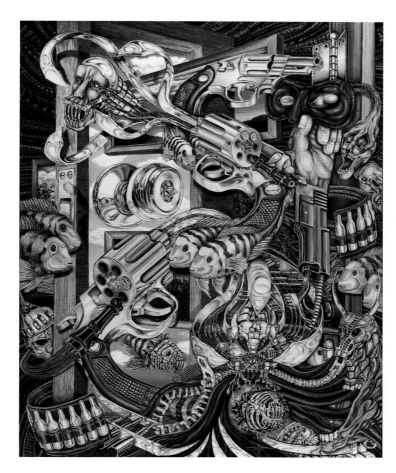

Ultraviolence at Walmart, 2009, oil on canvas, 24 x 30 in. Photography by Leigh Photographic

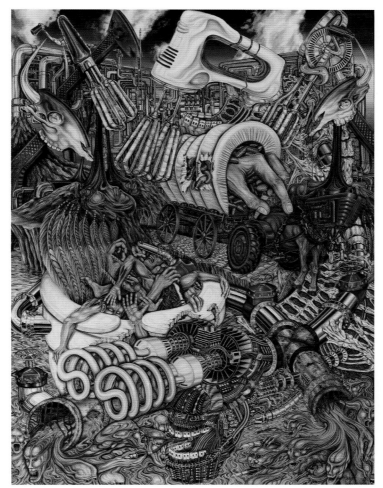

How the West was Lost, 2010, oil on canvas, 30 x 40 in. Photography by Leigh Photographic

Renee Taylor

Pottsville Beach, Australia
www.reneetaylorart.com

As an emerging artist I have been working both abroad in New Zealand and on the Gold Coast as a career since 2005. Born in Australia I was a passionate and was the highest graded art student in Queensland Schools for my grade in 1997. I then went onto a private arts academy at Morningside, Brisbane, for full training in all aspects of fine arts, painting, life drawing and the landscape, succeeding highly in portraiture and the landscape.

Most of my work is created and inspired from drawing on location. I like to capture most importantly the essence and spirit of that certain place. How the time of day, light, and weather affect the atmosphere and mood. To feel something from a painting is what gives rise to it. My work is to paint what is felt rather than what is seen.

I work mainly in mixed media and acrylic. The exploration of color and color harmony is a huge interest in my work. Another style of my work tends to be symbolic, although I am not always conscious of this. I am also inspired by simplicity and its beauty, capturing the essence of nature and life in something small like a leaf and its place in time and space. I am passionate for art, and each piece has a part of my heart and soul poured into it.

Grounded, 2006, oil, 66 x 140 cm.
Photography by Renee Taylor

206

Hast NZ, 2006, mixed media, 15 x 30 cm. Photography by Renee Taylor

Air, 2008, mixed media and acrylic, 51 x 51 cm.
Photography by Renee Taylor

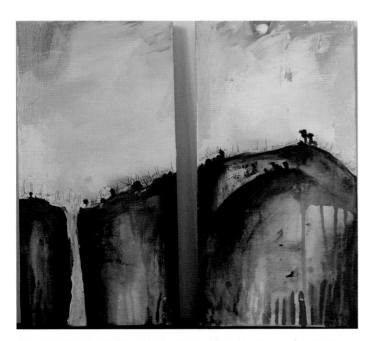

The Journey, acrylic and charcoal, 20 x 40 cm. each canvas.
Photography by Renee Taylor

Sally Tharp

Ashland, Ohio, USA
www.Sallytharp.com

The need to create has always been prevalent in Sally's life. After graduating from University of Rhode Island with a BFA in 1985, she worked in several creative capacities, though not necessarily in the traditional sense. In 2008, Sally became a full time artist. She currently prefers to work in oils and explores taking small, every day objects and painting them on a very large scale, focusing on color, form and most importantly light.

The objects Sally paints are aesthetically pleasing to her, and, although there are schools of thought that ascertain that the subject matter is of no consequence, Sally chooses carefully what she paints.

I am often drawn to the old, marred, scarred and imperfect things in life, feeling the need to show a side of them that is beautiful, giving them a voice. The objects I choose to paint hold an aesthetic beauty to me and I paint them in that light. I invite the viewer to experience the qualities in them that I find appealing and to seek the beauty in the often overlooked, sometimes imperfect items of life.

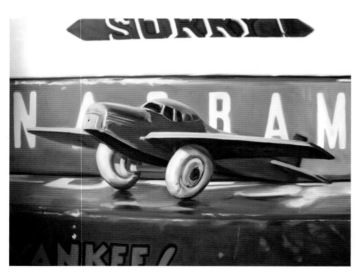

Adventure Awaits, 2010, oil on canvas, 36 x 48 in.
Photography by Sally Tharp

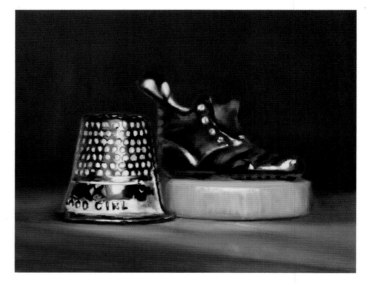

Yellow, 2010, oil on canvas, 16 x 20 in.
Photography by Sally Tharp

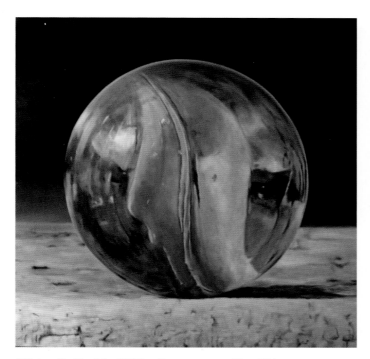

Michael's Marble, 2009, oil on canvas, 48 x 48 in.
Photography by Sally Tharp

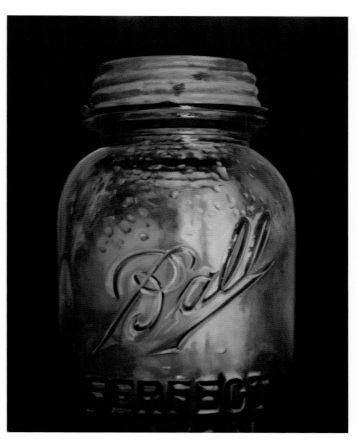

Getting' Steamed, 2010, oil on canvas, 40 x 50 in.
Photography by Sally Tharp

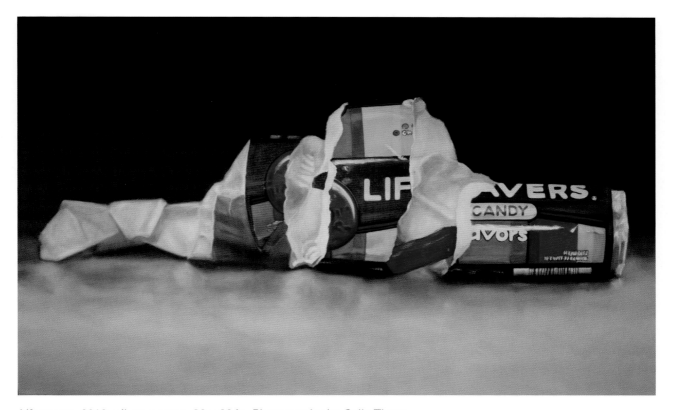

Lifesavers, 2010, oil on canvas, 36 x 30 in. Photography by Sally Tharp

Pavlos Triantafillou

Larisa, Greece
www.paintingsilove.com/artist/pavlostriantafillou

I am a 57 year old children toy trader. I live in Larisa, a historic city in central Greece. I have been married for 35 years and I have 2 sons. I spend most of my time between my job and my passion, the painting.

I am a self-taught artist. The last 3 years I devoted myself to studying and creating paintings. I usually use oil colors on canvas and some times acrylic colors on canvas. My subjects are usually portraits of every day people with different expressions that show joy and happiness, as well as sadness and poverty.

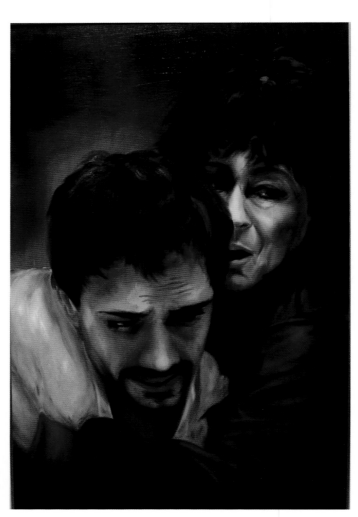

Tragedy, 2010, oil on canvas, 60 x 90 cm.
Photography by Pavlos Triantafillou

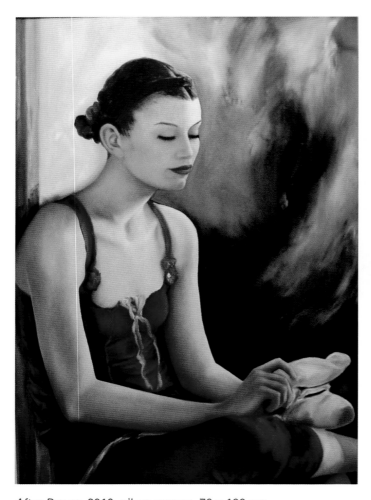

After Dance, 2010, oil on canvas, 70 x 100 cm.
Photography by Pavlos Triantafillou

Help, 2010, oil on canvas, 70 x 100 cm.
Photography by Pavlos Triantafillou

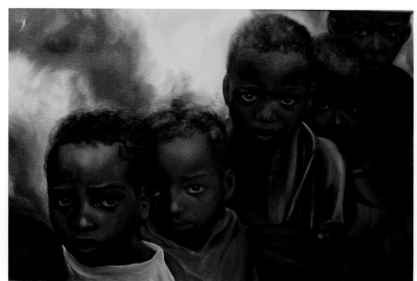

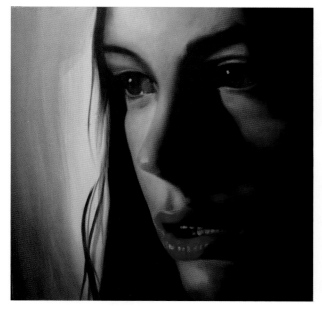

Beauty, 2010, oil on canvas, 60 x 60 cm.
Photography by Pavlos Triantafillou

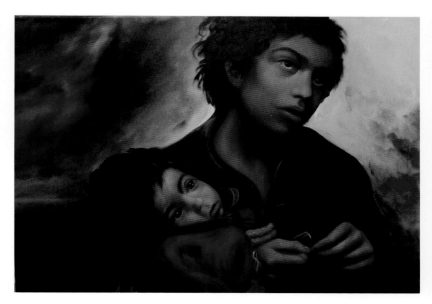

The Real Message, 2010, oil on
canvas, 70 x 100 cm. Photography
by Pavlos Triantafillou

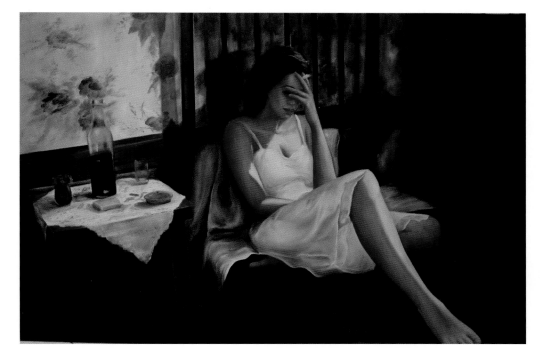

Thoughts, 2010, oil on canvas,
80 x 120 cm. Photography by
Pavlos Triantafillou

Maggie Vandewalle

Hixson, Tennessee, USA
www.maggievandewalle.com

Maggie Vandewalle was born and raised in Iowa City, Iowa. Through the encouragement of a high school art instructor, she applied for and received an art scholarship to the University of Iowa in 1981, where she earned a BFA in printmaking. After school she turned to painting, in part due to the cost of printmaking equipment, but also to achieve more immediate results. Since then she has received numerous awards and her work can be found in private and public collections across the United States and in Europe.

Maggie's work is driven by a desire to tell stories without words, to give the viewer as much to absorb as possible. She achieves the story though detail, pattern, and color. The details are not gratuitous; they work to urge the viewer closer, to find the emotion or moment in time she herself was captivated by.

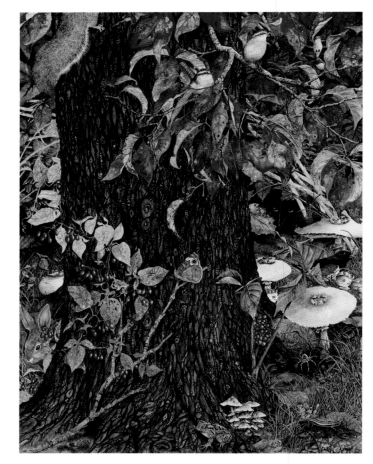

Minutiae, 2008, watercolor and gouache on cotton rag paper, 36 x 27 in. Photography by Doug Blumer

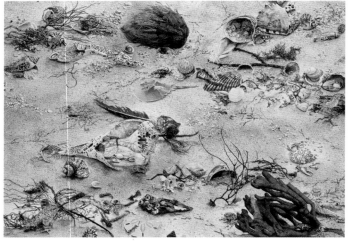

After the Storm, 2006, watercolor and gouache on cotton rag paper, 27 x 38 in. Photography by Doug Blumer

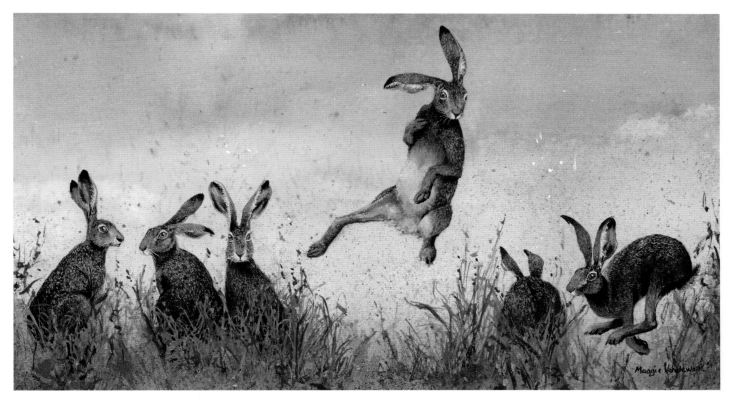

Hijinx, 2011, watercolor and gouache on cotton rag paper,
9 x 17 in. Photography by Chris Oughtred

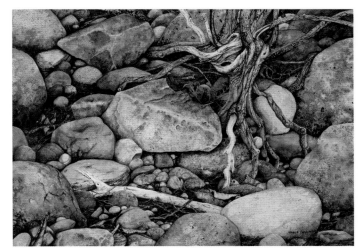

Tenacity, 2009, watercolor and
gouache on cotton rag paper, 16 x 22
in. Photography by Doug Blumer

The Brush Pile, 2010,
watercolor and gouache on
cotton rag paper, 28 x 50 in.
Photography by Doug Blumer

Vic Vicini

Livonia, Michigan, USA
www.ViciniArt.com

I attended Wayne State University and received a BFA in printmaking and painting. I was influenced by artists such as Richard Estes and Andrew Wyeth. Early in my career I focused on etching and engravings and exhibited throughout the Midwest.

Early in the 1990s I had the opportunity to meet the well known egg tempera painter Robert Vickrey at an opening. His detailed renderings had a huge influence on me. I experimented for a number of years in egg tempera and really enjoyed the science of the art.

For the past decade or so, I rediscovered oil and have not looked backed. My subject matter focuses on objects of nostalgia. My parents both came from San Marino, Italy, and you can imagine food was a big part of my upbringing. I enjoyed the culture of my heritage but my ambition as a youth was to discover America and all its charm. Memories of a typical American breakfast or dinner as a kid, going to little diners with my Dad and helping my little Italian Grandmother in the kitchen are things that are in my thoughts when I paint my still lifes. Whether its vintage cars, old toasters, or retro food packaging art, these are the thoughts and images that have a strong influence in my art. It seems that if it is retro more than likely I will put it on canvas.

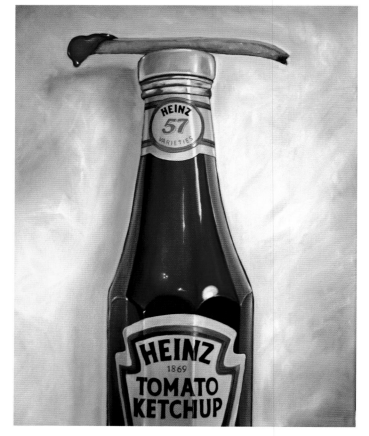

Heinz Tomato Ketchup, oil on canvas, 16 x 20 in.
Photography by Vic Vicini

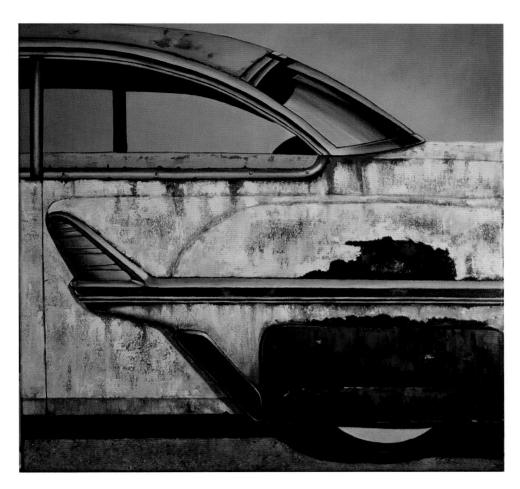

Mercury 55, oil on canvas, 24 x 30 in. Photography by Vic Vicini, Elliott Fouts Gallery

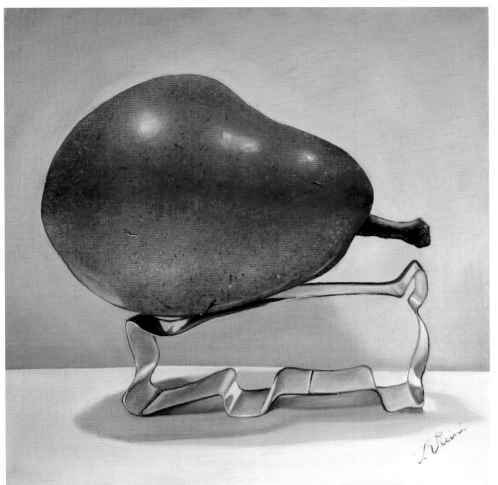

Piggy Back, oil on wood, 8 x 8 in. Photography by Vic Vicini

June Walker

West Midlands, UK
www.june-walker.artistwebsites.com

I was born and brought up in Scotland. I studied animal behavior before emigrating to New Zealand, where I was a free-lance children's writer/illustrator, specializing in stories about animals. (My stories have been published in New Zealand school journals, Australian school magazines, and USA's Cricket magazine).

I became interested in folk tales and the art of non-Western cultures whilst living in NZ and when I returned to the UK, I studied the anthropology of art. In the UK, I worked initially as a researcher in art and design, studying the design of toys for newborns. I began my career as a practical artist in 2000.

My artwork has been exhibited in one-person shows in Scotland at Gallery 3, in New Zealand at Manurewa City library, and in group exhibitions in Scotland and England. I am interested in the whimsical in art: imaginative imagery, playful colors. My main theme is the relationship between animals and people in imaginary landscapes. To make my paintings, I usually work from small doodles, which I enlarge for the painted version. I try not to have a specific idea in mind when I start my preliminary drawings. Instead, I let the pen or pencil scribble around until a figure becomes clear. This results in fairly idiosyncratic forms and imagery. The theme or title of the work usually becomes clear at this end of the drawing process. For the painted version of the sketch, I do a colorful under-painting; an abstract configuration of shapes. I, then, superimpose the sketch work on dark and light tones to make the figures more prominent in some way. I am continually looking for new ways to approach my painting. Currently, I am experimenting with the use of texture and mixed media.

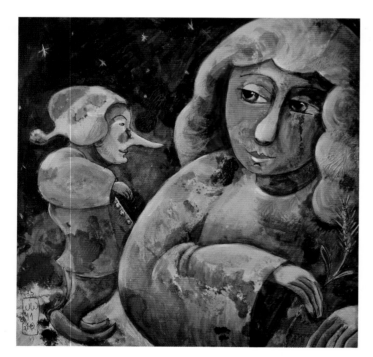

Rumplestiltskin, 2010, acrylics on paper, 11 x 11 in.
Photography by June Walker

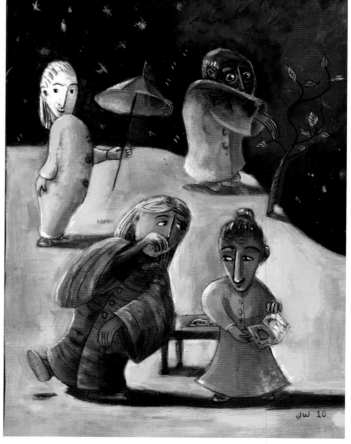

Four Friends, 2010, acrylics on paper, 6 x 8 in.
Photography by June Walker

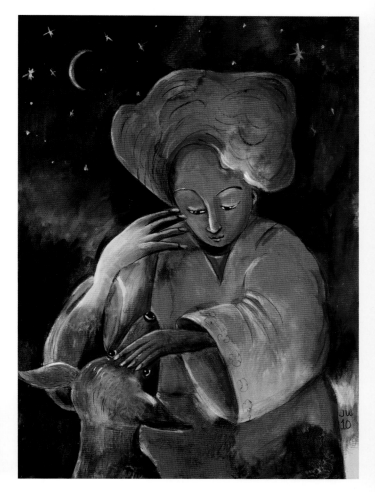

Patting the Dog by Moonlight,
2010, acrylics on paper, 8x12 in.
Photography by June Walker

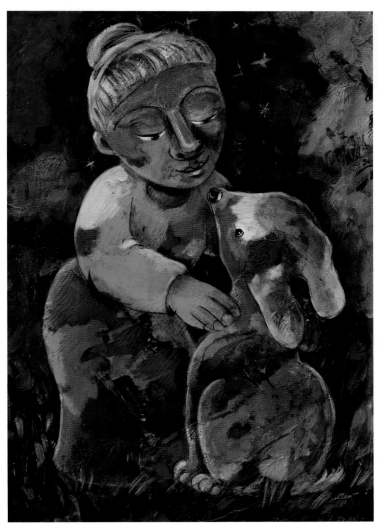

Dogstar, 2010, acrylics on paper, 8 x 12 in.
Photography by June Walker

Veronica Winters

State College, Pennsylvania, USA
www.veronicasart.com

Born in 1976, Veronica Winters immigrated to the USA over 12 years ago from Moscow, Russia. She received her BFA in art from the Oklahoma State University in 2003 and her MFA in painting from Penn State in 2005. Since then, Veronica has been painting full-time and teaching both privately and in public schools. In 2007 and 2010 Veronica took advanced painting classes at the Art Students League of New York, taught by contemporary realist artists. Veronica's paintings and drawings have been featured in several literary magazines and published in some art magazines, including *Artists & Illustrators*, *Leisure Painter*, *American Art Collector*, *American Artist Studios,* and others. Also, Veronica has published her two instructional books — *Master Realist Techniques in Colored Pencil Painting in 4 weeks: Projects for Beginners* and *Flowers: a step-by-step guide to master realist techniques in graphite and colored pencil painting*. Her two art catalogs *Life in Colored Pencil* and *Surrealism & Mythology in Painting* summarize Veronica's artistic endeavors with color illustrations on each page. Veronica has received numerous awards and her works can be found in private collections in the U.S.A. and Europe.

I create art based on the environment I'm living in for a period of time. Thus, my paintings explore influences, differences, beauty, mysticism, and experiences that come from the outside world and resonate within me. My artwork can be separated into series of paintings that are devoted to different environments or thoughts. I may spend a year working on one theme and, then, switch to something unexpected if I encounter fresh content or strong influence upon me. However, my artwork follows several constants: vivid color, representational style and surreal content. I work in two mediums: oil painting and colored pencil drawing. Both mediums are vital to my development as an artist. Both are important in the process of capturing the mystery of life on a simple flat surface. While my colored pencil drawings are realistic and precise in capturing elaborate still lives, my oil paintings are less strict technically and focus more on landscapes and surreal imagery.

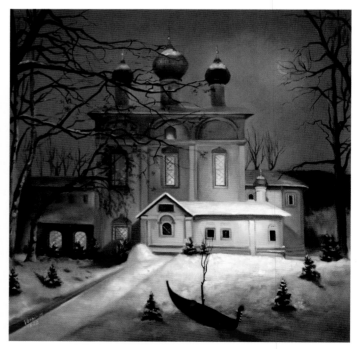

Monastery of Memories, 2008, oil on canvas, 36 x 36 in.
Photography by Veronica Winters

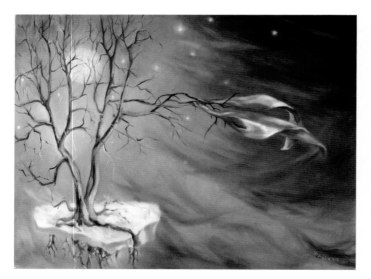

Moonlit Tree, 2007, oil on canvas, 22 x 34 in.
Photography by Veronica Winters

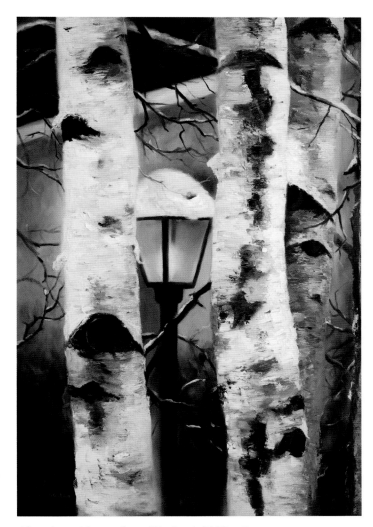

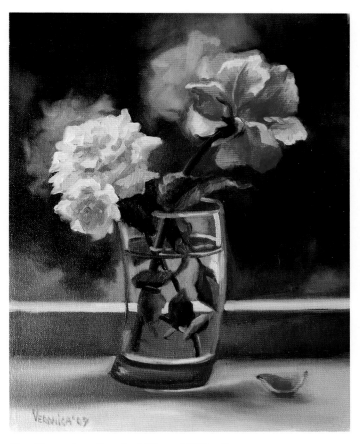

Two Roses in a Crooked Glass, 2009, oil on canvas, 11 x 14 in. Photography by Veronica Winters

Abandoned Lamp Post (Birches), 2009, oil on canvas, 24 x 36 in. Photography by Veronica Winters

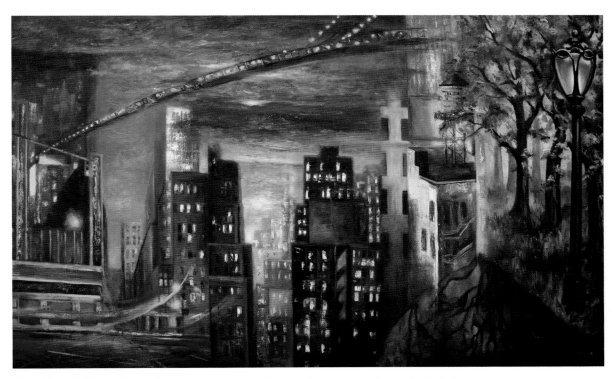

New York Calling, 2009, oil on canvas, 36 x 48 in. Photography by Veronica Winters

David Woodward

Miami, Florida, USA
www.davidwoodwardstudio.com

David uses bold colors with a painterly sensibility to combine popular iconic images, comics, phrases and type to create thematic pop art. Applying his graphic art background and his love for painting David creates bold artwork that reflects his observations on the culture we live in, either the profound, or the ridiculous. Using juxtapositions of symbolism and tongue in cheek metaphors his work doesn't always reveal itself at first glance. The deeper meaning can be found after the initial pop eye candy has time to settle into the consciousness.

David graduated from the Art Institute of Ft. Lauderdale and currently works in Miami, Florida.

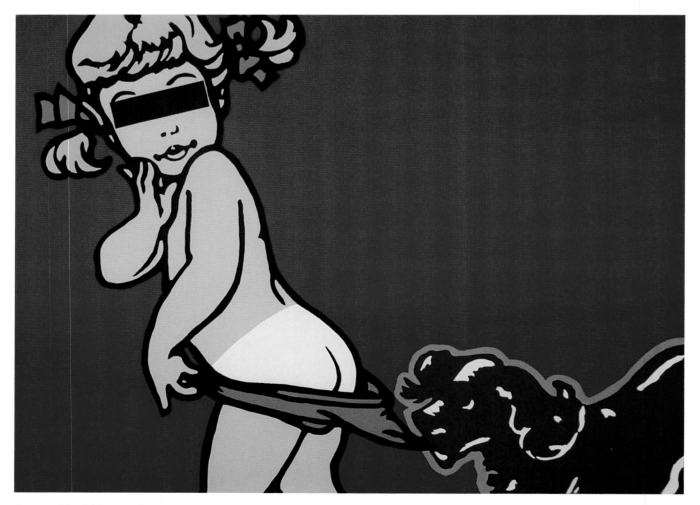

Censorship, 2004, acrylic on canvas, 48 x 36 in. Photography by David Woodward

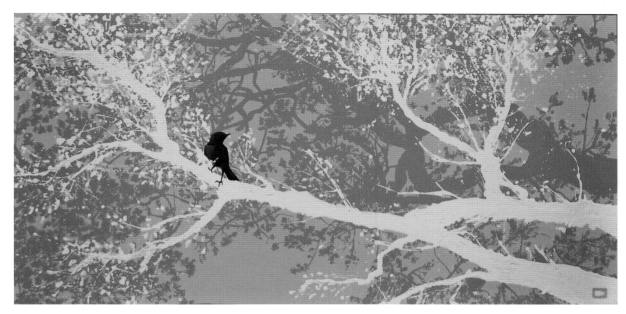

Little bird, 2010, acrylic & latex on canvas, 48 x 24 in. Photography by David Woodward

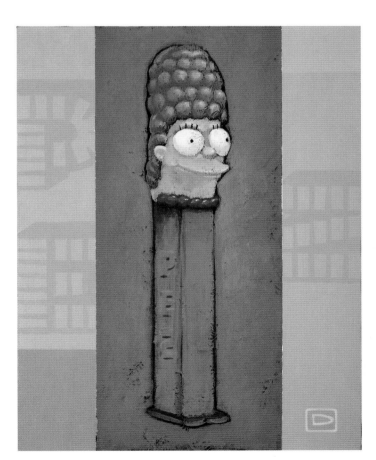

Pez Marge, 2005, acrylic on canvas, 12 x 14 in.
Photography by David Woodward

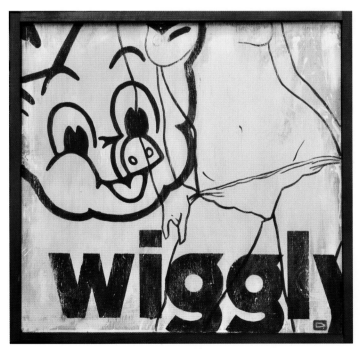

Piggly Wiggly, 2008, acrylic on wood 24 x 24 in.
Photography by David Woodward

Charlene Murray Zatloukal

Lincoln, Nebraska, USA
www.charlene-zatloukal.artistwebsites.com

I am a self taught artist, writer, mom and grandma, living in the Midwestern Plains with my art and a lifetime of memories. My dark and dreamy paintings and prints are rather sad and surreal in nature, at times a little whimsical and sometimes a little weird. My artwork covers a wide range of images, styles and media. I love to "tell stories" with my art.

Creating art is what I do...it is how I live... how I connect with the world that exists outside of my studio... how I connect with my own feelings. It is my hope that each work of art that I create, invoke a reaction of some kind in the viewer, and a special connection with its owner.

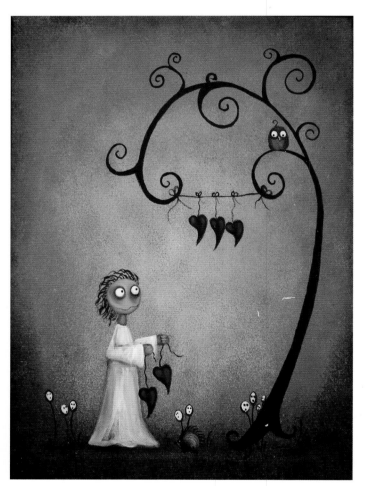

On the Line, 2010, acrylic on canvas, 11 x 14 in.
Photography by Charlene Murray Zatloukal

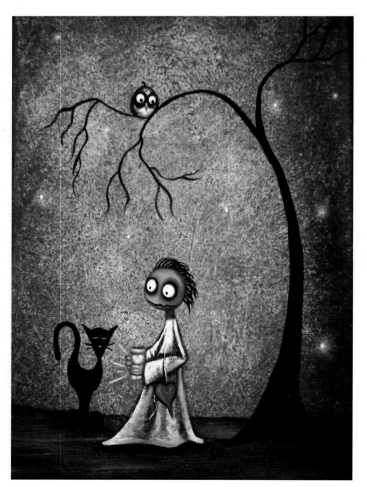

Catching Fireflies, 2010, acrylic on canvas, 11 x 14 in.
Photography by Charlene Murray Zatloukal

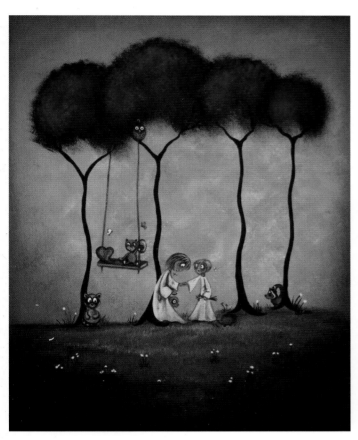

One Moment, 2010, acrylic on canvas, 16 x 20 in.
Photography by Charlene Murray Zatloukal

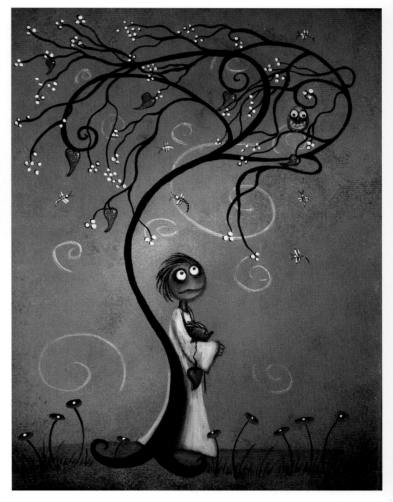

Whichever Way the Wind Blows, 2010, acrylic on canvas, 16 x
20 in. Photography by Charlene Murray Zatloukal

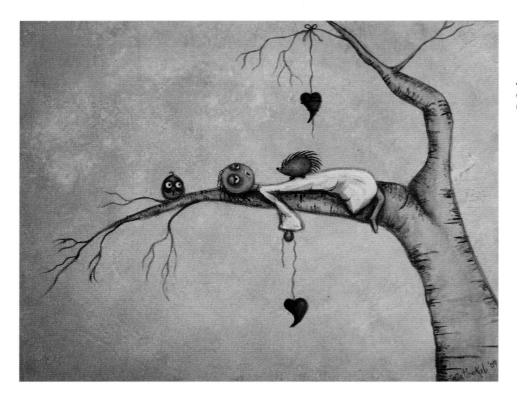

Sweet Dreams, 2009, acrylic on canvas, 12 x 16 in. Photography by Charlene Murray Zatloukal

Wonderland Tea Party, 2010, acrylic on canvas, 16 x 20 in. Photography by Charlene Murray Zatloukal

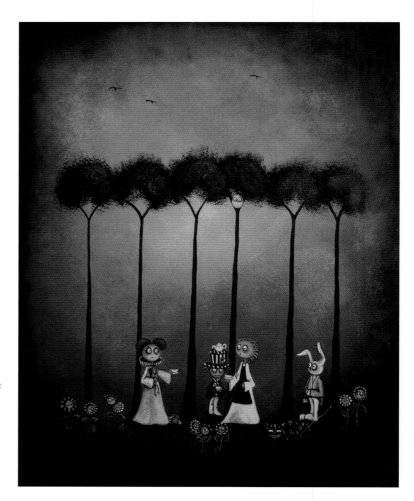